MANHATTAN WITH LOVE

MANHATTAN WITH

PAINTINGS AND TEXT BY

DOROTHY RICE

GLEN HOUSE
COMMUNICATIONS
in association with
JOURNEY EDITIONS

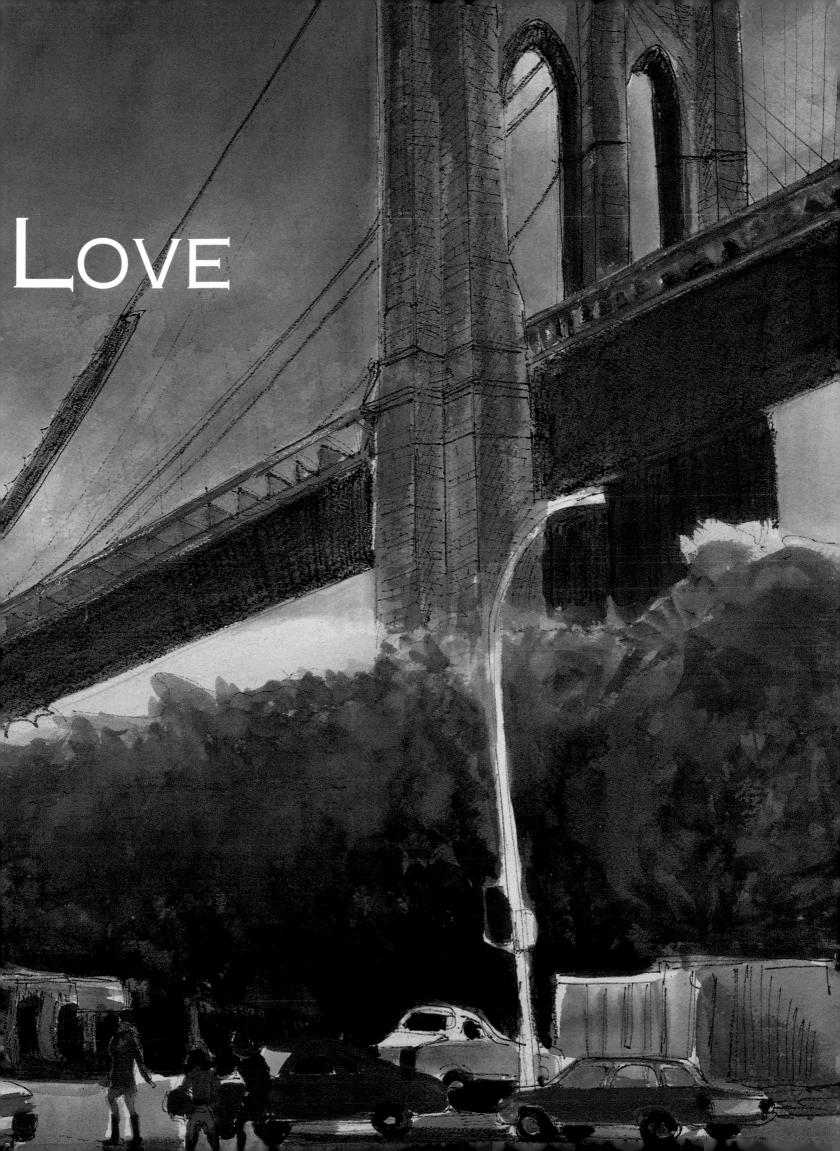

LOVE

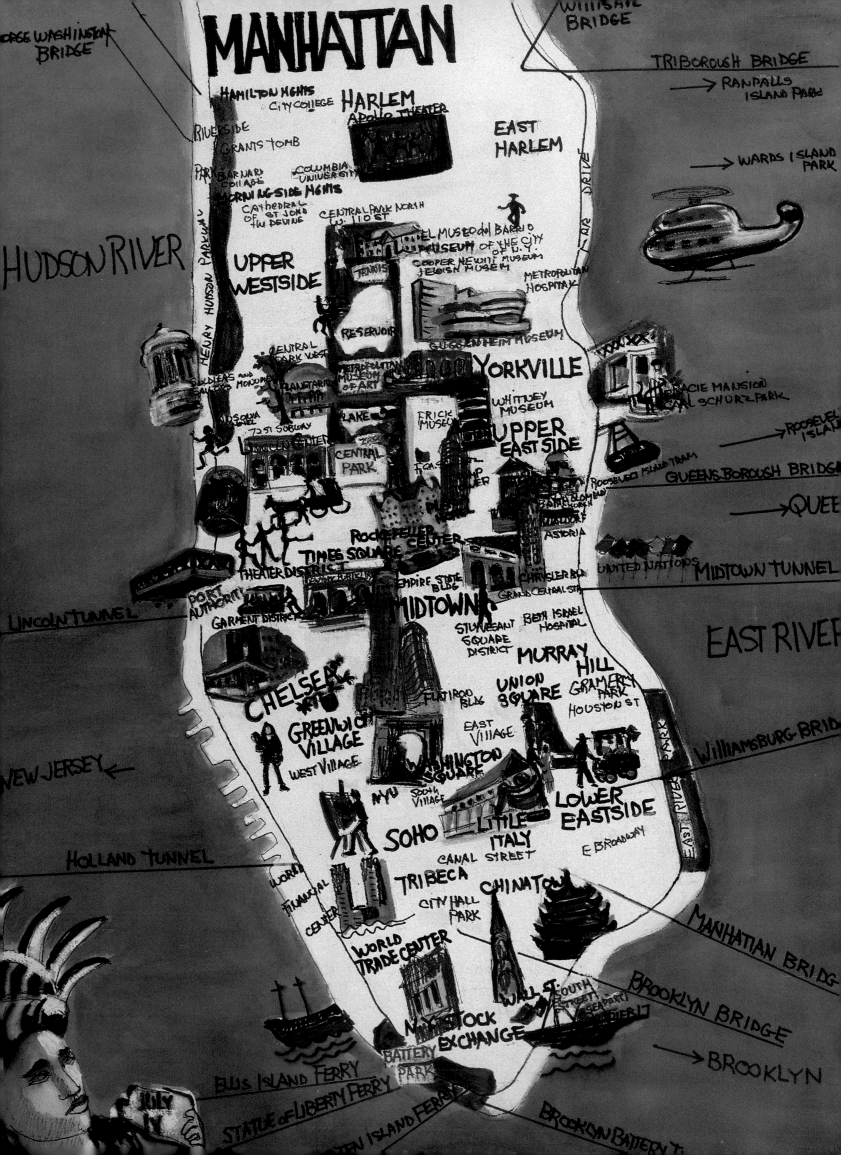

CONTENTS

4 Map of Manhattan

9 Getting into Manhattan

19 57th Street

31 Around Central Park
39 *Museum Mile*

45 In Central Park

55 The Upper West Side

67 Morningside Heights and Upper Manhattan

73 Harlem and Spanish East Harlem

77 Yorkville

81 The Chic East Side

95 Midtown
101 *Around Rockefeller Center*
111 *The Theater District*
118 *Garment Center District*
123 *Gramercy Park*
125 *Chelsea*
129 *Union Square*

131 Washington Square and Greenwich Village

139 The East Village

145 NoHo, SoHo, TriBeCa

149 Little Italy, Chinatown, Lower East Side

155 Lower Manhattan
157 *South Street Seaport*
167 *Wall Street*
169 *Battery Park*

175 About Dorothy Rice

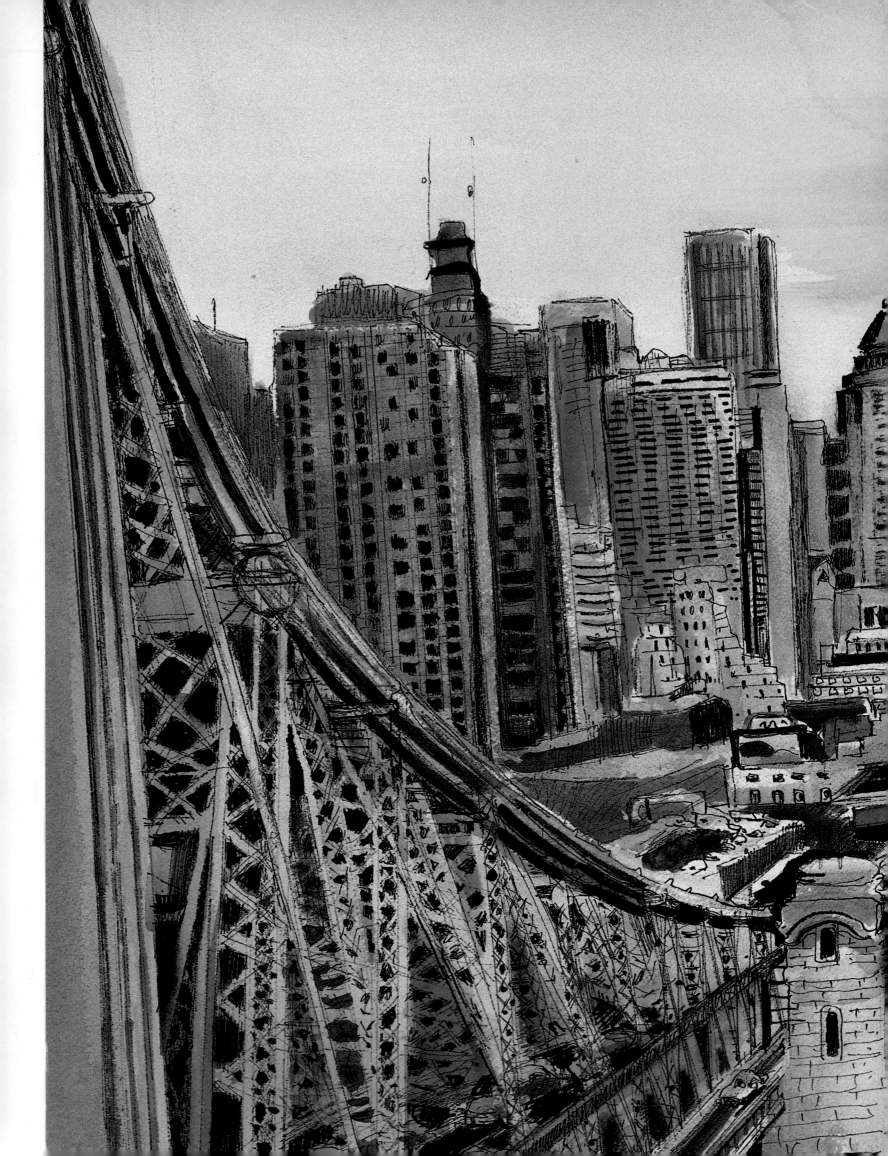

GETTING INTO MANHATTAN

AS A CHILD, MY ENTRANCE INTO Manhattan was via the Manhattan Bridge. My mother would drive us into the city from our Flatbush home in Brooklyn. Dressed in my best outfit, I sat beside her in the front seat as she doled out violet Lifesavers to keep me happy during the trip. The first breathtaking sight of the famous skyline gave me shivers of joy and anticipation—I couldn't wait to get to Manhattan! To this day, even though I now live in Los Angeles, I still eagerly look forward to that first glimpse of Manhattan skyline signaling that, once again, I am *home.*

Over the years I have traveled on most of the existing routes into Manhattan. There are plenty of them, each offering its own unique course into the heart of the city. Most visitors arrive by plane, landing at either Kennedy, La Guardia, or Newark Airport and then gearing up for the bus or cab ride into Manhattan. When you take a cab, you get a firsthand glimpse of the New York melting pot. If you

Queensboro Bridge

Also known as the 59th Street Bridge, the Queensboro Bridge's intricate triple-steel span stretches from Queens Plaza to 2nd Avenue and East 59th Street in Manhattan. Huge vaulted areas underneath the ramp on the Manhattan side were originally the site of a Farmers' Market.

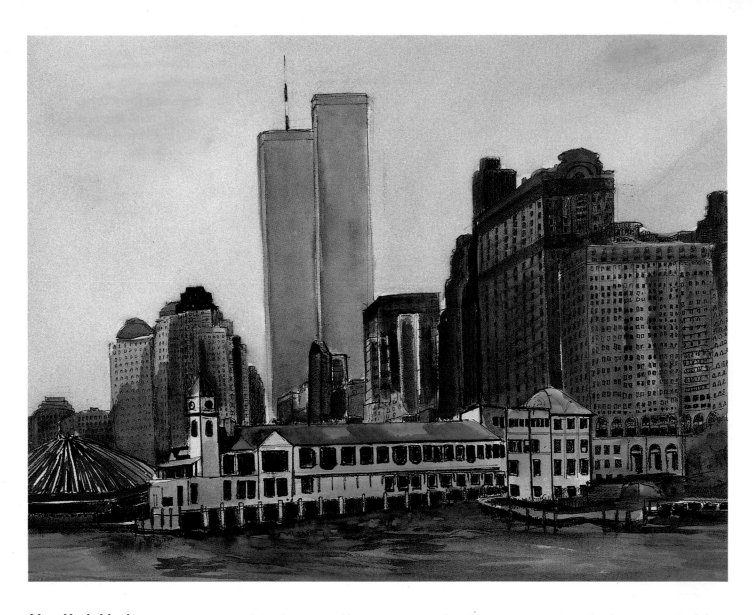

New York Harbor

Looking at New York Harbor from the deck of a ship, we see the clock tower on Pier A. Originally a firehouse and a wharf for fireboats, this boat landing dominates the view of Battery Park, with the World Trade Center's Twin Towers in the distance. The Cirque du Soleil performs next to the boat landing when it comes to town.

Manhattan offers every mode of transportation the human mind has managed to dream up. A five-minute tram ride carries you to Roosevelt Island, a jitney whisks you away to the Hamptons on Long Island, and a helicopter can take you to the top of the world (the roof of a skyscraper, that is). In yet another way to get around this amazing city, parachutists have even been known to jump off skyscrapers! You can walk, jog, hike, bicycle, skateboard, or ride a moped or a horse into or through Manhattan. I have even seen blimps cruising the skies over the city. You can also arrive via seaplane or submarine. But no matter how you choose to get there, and no matter whether you're a first-time visitor or a born-and-bred New Yorker returning home, coming into Manhattan is sure to inspire a rush of excitement, admiration, and awe.

For me, it's just love.

Circle Line Boat >

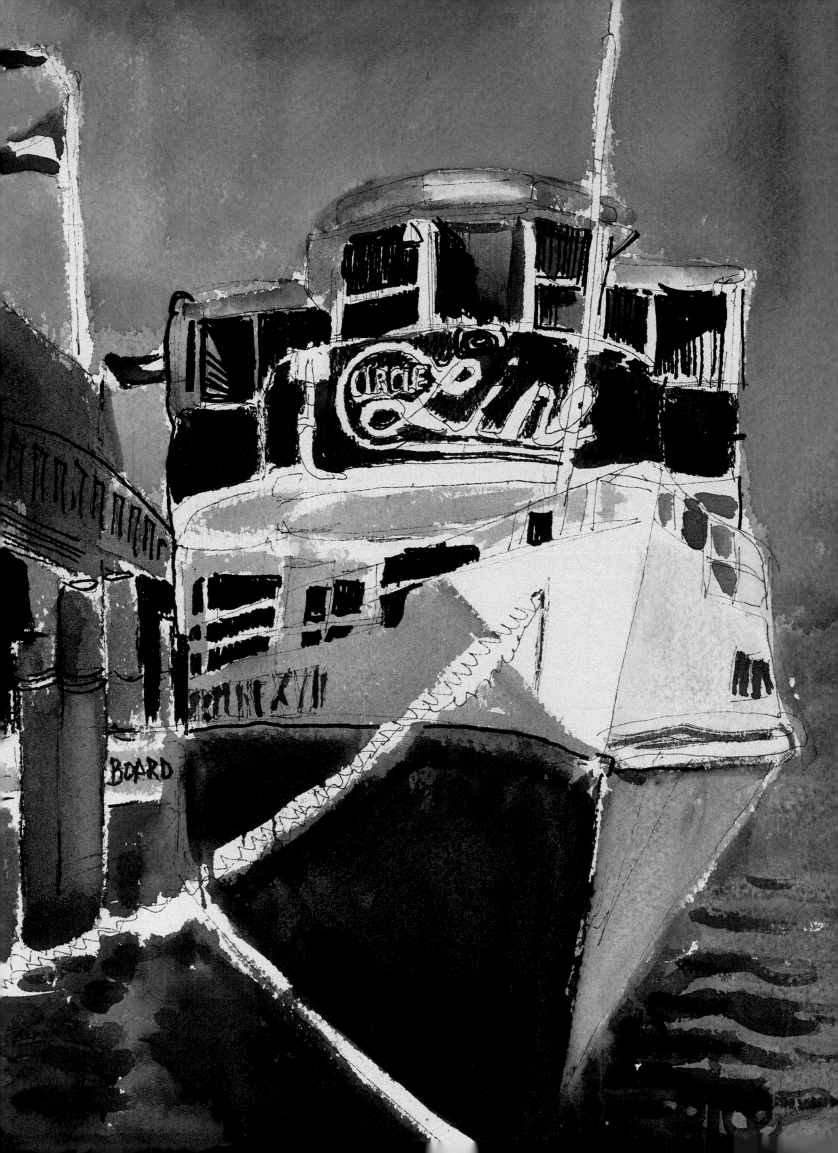

*Entering
Manhattan along
FDR Drive*

*Port Authority
Bus Terminal*

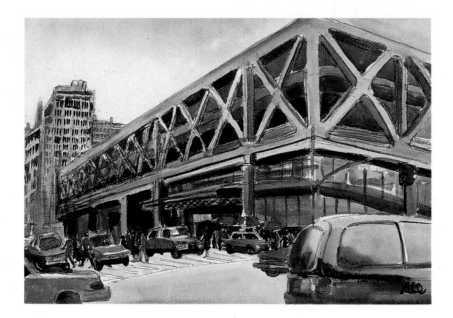

*Helicopter Coming
in for a Landing
at the Heliport*

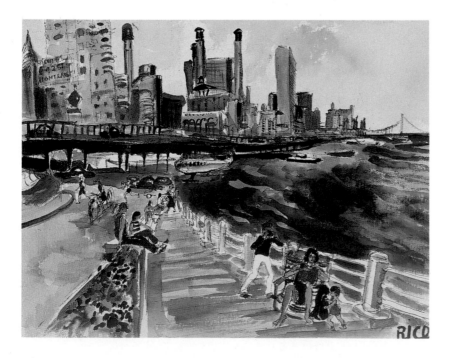

*Subway Train >
Arriving at Hunter
College Station*

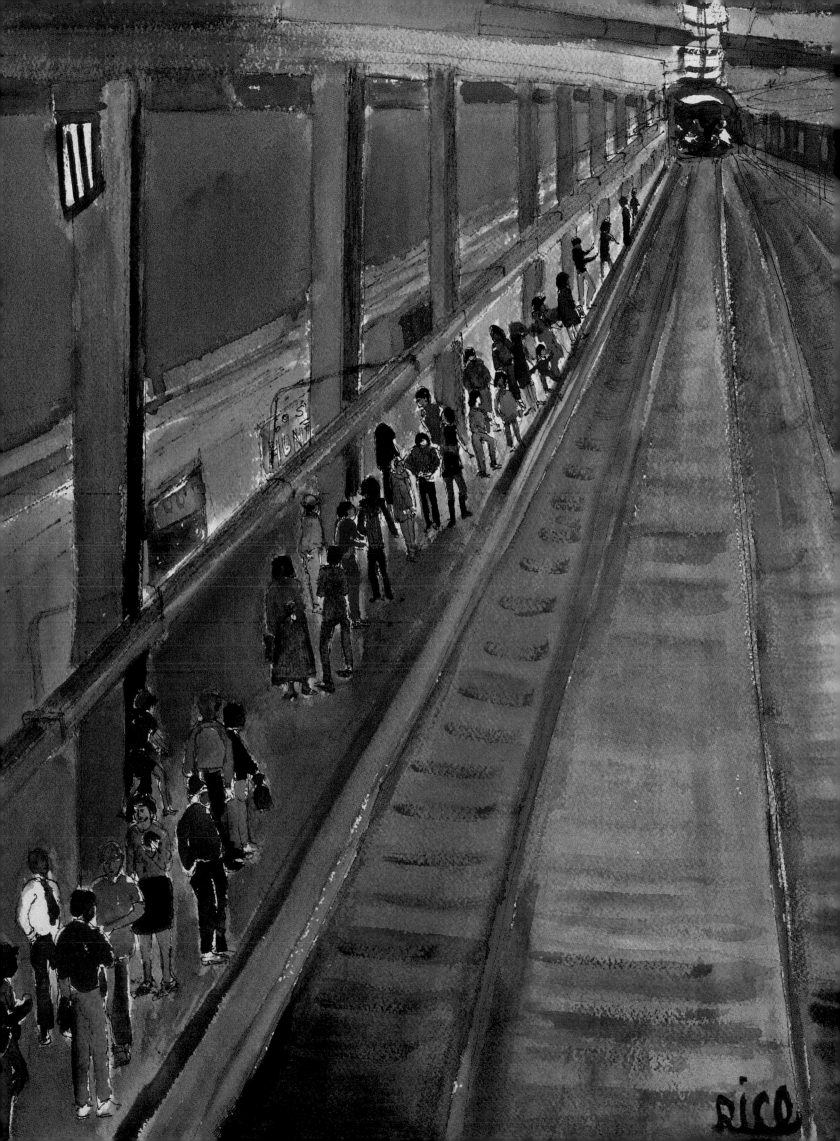

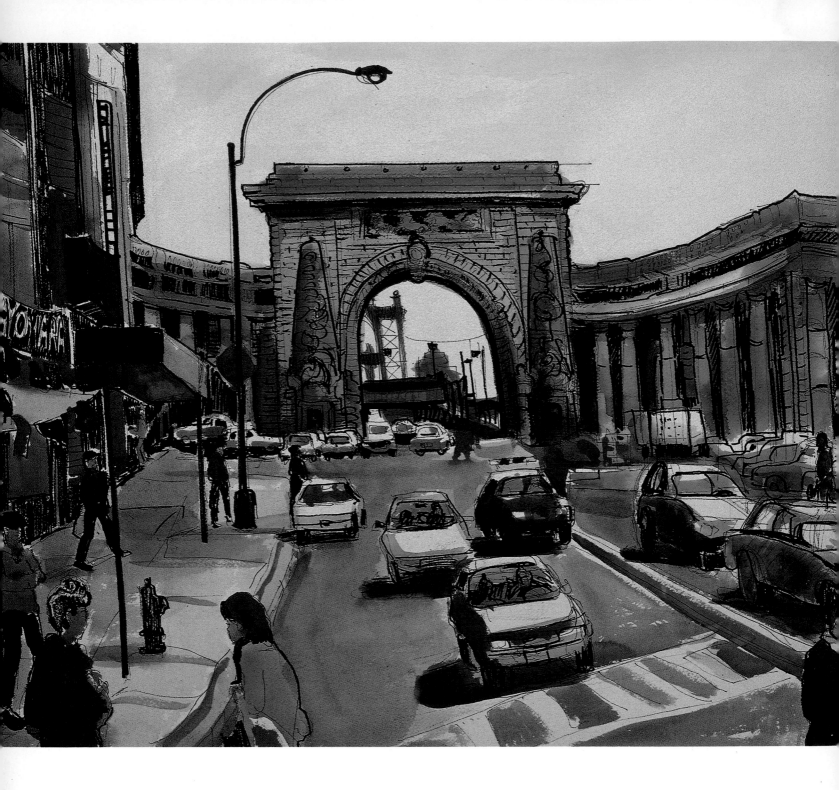

Manhattan Bridge

As you approach from Bowery and Canal Streets you see the dramatic
gateway to the Manhattan Bridge, a triumphal arch modeled after the
17th-Century Pointe St. Dennis in Paris, framed by curved colonnades
designed in the style of Bemini's at St. Peter's Square in Rome. Granite
sculptures flank either side of the bridge. Over the arch is a frieze by
Charles Rumsey depicting Indians on horseback hunting buffalo. The
bridge opened in 1909, and this is the site where Washington began
his victory march into New York.

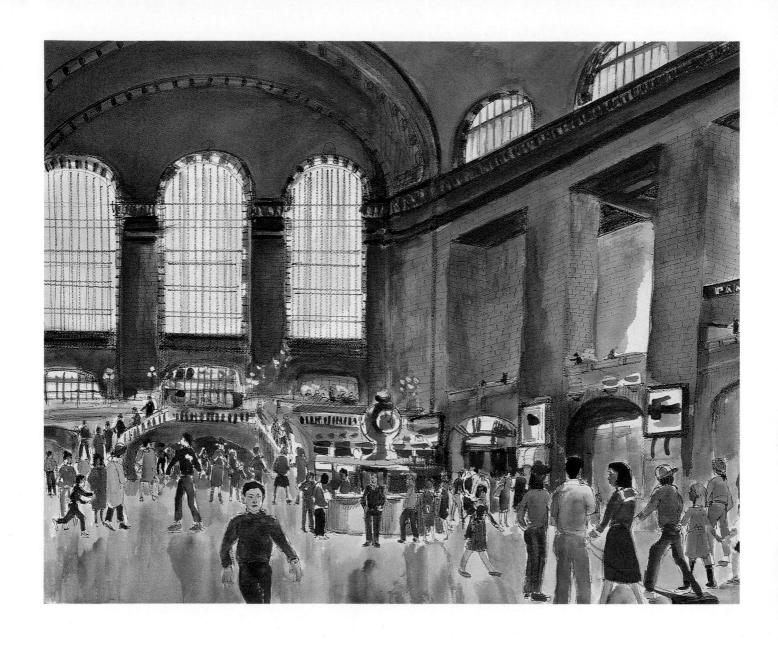

Inside Grand Central Station

This landmark public building was saved from the wrecking ball in the 1970s and skillfully restored to its turn-of-the-century beatuy and grandeur. Its soaring, vaulted ceiling and great arched windows shower visitors below with rays of sunlight.

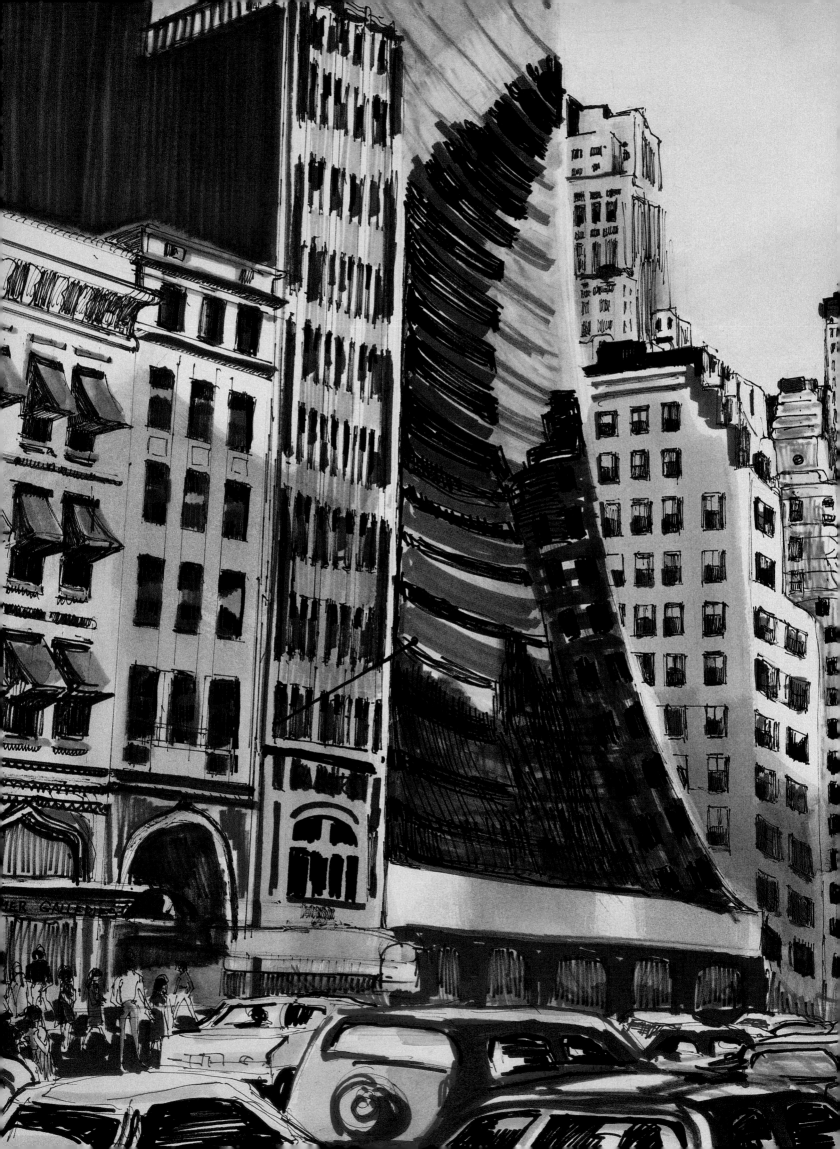

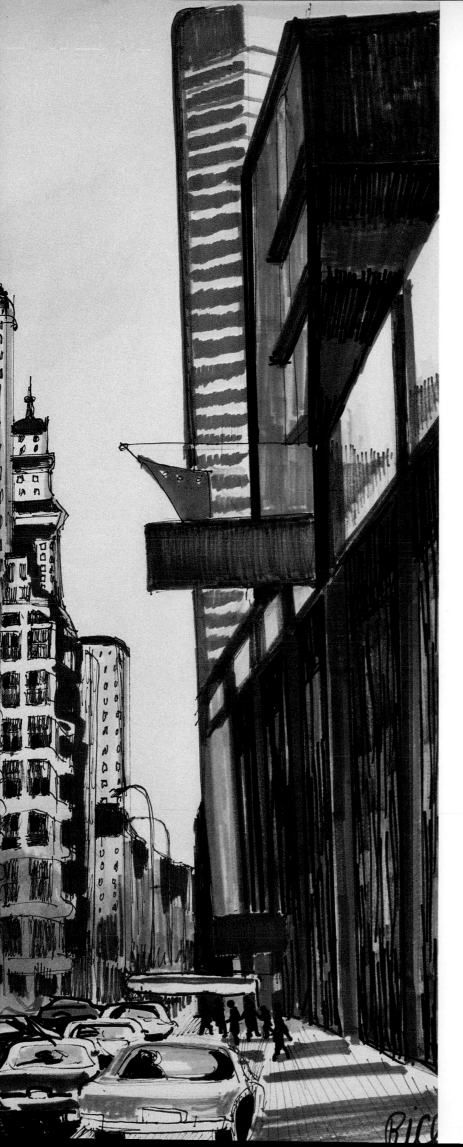

57TH STREET

MY FAVORITE INTERSECTION IN Manhattan is where 57th Street meets Fifth Avenue. It's a wonderful starting point. Once I have crossed that corner, I feel elated. I am really in Manhattan! I usually start walking from 57th Street and Lexington Avenue, browsing in the many antique and designer-clothing stores and visiting well-known art galleries in the Fuller Building such as the Pace and the Andre Emmerich, all the while hoping to run into an old friend by the time I reach Fifth Avenue. Sometimes I stop for lunch in the elegant lobby of the 57th Street Four Seasons Hotel or the Trump Tower cafeteria or Henri Bendel's restaurant a few streets down Fifth Avenue. Sometimes I shop at Bergdorf Goodman. I like to pop into one of the city's great bookstores—Barnes and Noble, Brentano's, Rizzoli, B. Dalton, or Doubleday, which are all in the vicinity—before wandering over to Burberry's or Chanel if I need to buy a gift. It's always a delight to view the latest toys at F.A.O. Schwarz or play with the gadgets in the Warner Bros. store. I never miss an opportunity to see the jewelry displays at Tiffany, Bulgari, and Van Cleef and Arpels, and dream of someday owning one of their gorgeous diamond necklaces.

57th Street between Fifth and Sixth Avenues

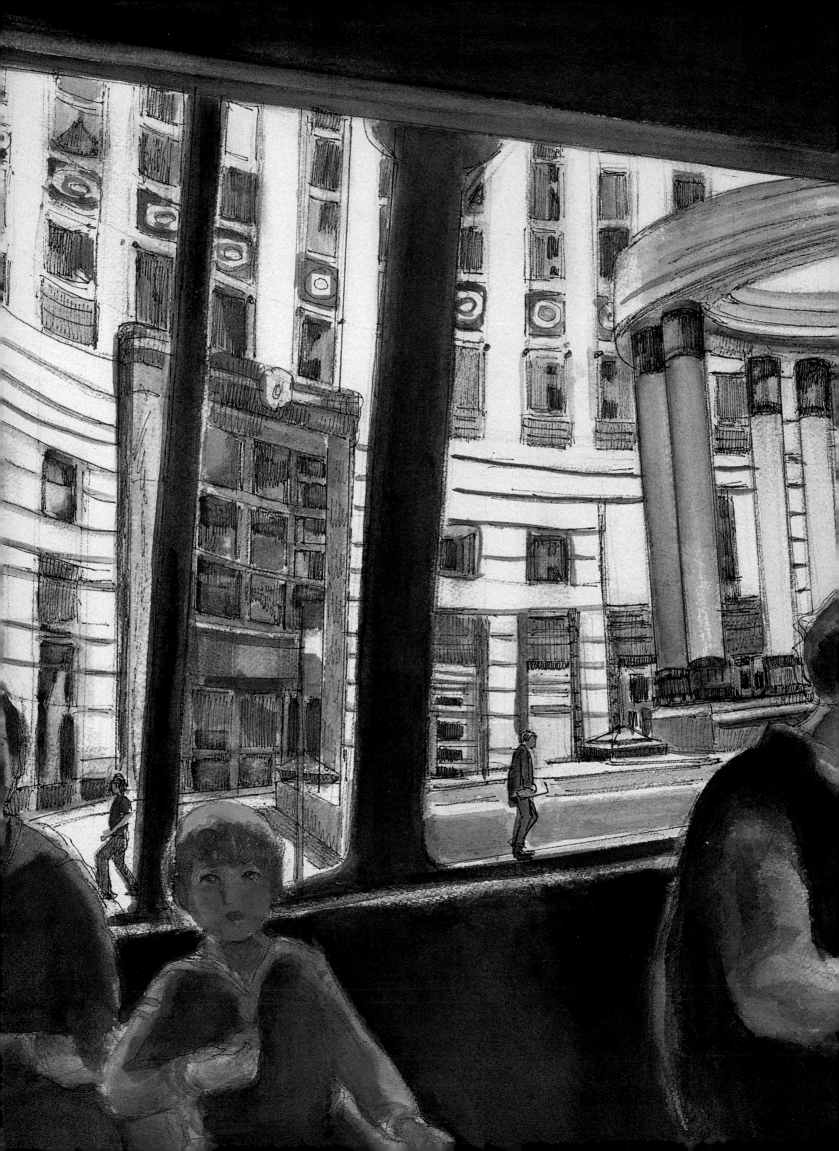

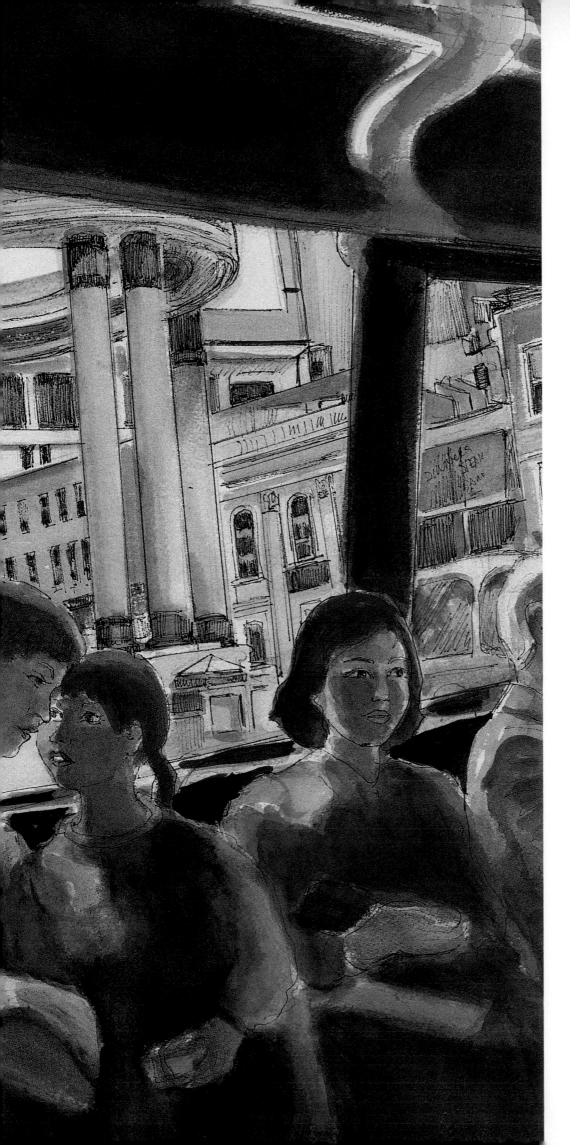

Bus Ride on 57th Street

From the window of a bus at East 57th Street and Lexington Avenue, the Place des Antiquaires, featuring over 90 exclusive antique shops in 50,000 square feet, beckons to the serious shopper and casual browser. The exquisitely designed building opened in 1986.

Love on 57th Street and Fifth Avenue

21

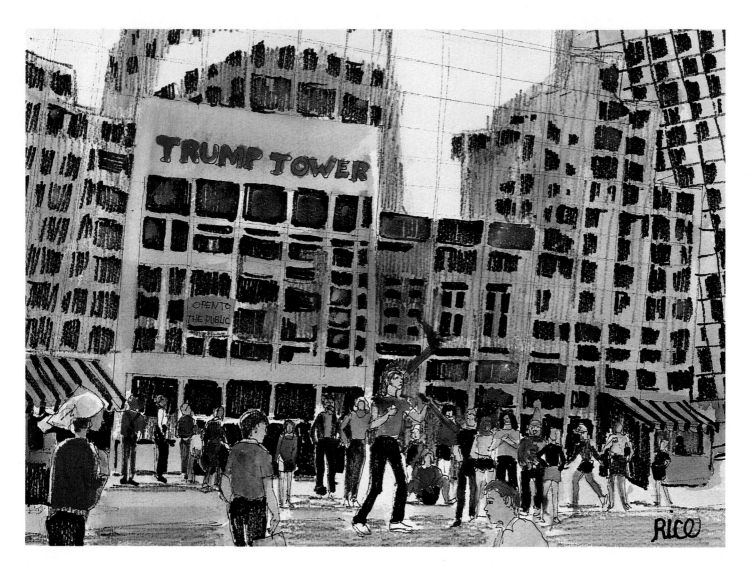

Trump Tower

The sleek post-modern facade of this skyscraper is almost outdone by the opulent pink-marble shopping plaza that lies within. Trump Tower is a prime example of the love of glamour that characterized the architecture and design of the 1980s.

As I head toward the Avenue of the Americas (still known to many by its original name, Sixth Avenue), I try to take in the art galleries on the way—the changing exhibits at the Marlborough, the Kennedy, and the Hammer. Then I might pay a visit to Hacker Art Books, the largest art bookstore in Manhattan.

This amazing area also boasts the famous Russian Tea Room, Carnegie Hall, the Hard Rock Cafe, and the Art Students League, where I studied art. If one of those sudden rainstorms hits, you can always purchase an inexpensive umbrella at Uncle Sam's Umbrella Shop. During the day, the tantalizing smell of hot dogs, pretzels, and various ethnic foods compete for your attention. Late at night, you can find a kiosk open where you can pick up an evening newspaper to take with you as you stroll down to Carnegie Deli for a late-night snack.

Of all the corners in Manhattan, 57th Street and Fifth Avenue is the best spot for people watching and soaking in the sights and sounds of a city constantly on the move. The sound of rushing traffic mixed with foreign-language conversations accompanies the parade of the latest fashions streaming by. It makes me feel right at home.

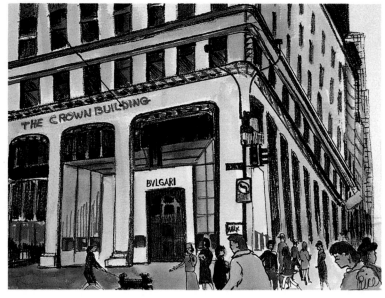

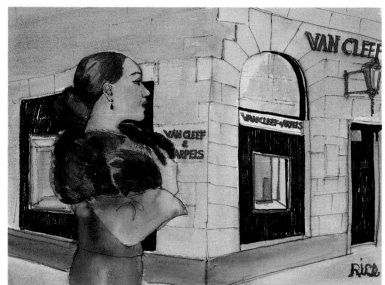

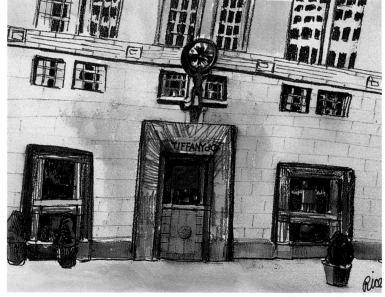

Inside Trump Tower

Top

Bulgari

This newly designed store in the Crown Building on the southwest corner of 57th Street dazzles the eye with sparkling displays of Italian jewelry and gems.

Middle

Van Cleef and Arpels

Known for its stunning one-of-a-kind jewelry creations, this treasure chest of exclusive designs can be found on the northwest corner of 57th Street.

Tiffany & Co.

Situated on the southeast corner of 57th Street, Tiffany's beautiful window displays of expensive jewelry are a joy to behold.

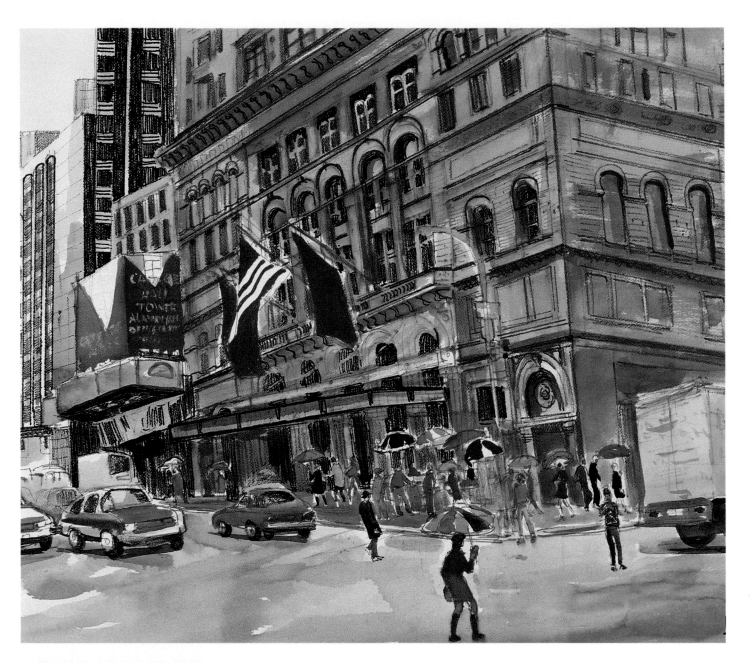

Carnegie Hall in the Rain

Completely restored in 1986, this illustrious concert hall has welcomed most of the world's greatest musicians over the past hundred years. Tchaikovsky conducted the New York Philharmonic in the hall's premiere concert. Gustav Mahler, Bruno Walter, Leopold Stokowski, Arturo Toscanini, and Leonard Bernstein also conducted here, along with jazz immortals W. C. Handy, Count Basie, Benny Goodman, Duke Ellington, and Stan Getz.

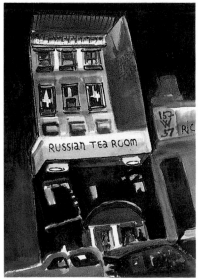

Russian Tea Room

I spent many evenings of my early professional life as a model and actress in the Russian Tea Room, a celebrated hangout for actors, artists, writers, musicians, ballet dancers, directors, producers, and agents. I would bring my dates here, hoping to run into friendly faces and catch up on the day's news and gossip. Celebrities can usually be spotted holding court in the front booths.

F.A.O. Schwarz Toy Store >

Perhaps the most famous toy store in the world, F.A.O. Schwarz stocks the most extravagant selection of toys to be found anywhere. A singing clock welcomes all who come to shop in toy land.

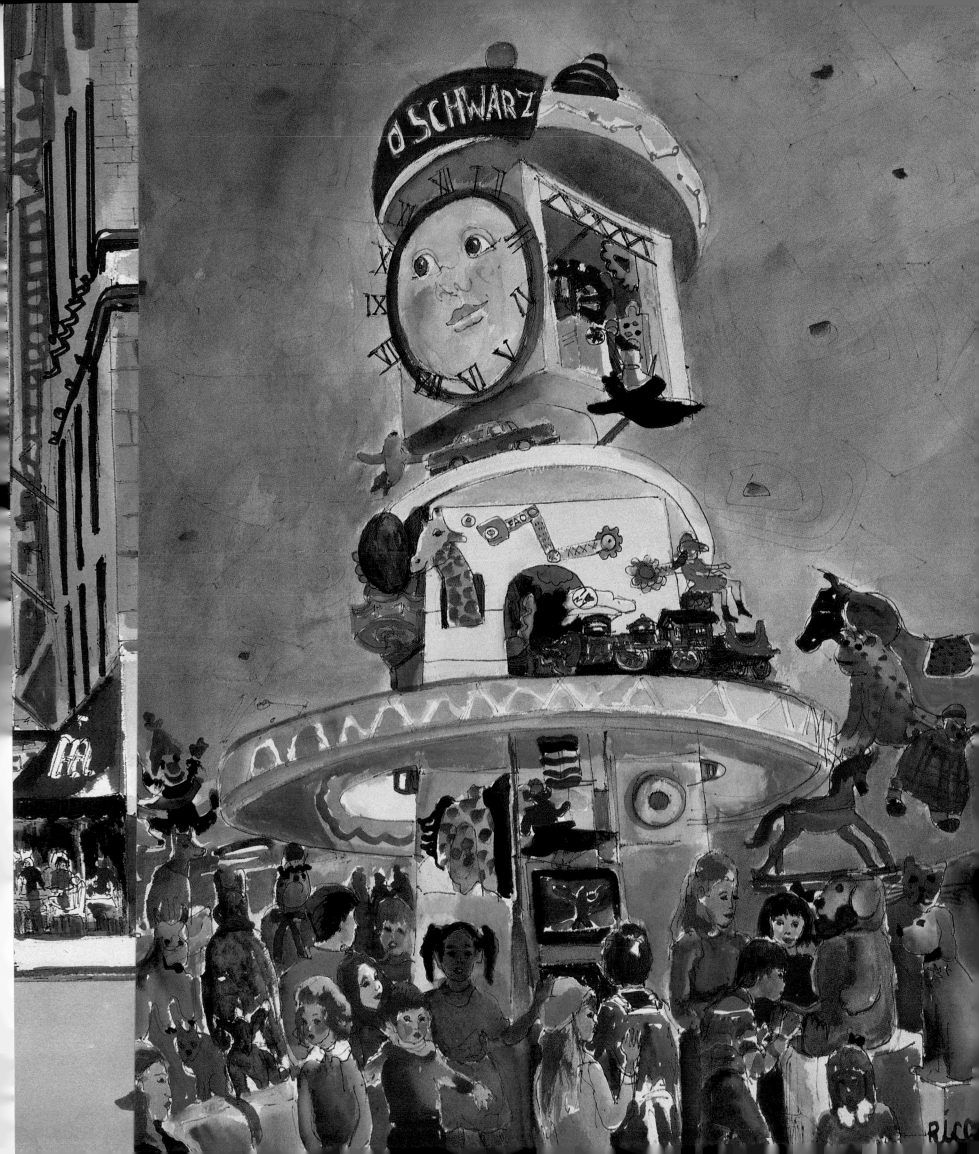

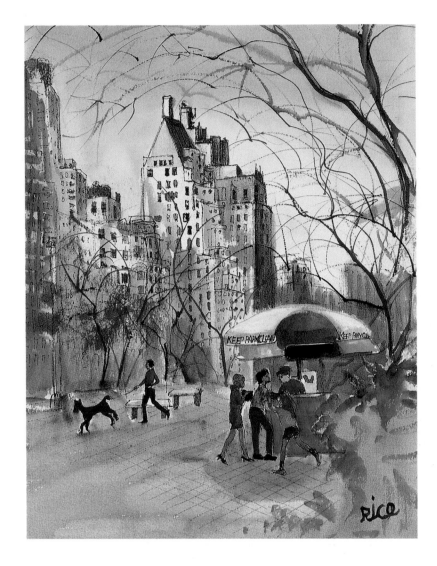

Corner Entrance to the Park at Central Park South and Fifth Avenue

Clock in Front of the Sherry Netherland Hotel

**Walking Uptown on >
Fifth Avenue and
Central Park East**

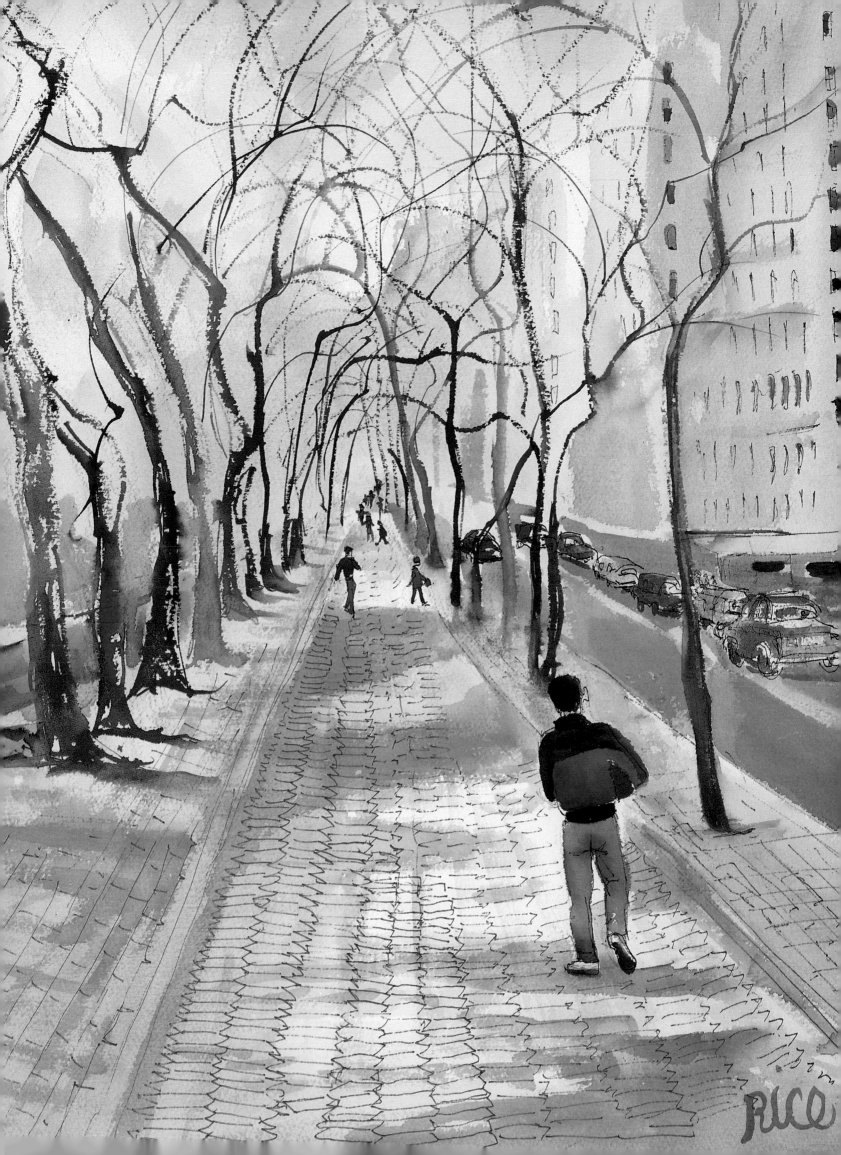

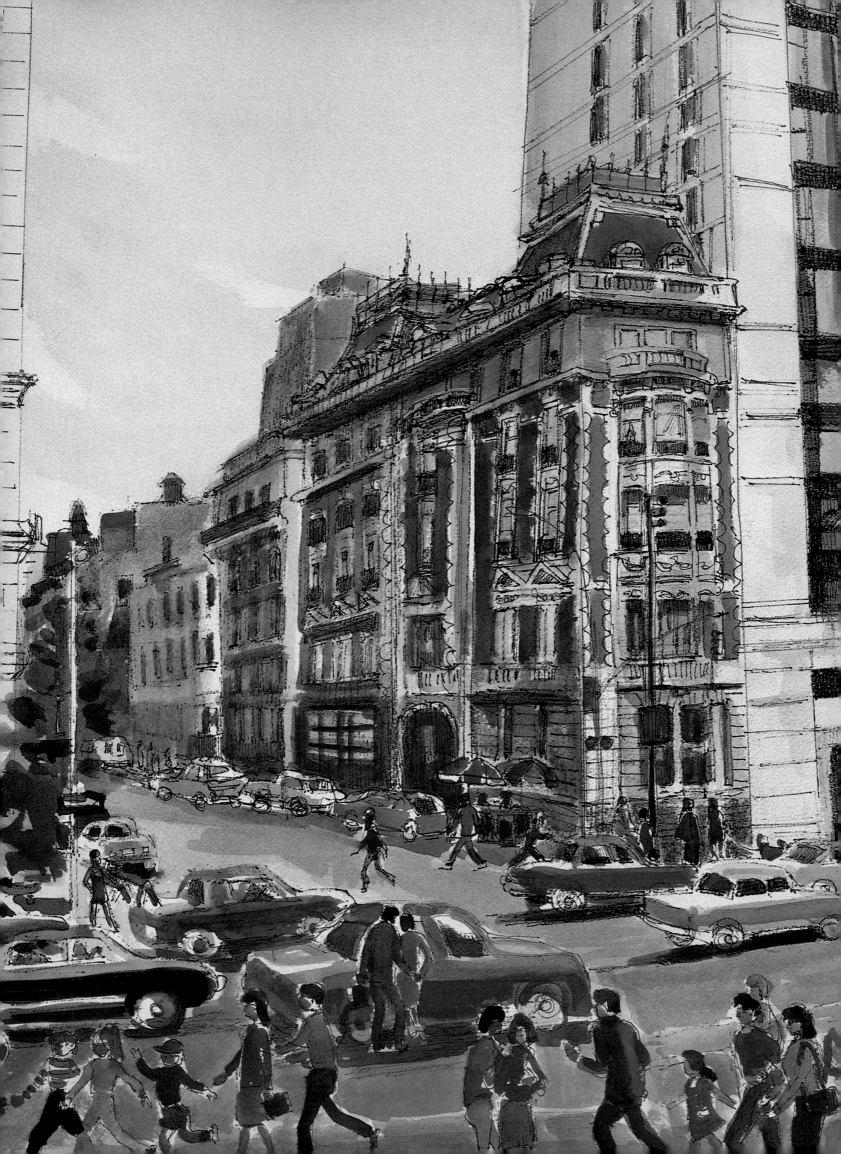

MUSEUM MILE

STROLLING ALONG Museum Mile on Fifth Avenue on the east side of Central Park, you will encounter many cultural institutions between East 70th and East 103rd Streets. These include the Frick Museum, the Metropolitan Museum of Art, the Yivo Institute for Jewish Research, the Solomon R. Guggenheim Museum, the National Academy of Design, the Cooper-Hewitt Museum, the Jewish Museum, the International Center of Photography, the Museum of the City of New York, and El Museo Del Barrio. A side trip to Madison Avenue and 75th Street brings you to the Whitney Museum of American Art. Some were designed as public buildings by well-known architects such as Calvert Vaux, who designed the Met, and Frank Lloyd Wright, who designed the Guggenheim. Many of the museums began as mansions for the well-to-do. Felix M. Warburg's home is now the Jewish Museum, Andrew Carnegie's home is the Cooper-Hewitt Museum, and Henry Clay Frick's home holds the famed Frick collection.

On Museum Mile

Across the street from the Metropolitan Museum of Art at 81st Street and Fifth Avenue is the elegant, red-and-white Duke Seaman's Mansion, which received the 1986 New York Landmark Conservancy Chairman's Award for Excellence in Restoration.

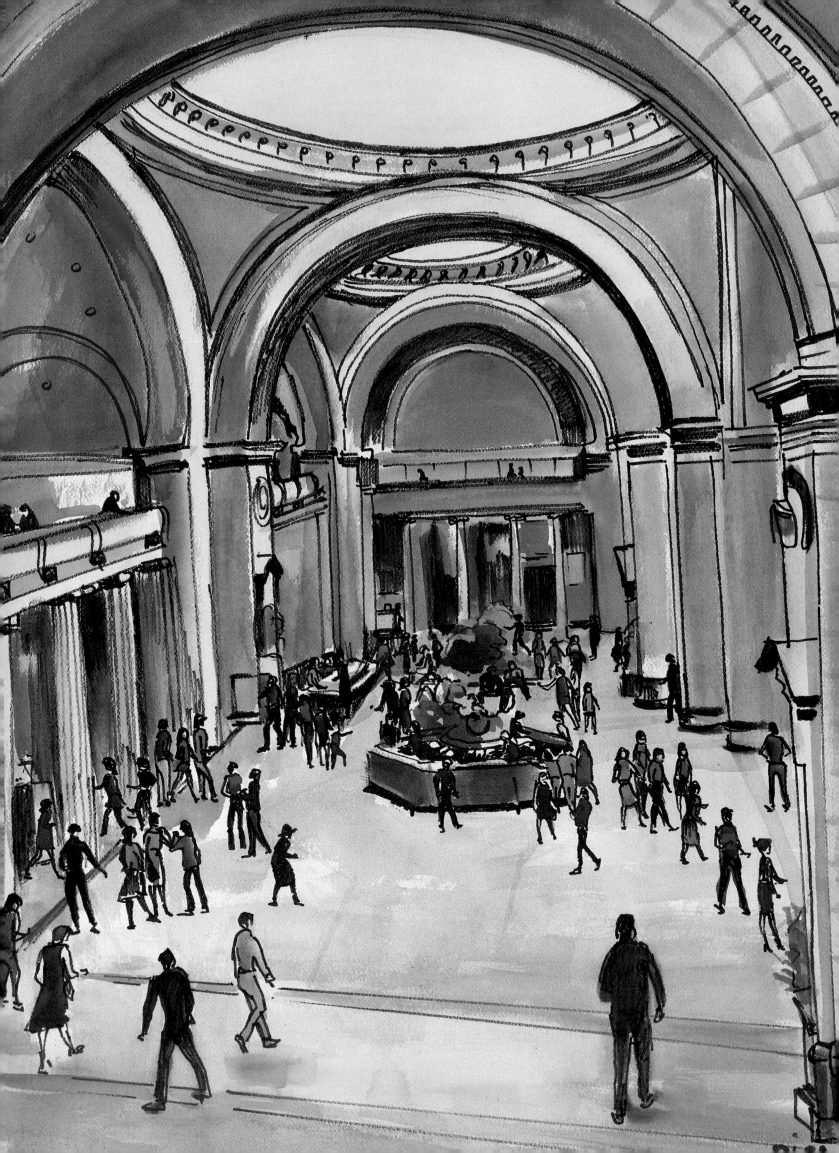

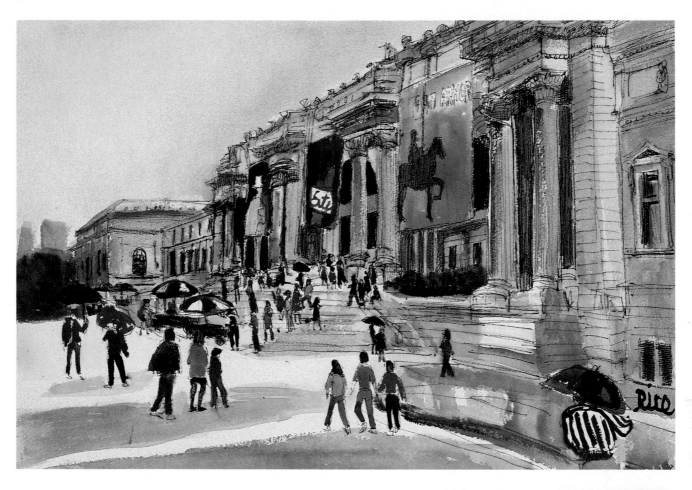

Entrance to the Metropolitan Museum of Art

Flanking the grand flight of steps leading up to the entrance of the museum on 82nd Street and Fifth Avenue are two enormous fountains. Streams of people move from the rotunda of the Great Hall to the extensive collections of European, American, Greek, Egyptian, Roman, medieval, Near and Far East art, sculpture, and artifacts. The Met's 3.3 million works of art make it the largest art museum in the Western Hemisphere. Visit the gift shop on the first floor before dining at one of the poolside tables in the rather hectic cafeteria.

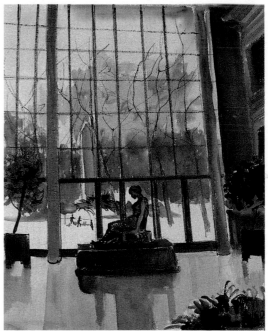

Looking Out from the Windows of the Metropolitan Museum at Cleopatra's Needle

Cooper-Hewitt Museum

Housed in Andrew Carnegie's former home, this sixty-four-room mansion contains the Smithsonian Institution's Museum of Design. The changing exhibits alternately highlight a different facet of the world of design.

< **Rotunda of the Great Hall of the Metropolitan Museum of Art**

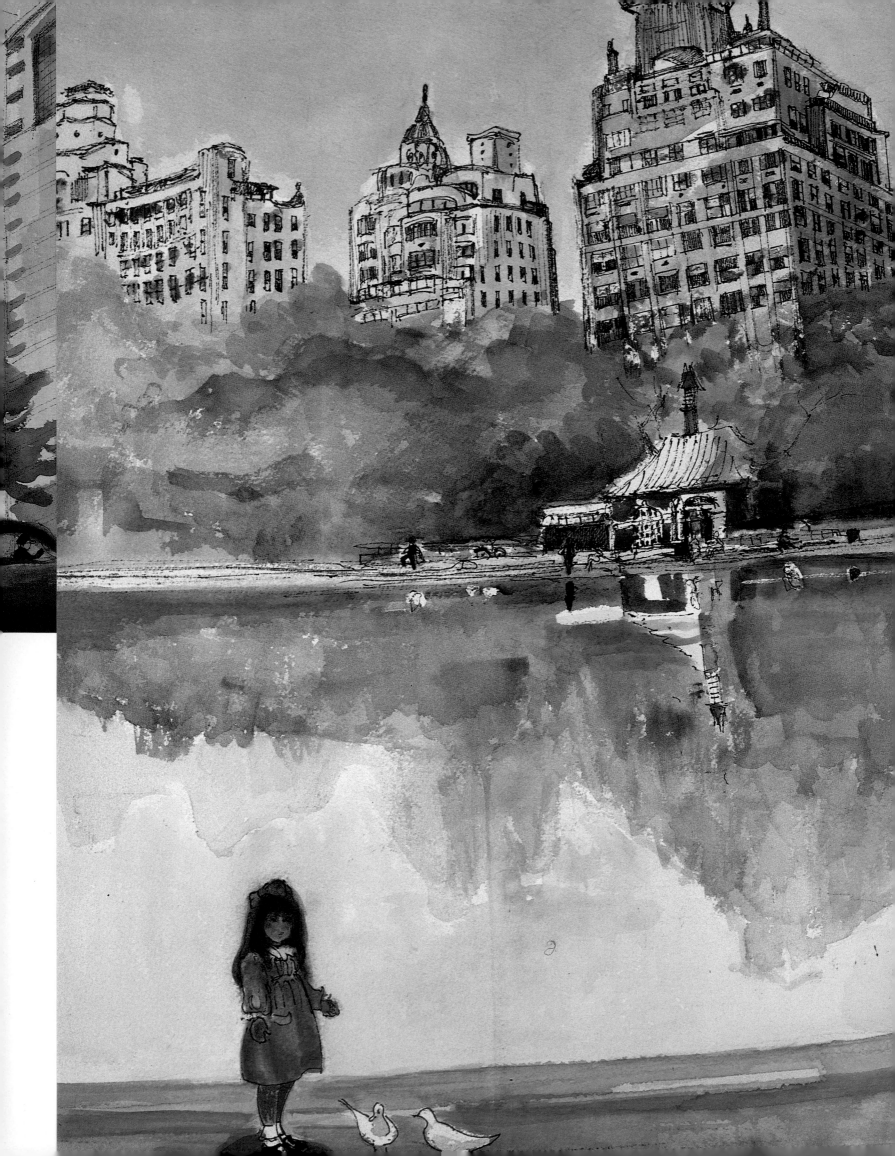

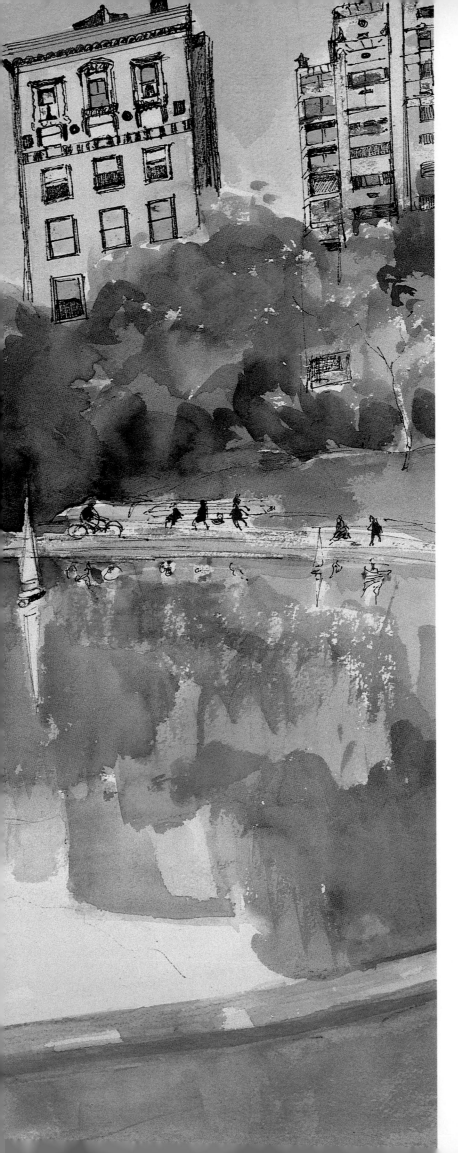

IN CENTRAL PARK

CENTRAL PARK IS JUST THAT—absolutely central. Separating the East Side from the West Side, it is the lush back yard New Yorkers can't live without, the place they hold dear to their hearts. The extraordinary presence of this 843-acre park in the middle of the concrete-and-glass metropolis of Manhattan is like something out of a fairy tale.

Each season, Central Park offers its own marvelous attractions that seem to cast a unique spell. In winter, shimmery whiteness and graceful trees provide the perfect picture-postcard backdrop of skaters gliding over the frozen pond. The start of spring is celebrated with a profusion of flowers, sweethearts holding hands, and brightly colored baby strollers being pushed leisurely toward the park's playground. Fall is luscious, with the changing of the leaves, boaters on the lake enjoying the crisp air, and energetic games of tennis, softball, and soccer. In summer, the park is crowded day and night and is certainly the place to be for everything from open-air theater to sunbathing and picnicking by the ponds and in the meadows. During the

Conservatory Water

A little girl feeds the pigeons at the edge of the formal pond where remote-controlled model sailboats send ripples across the reflected view of the Manhattan skyline.

45

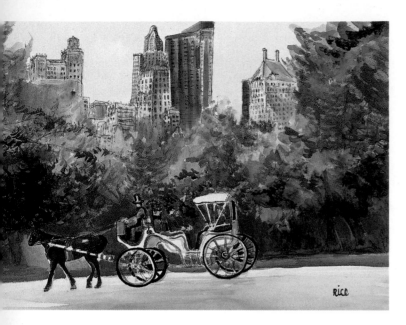

Spring in Central Park

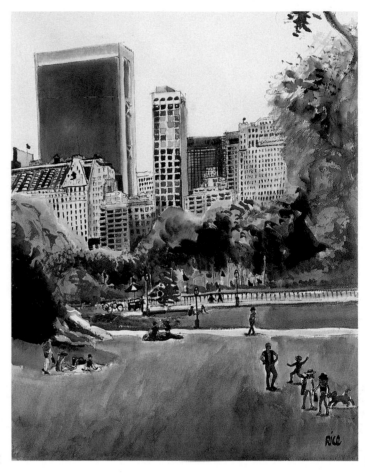

Summer Comes to Central Park

summer months, it seems as if everyone in Manhattan is in the park listening to concerts, enjoying the Shakespeare-in-the-Park shows, playing games, eating hot dogs and ice cream, or just watching everyone else.

All year round, dedicated joggers do their laps around the reservoir, braving all kinds of weather. Dogs of every shape and size take their owners for walks along the many park paths, and the zoos for children and adults are always a popular destination. So is the Alice in Wonderland statue, immortalized in bronze, along with the Mad Hatter, the Cheshire Cat, and the Dormouse, all surrounded by toadstool seats. A ride in a horse-drawn carriage through the park offers endless sightseeing opportunities. In addition to playgrounds and skating rinks, there is the Dairy, the Carousel, the beautiful Belvedere Castle, and the Hans Christian Andersen statue, which offers a welcoming lap for youngsters who love to climb. It's all part of Central Park—that wonderful, magical piece of Manhattan!

Top
Ice Skating in the Park >

One of the two ice-skating rinks in the park, Wollman Rink is a popular meeting spot. In the summer, it is transformed into a roller-skating rink.

The Seals at Central Park Zoo >

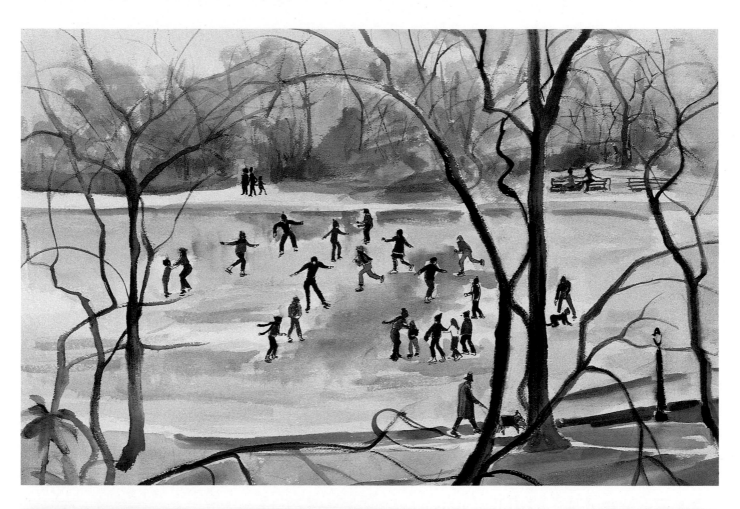

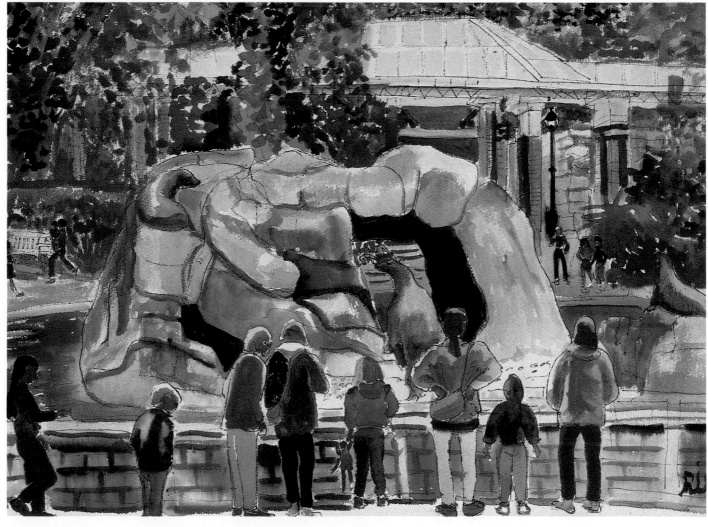

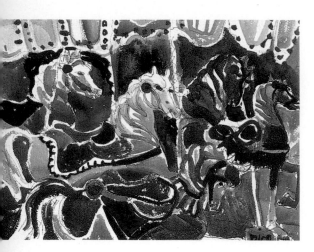

Carousel

Fifty-eight exquisitely carved steeds
prance to real hurdy-gurdy music.
Dating from 1908, the carousel
was originally in Coney Island.

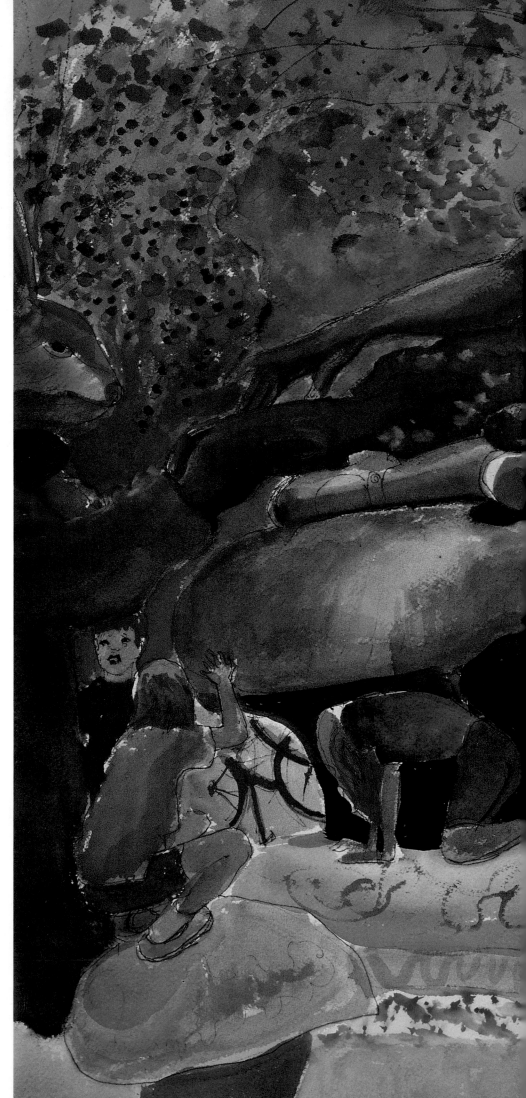

**Alice In Wonderland
Statue in Central Park**

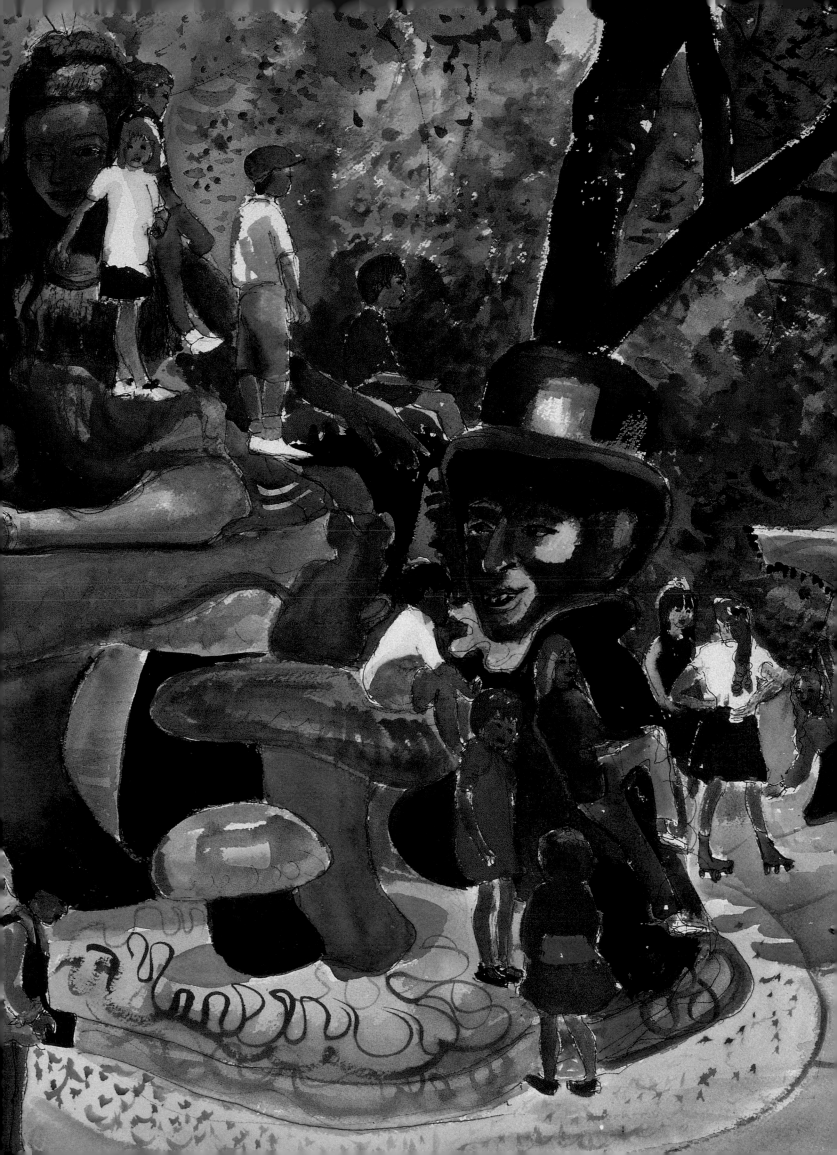

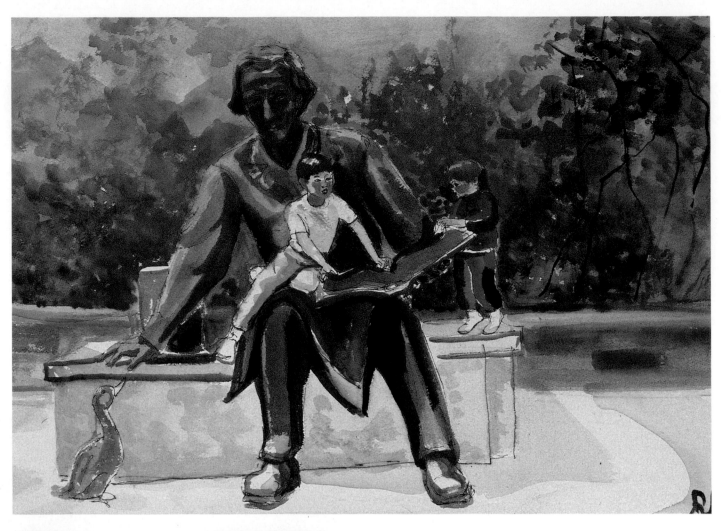

Hans Christian Andersen Statue

The perfect place for children to gather and enjoy summertime storytelling sessions.

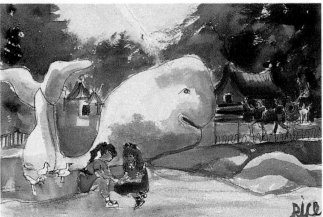

Children's Zoo

Jonah's whale coexists peacefully with both ducks and youngsters at the zoo. Children can also romp in Old MacDonald's farm aboard Noah's Ark or tour a pint-sized castle. A petting zoo features barnyard favorites and even a friendly, fluffy llama.

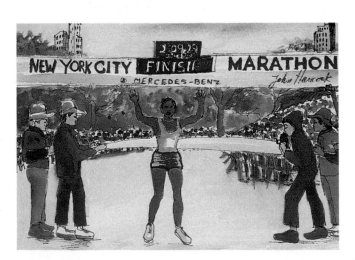

Crossing the Finish Line of the New York Marathon in Central Park

Courtyard of Tavern-On-The-Green Restaurant >

Every time I see Tavern-on-the-Green, I think of an enchanted chalet in the forest. From season to season, it shimmers with beauty and makes a delightful subject to paint. Horse-drawn carriage's glide by this picturesque restaurant, creating a romantic atmosphere for all who visit.

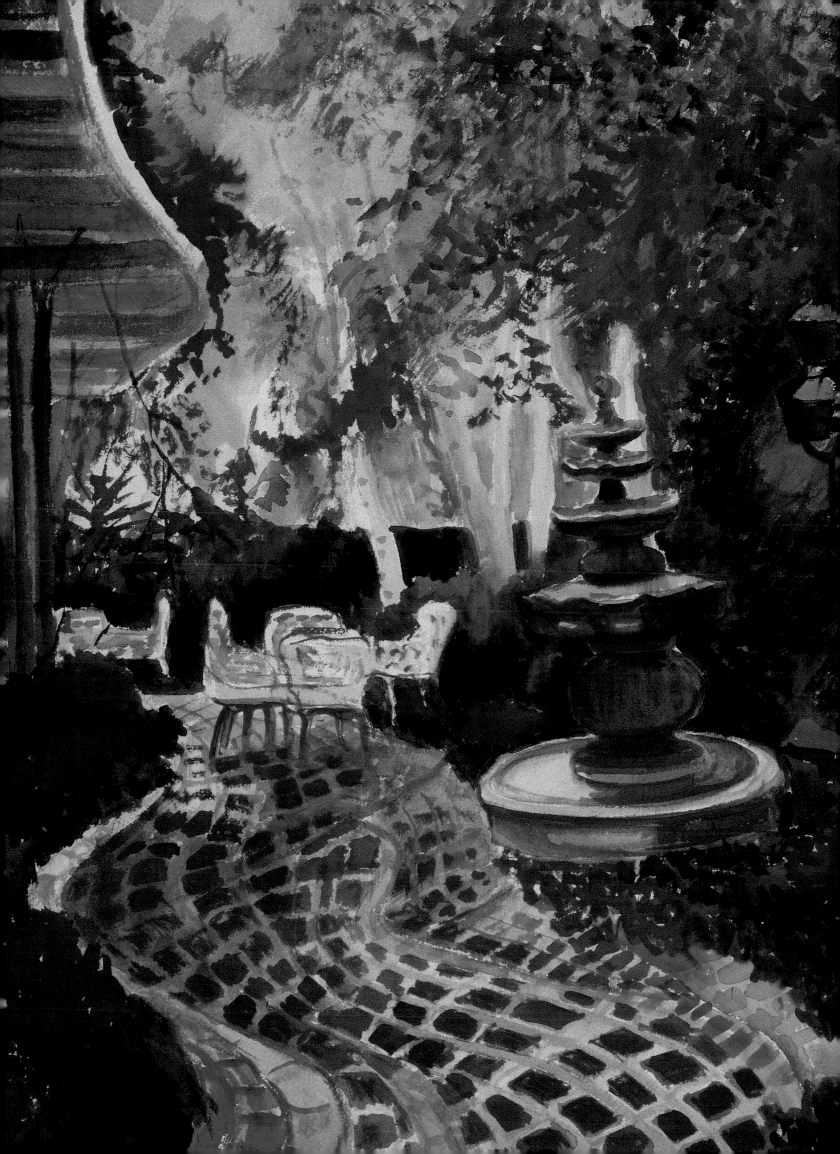

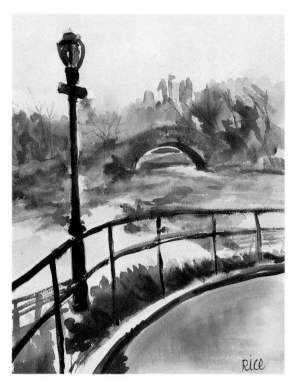

Winter in Central Park

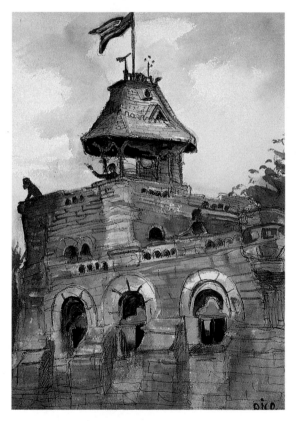

Belvedere Castle

Atop Vista Rock, the second highest point
in Central Park, sits Belvedere Castle,
a smaller version of a gothic revival Scottish
castle, which is my favorite place to view
the surrounding Manhattan skyline.

Autumn in Central Park

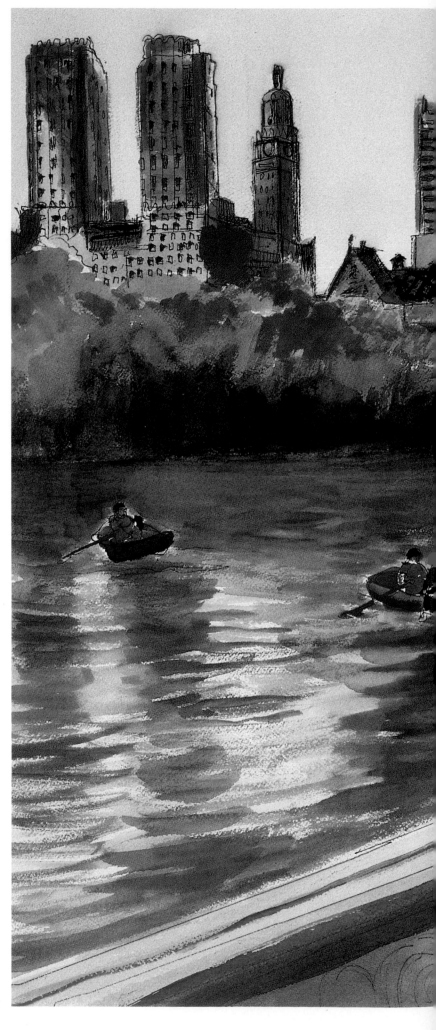

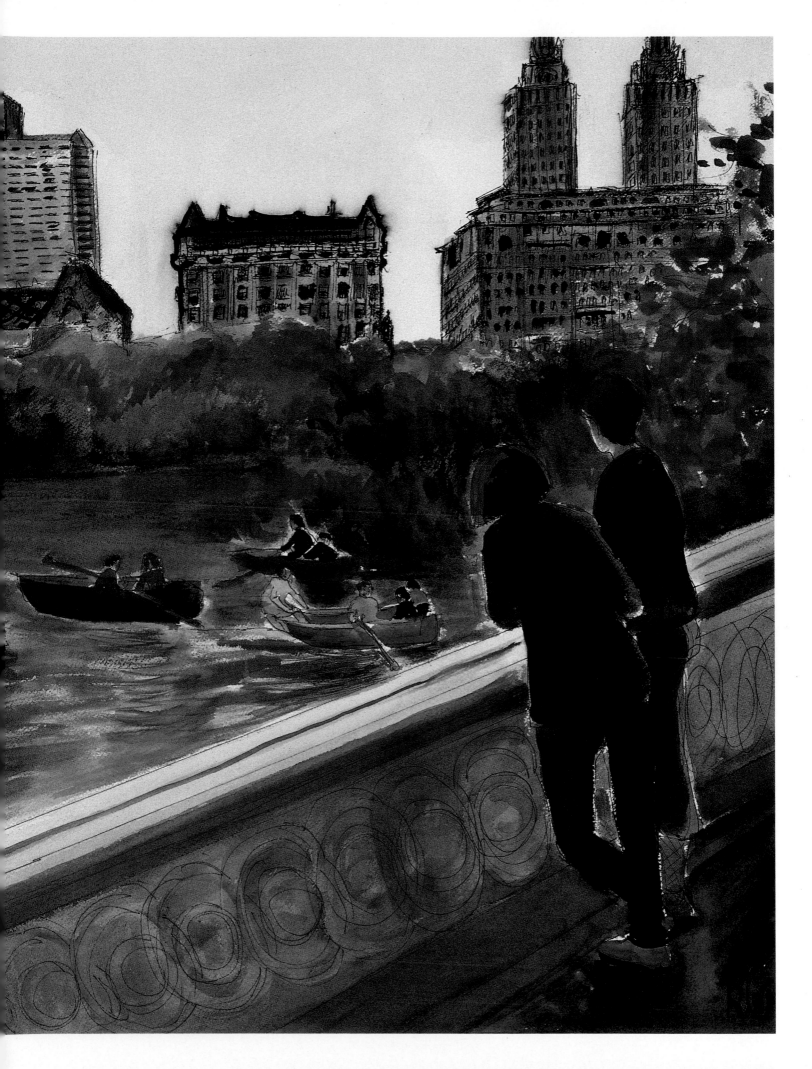

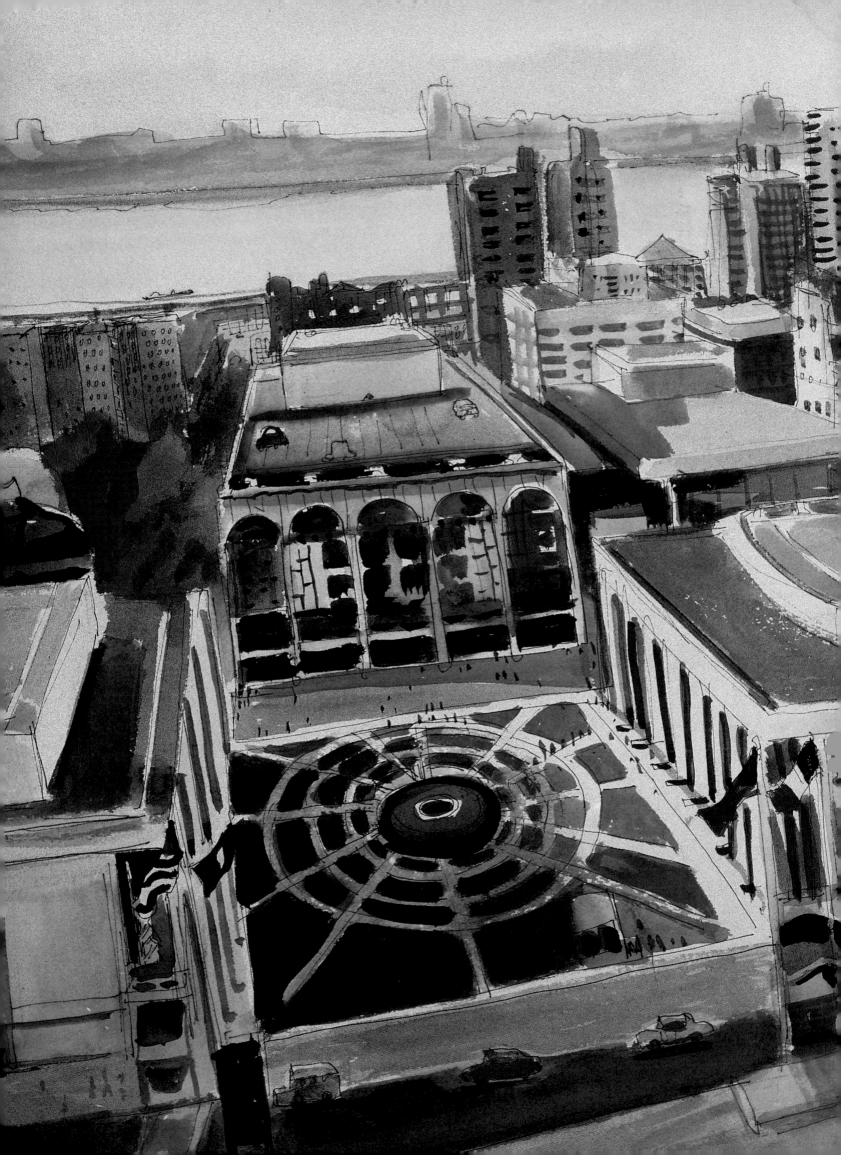

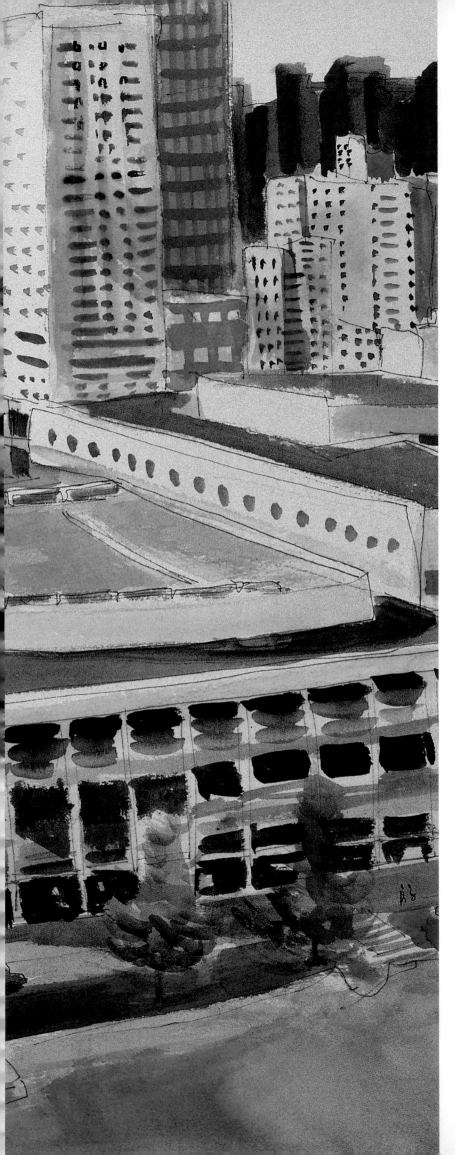

THE UPPER WEST SIDE

T HIS SLICE OF MANHATTAN, WITH all its movie houses, performing arts centers, boutiques, shops, and gourmet restaurants, attracts a cultural and social vanguard that has a passion for the arts and a high lifestyle. The Upper West Side is a strip bounded east and west by Central Park West and the Hudson River, and stretches from Columbus Circle north to just short of Columbia University in Morningside Heights.

Lincoln Center for the Performing Arts

Located on fourteen acres at Broadway and West 64th Street, Lincoln Center is home to the famed Metropolitan Opera House, the New York State Theater, Avery Fisher Hall and the Juilliard School of Music. Beautiful fountain displays and world-class entertainment abound, delighting five million theatergoers a year. From a friend's apartment window, I was able to capture this smashing view of Lincoln Center.

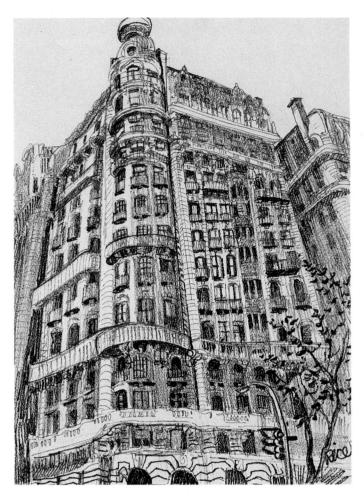

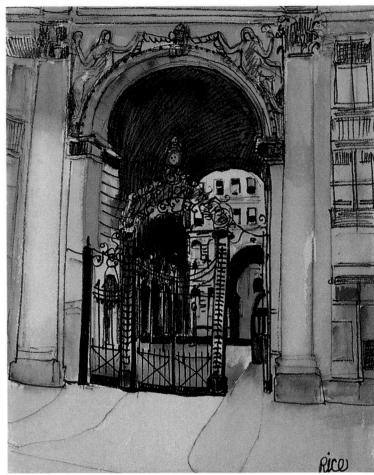

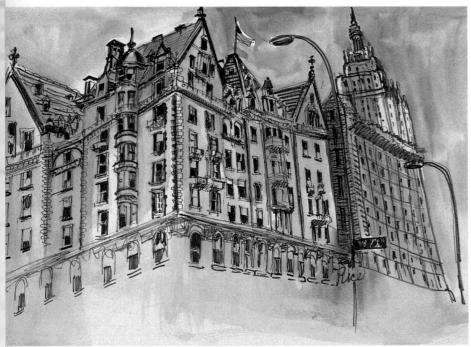

Above left
The Ansonia

On Broadway between 73rd and 74th Streets stands the Ansonia Hotel in all its faded glory. In 1901, the Ansonia opened with a grand flourish, boasting two swimming pools and a lobby fountain with live seals. There was even a roof garden with a live bear roaming around for good measure! Flamboyant notables have resided there over the years, including an incredible array of opera singers and musicians who were attracted to the Ansonia's soundproof rooms.

Above right
Apthorp Apartment Building

This Renaissance Revival building occupies an entire block from Broadway to West End Avenue between West 78th and West 79th Streets. Individual apartments are entered through high, vaulted tunnels, and a fountain spouts and splashes at the center of the interior court.

Skyline of the Dakota Apartments

This brooding building on Central Park West and West 72nd Street dominates the skyline. Passing by it brings vivid scenes from both real life and fantasy to mind—the death of John Lennon, who was shot in the entryway, and the haunting apartment scenes of the movie *Rosemary's Baby*, which was filmed here. Notable tenants have included conductor Leonard Bernstein; his wife, actress Felicia Montelagre; and playwright William Inge.

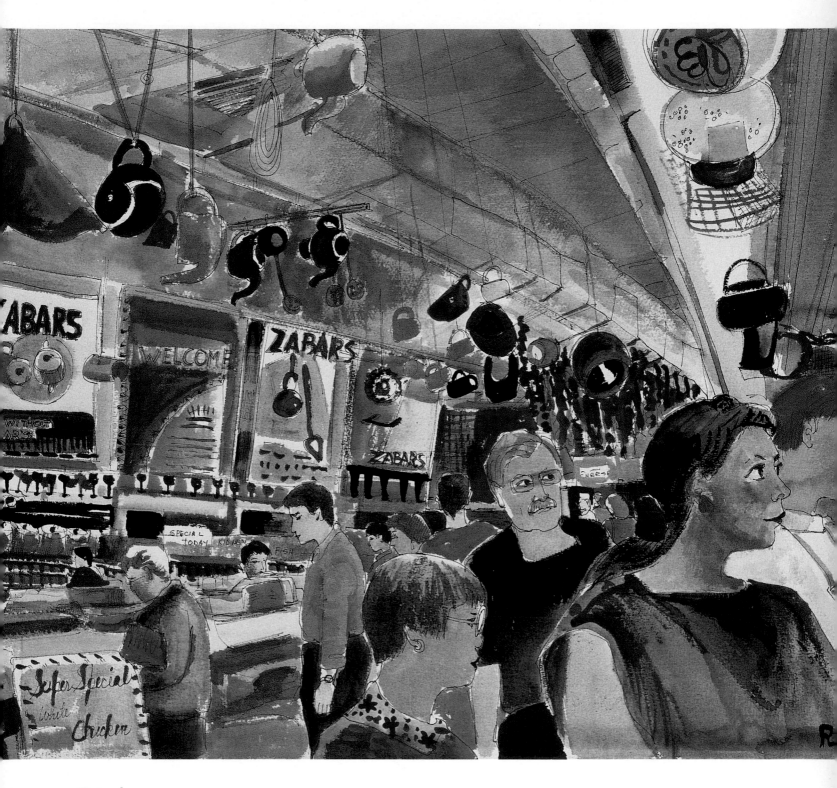

Zabar's

This gourmet delicatessen knocks you out with
its displays of exquisite foods, coffee, and
cheese from around the world amidst a wide
selection of dishes and cookware.

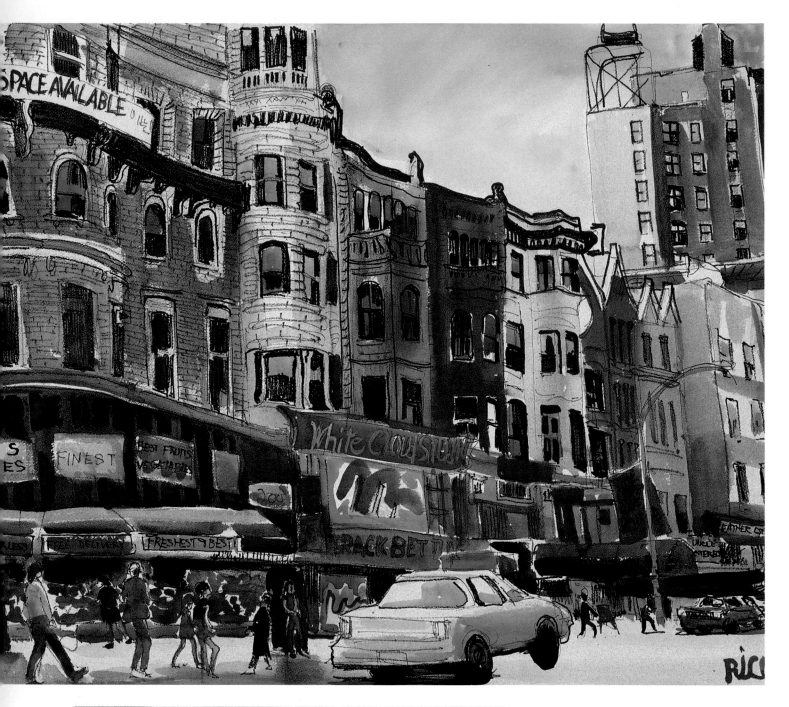

West 72nd Street and Broadway

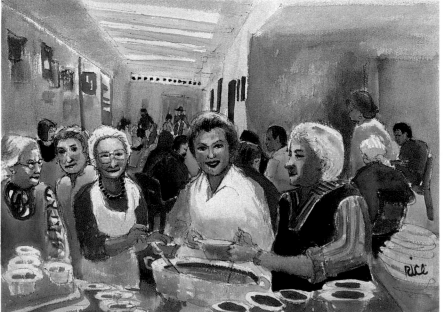

Soup Kitchen

Sponsored by the National Council of Jewish Women, this busy West 72nd Street soup kitchen has been in operation for many years. Its cheery presence is greatly appreciated by the many people it serves daily.

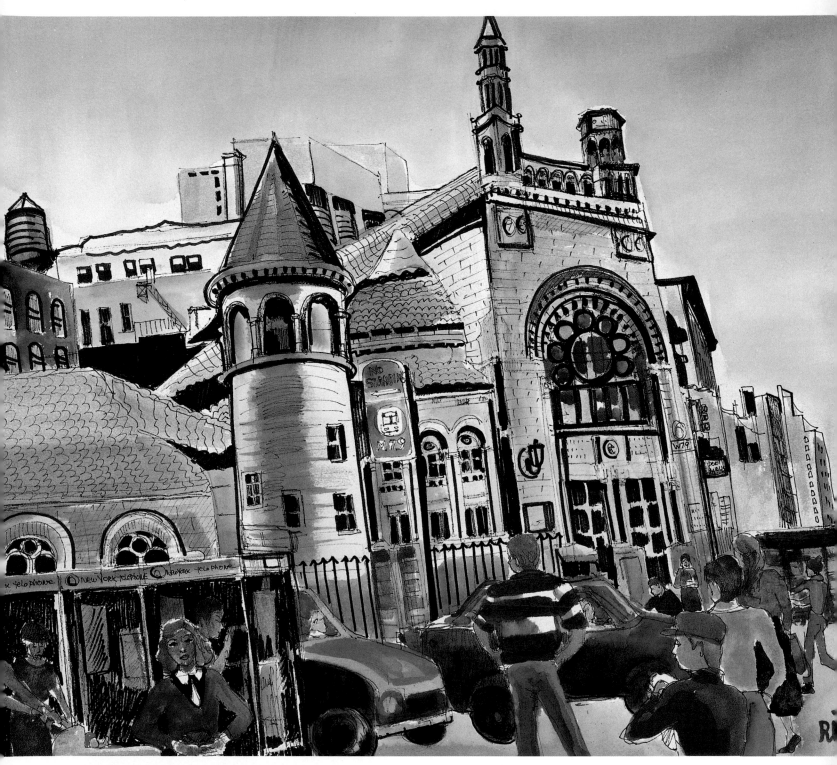

Waiting for the Crosstown Bus

Across the street at Broadway and West
79th Street is the First Baptist Church with
its rambling castle-like facade.

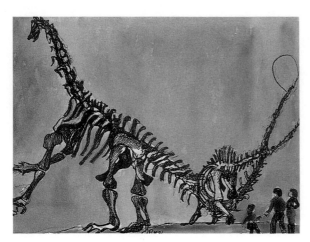

Dinosaurs in the Museum of Natural History's Great Hall

Hayden Planetarium in the American Museum of Natural History

The 72nd Street IRT Subway Station

A rare survivor, this ever-popular subway station, which opened in 1904, has become a national landmark.

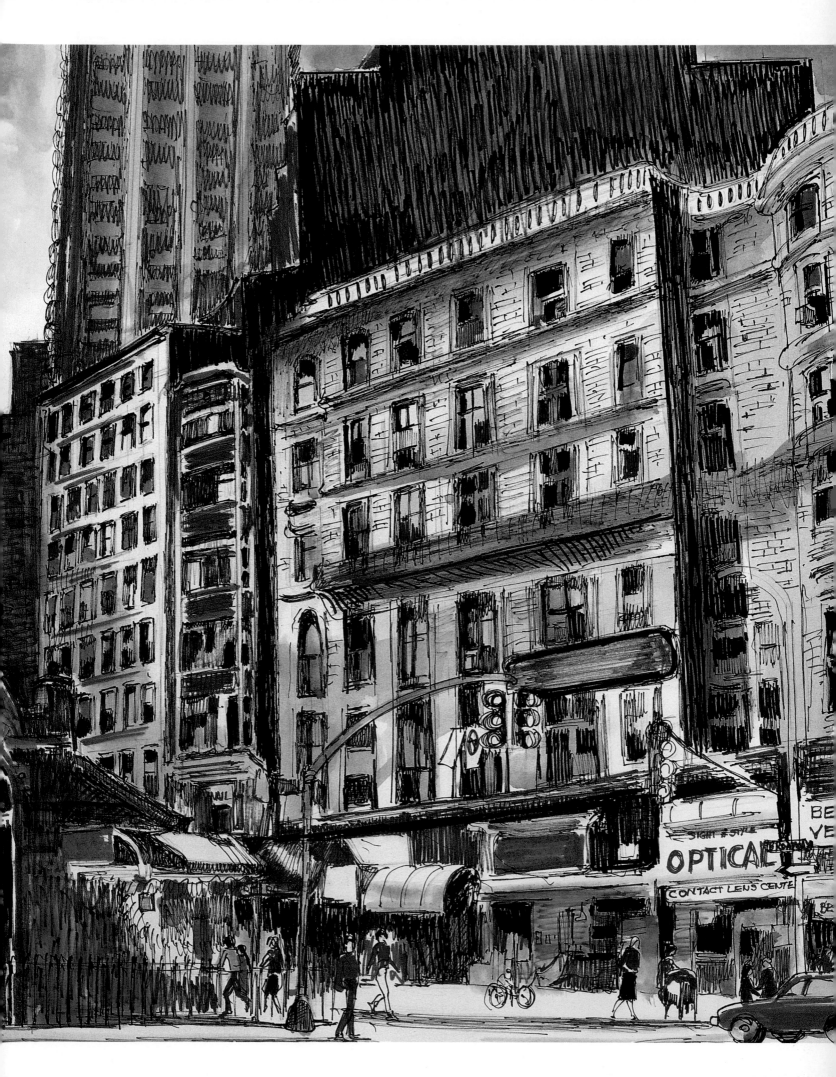

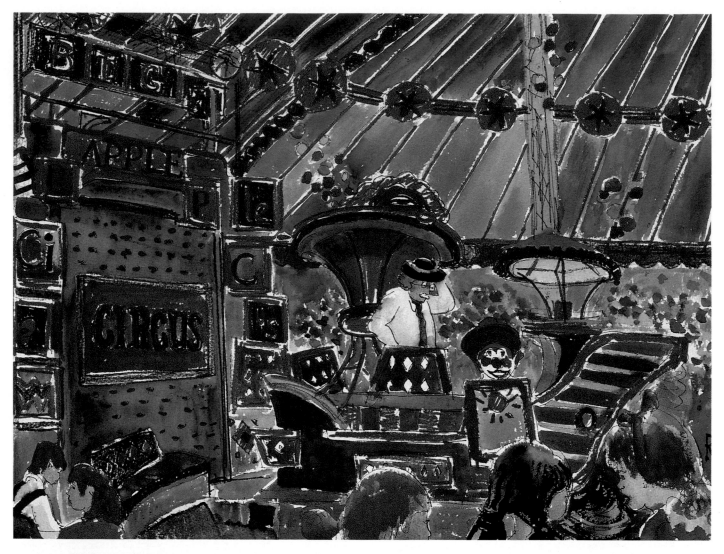

79th Street Boat Basin

Here you can enjoy the cool marine breeze
as you survey boats that are permanent homes
to nautical Manhattanites.

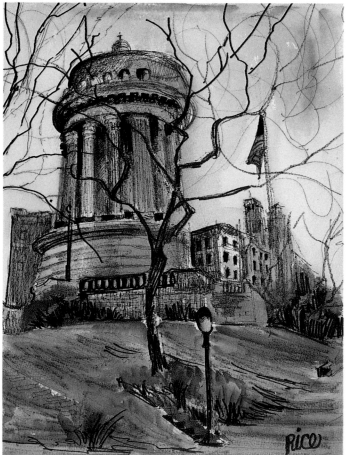

Soldiers' and Sailors' Monument
in Riverside Park

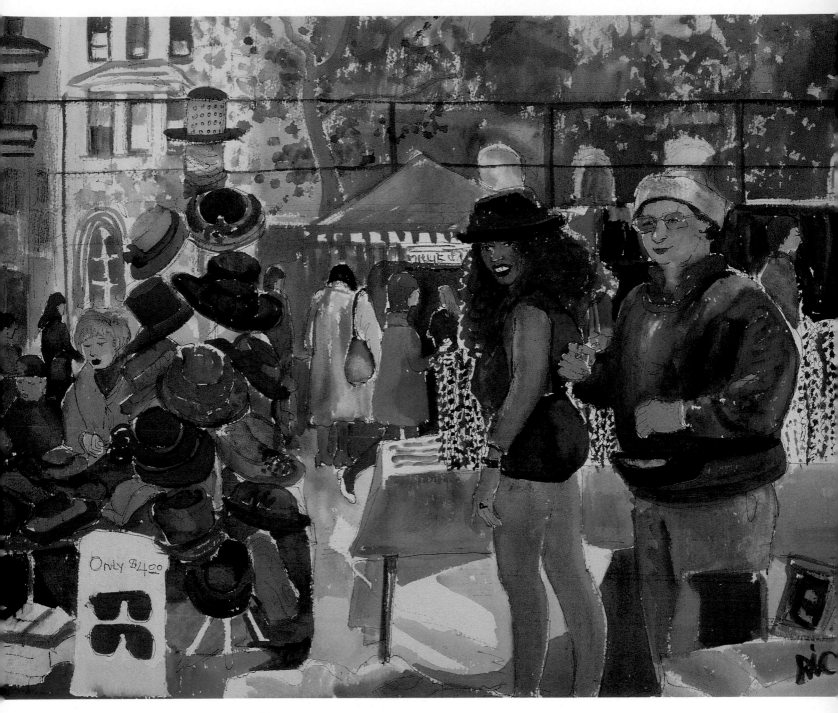

Flea Market on West 77th Street

Sunday brings out the crowds on Columbus Avenue. After buying everything in sight, my friends and I went to have an early dinner at a nearby restaurant. This funky flea market is diagonally across the street from the Museum of Natural History.

Opposite top
The Big Apple Circus

Surrounded by hundreds of pint-sized fans, the clowns and magicians cast a spell over the enraptured audience—children, parents, and myself included. This small, charming circus performs at Lincoln Center.

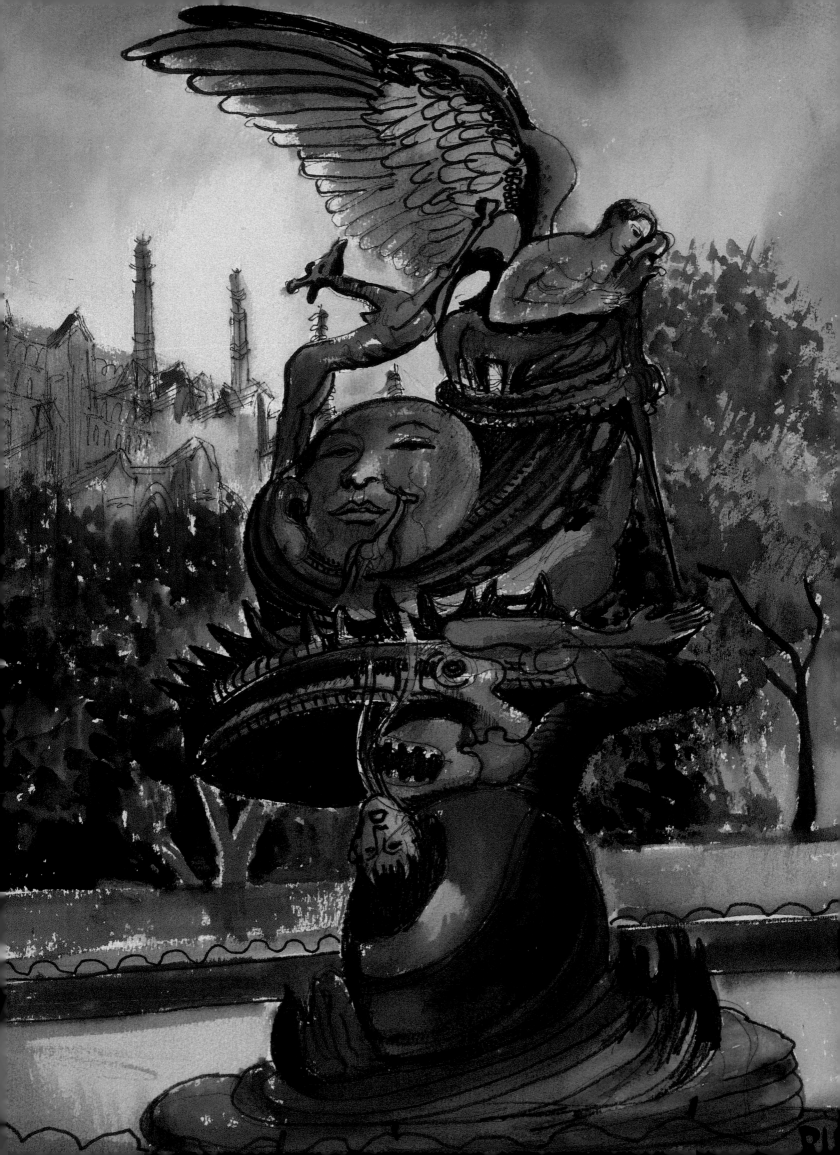

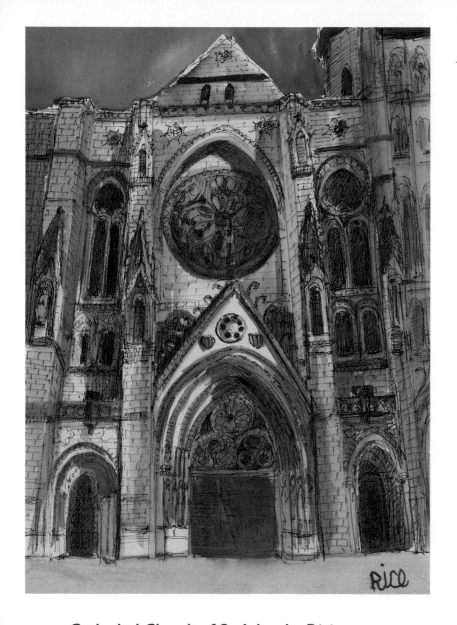

Cathedral Church of St. John the Divine

Under continuous construction since 1892, this enormous Episcopal church will be the world's largest cathedral when it is finished. Its eclectic selection of carvings range from Nelson Mandela to the Manhattan skyline to more traditional subjects. Getting lost in this remarkable structure is an experience I would like to have again and again. I particularly liked the section of the interior dedicated to poets. Many civic activities and concerts find a suitable forum in this extraordinary cathedral.

< Peace Fountain

Celebrating the triumph of good over evil, this incredible statue is the result of a group effort, with a variety of artists contributing to the piece. It took several trips for me to appreciate the many beautiful angels and intricate designs that add to the fountain's impact. With the Cathedral of St. John the Divine in the background, the Peace Fountain in its parklike setting is overwhelming.

MORNINGSIDE HEIGHTS AND UPPER MANHATTAN

ABOVE THE UPPER WEST SIDE is Morningside Heights, which is defined by Cathedral Parkway (110th Street) and West 125th Street from south to north and by Morningside Park to the Hudson River from east to west. Students roam the campus of Columbia University and its domed Low Library and live in the surrounding area. The magnificent Cathedral Church of St. John the Divine is a place for both worshippers attending its services and lovers of fine architecture. On a high bluff looking over the Hudson River at West 122nd Street and Riverside Drive sits the imposing mausoleum that contains Grant's Tomb, a monument to the Union commander and former U.S. President.

Upper Manhattan, the most northern area of the island, is bounded by 155th Street on the south and by water on all other sides—the Harlem River to the east, Spuyten Duyvil Creek to the north, and the Hudson River to the west. It is a diverse area consisting of both rugged working-class neighborhoods, yuppie enclaves, and lush parks. The crown jewel of Upper Manhattan is the Cloisters, a museum of medieval art high on a bluff of Fort Tryon Park, with magnificent, unspoiled views of the Hudson and the Palisades.

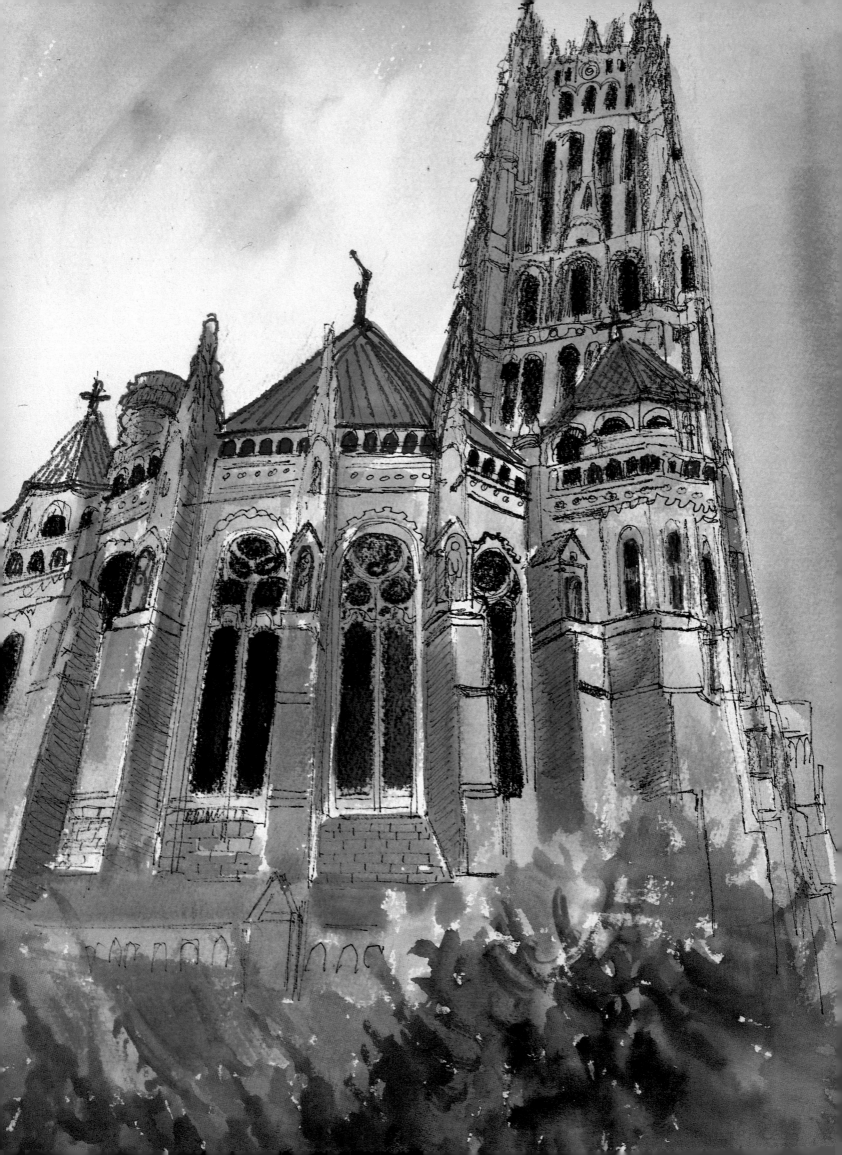

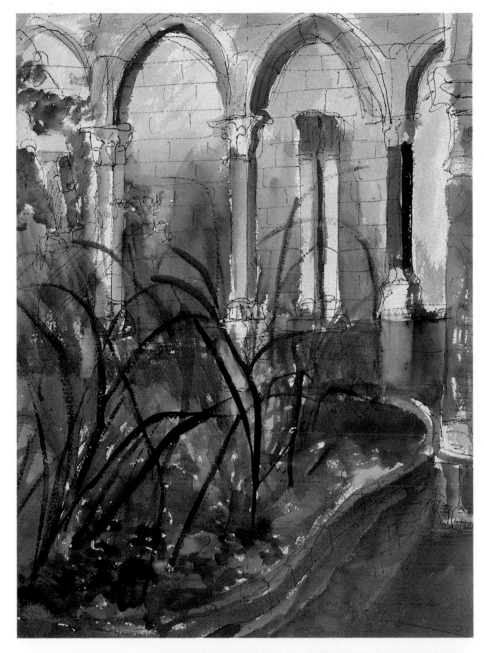

The Cloisters

One of the most enjoyable journeys in Manhattan is the Madison Avenue #4 bus ride to the Cloisters, which houses a remarkable collection of five medieval European cloisters. Crisscrossing the interesting, colorful neighborhoods of Washington Heights and Spanish Harlem, this destination lies one mile north of the George Washington Bridge, at the northern tip of Manhattan. Financed by John D. Rockefeller, the Cloisters was assembled from pieces taken from various medieval convents and churches of Europe. The gardens, lushly planted with herbs and flowers, are a branch of the Metropolitan Museum of Art. Painting in the Cloisters gardens was a treat until an overly zealous guard removed me from my perch. Photography is a safer bet, so be sure to bring a camera.

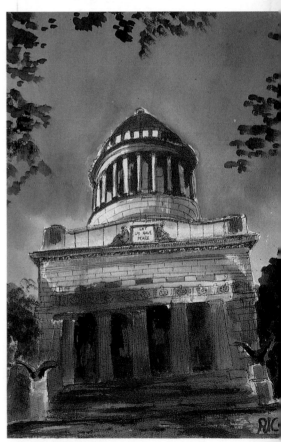

< Riverside Baptist Church

The Gothic Revival design of this church on Riverside Drive across from Grant's Tomb is based on the Chartres Cathedral in France. Its massive bells have a five-octave range.

Grant's Tomb

Housing the remains of Ulysses S. Grant and his wife, this tomb was completed two years after the popular U.S. President's death in 1897. I fell in love with the marvelous mosaic-tiered seats surrounding the building.

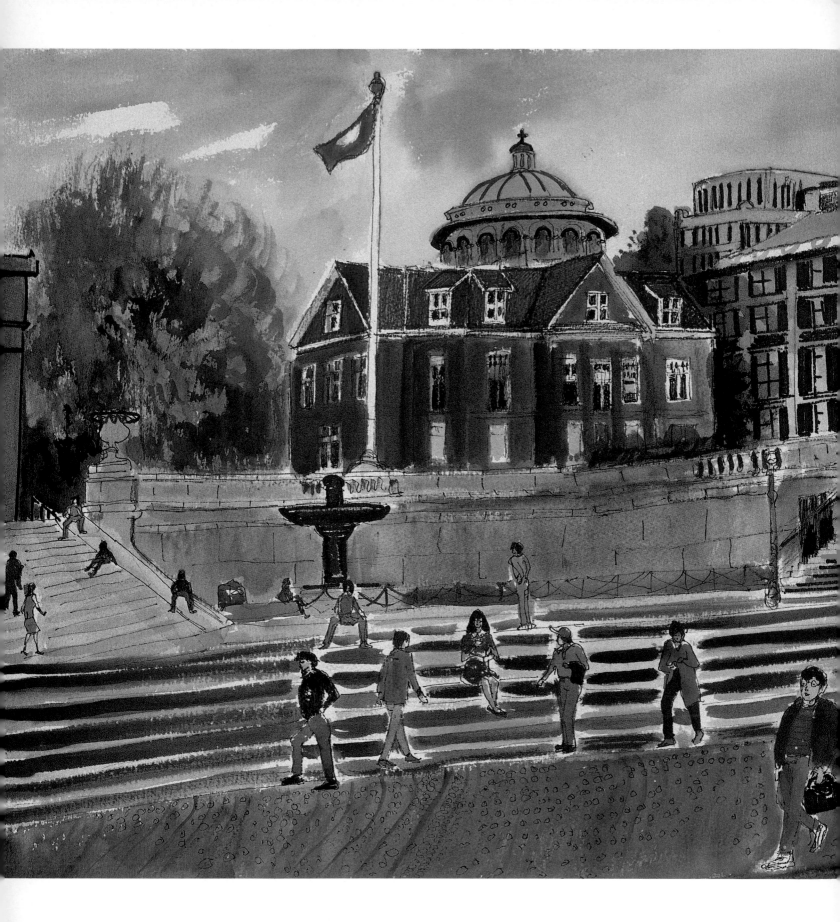

Columbia University

Founded in 1754, this prestigious Ivy League
university in Morningside Heights is now coed.
Alexander Hamilton and Theodore Roosevelt
are among its roster of accomplished alumni.

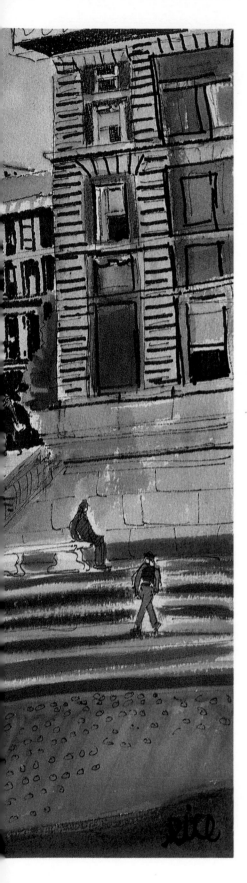

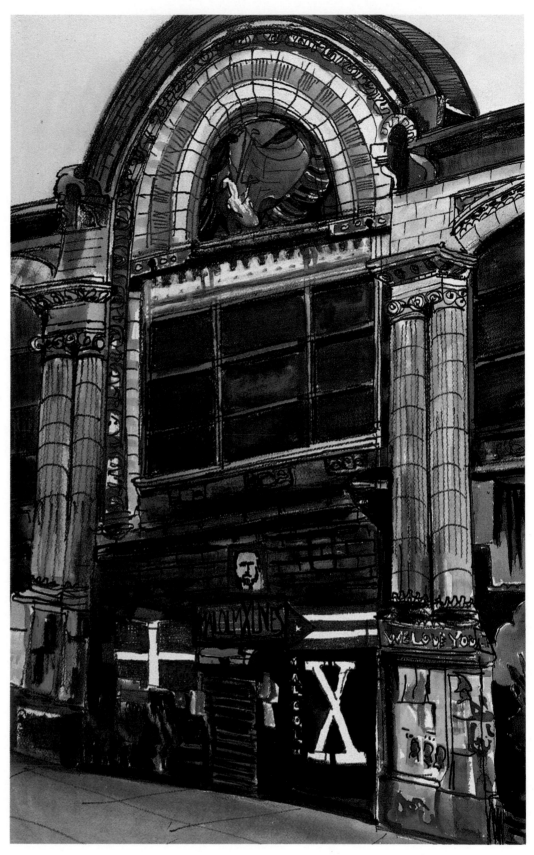

Shrine to Malcolm X

On my way to the Cloisters, I stopped to explore this remarkable tribute to Malcolm X. The graffiti on the building in which he died is a striking design in itself.

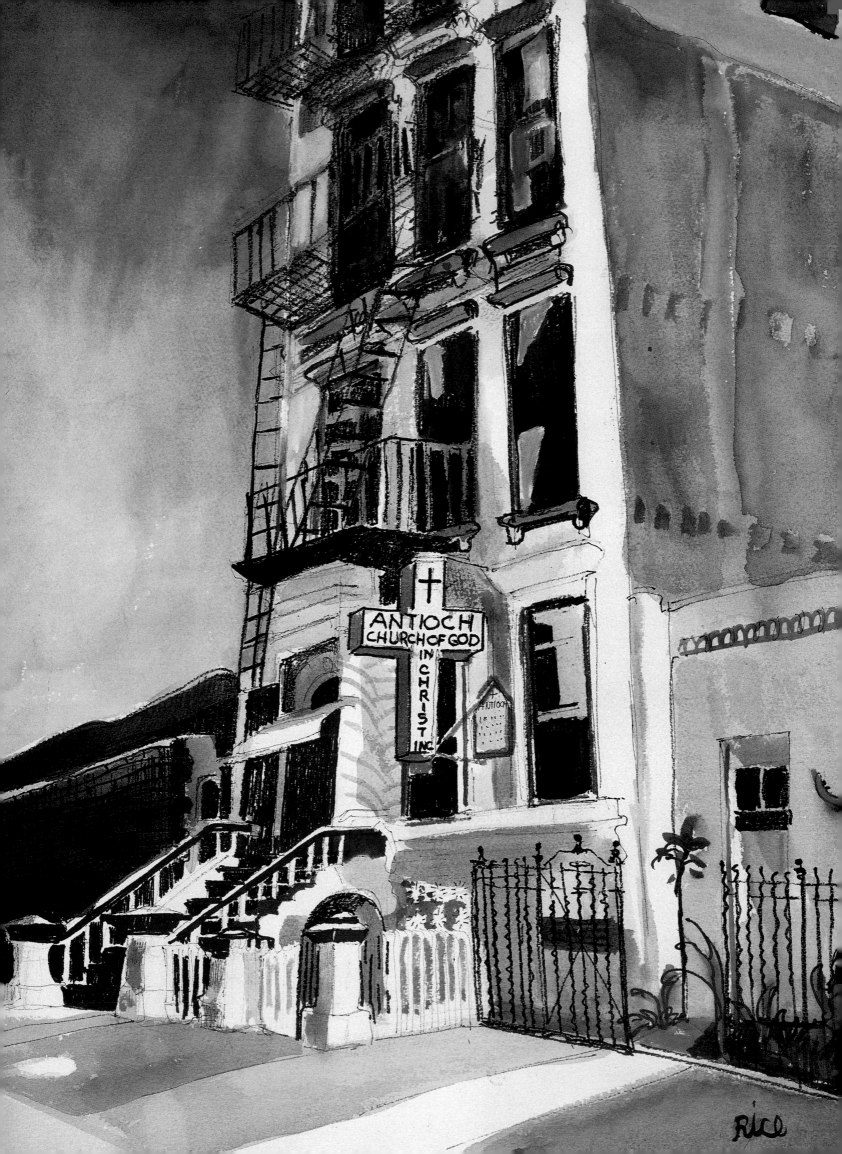

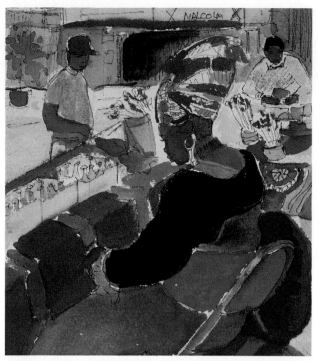

Merchant on 125th Street

HARLEM AND SPANISH EAST HARLEM

N O OTHER SECTION OF MANHATTAN arouses as much enthusiasm as Harlem, which is bounded by 110th Street, Morningside Heights, 155th Street, and the Harlem River. Established by Peter Stuyvesant in 1658 as the village of New Harlaam, it's home to a diverse population of Jews, African Americans, Hispanics, and immigrants from around the world. The Harlem of today sings out the presence of its people in rap clubs, soul food restaurants, lively dance halls, cool jazz rooms, and especially its joyous churches renowned for their rousing gospel services.

The Apollo Theatre on West 125th Street also represents the vitality and resilience of this community and has been a nationally known venue for some of the biggest entertainers. Josephine Baker, Lena Horne, Duke Ellington, Sammy Davis, Jr., and the Jackson Five all got their start here. After a period of decline, the Apollo is now experiencing another cultural renaissance, bolstered by a new generation of rising young entertainers.

Spanish East Harlem, once called Italian Harlem, is bounded by 106th Street, Park Avenue, 125th Street, and the Harlem River. It is also known as *El Barrio*, which means "the neighborhood." It is home to a largely Puerto Rican population whose heritage and Caribbean culture have defined Spanish Harlem since World War I. Family grocery stores, called *bodegas*, and ethnic restaurants invite the traveler to sample their fine cuisine. *La Marqueta* is the Spanish East Harlem's central market.

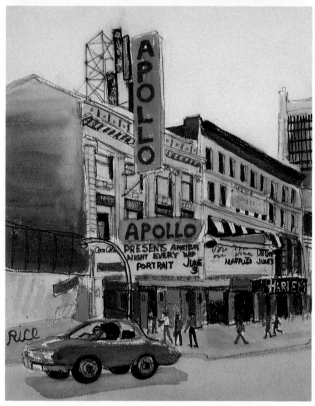

The Apollo Theater

< Antioch Church of God Christ, Inc.

This tenement church in Harlem moved me with its simplicity and well-kept exterior.

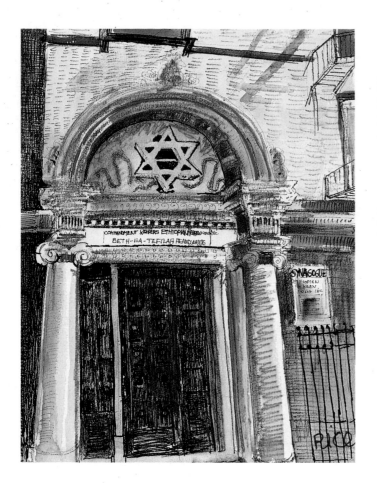

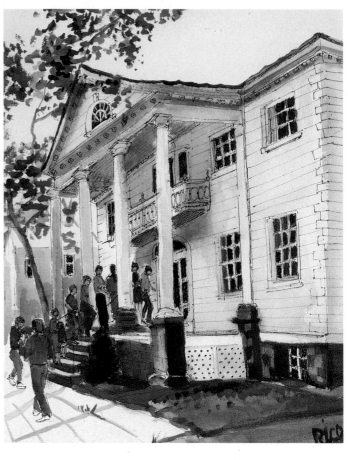

Ethiopian Hebrew Congregation of Harlem

At One West 123rd Street, this synagogue, a former merchant banker's mansion, conducts choir services in Hebrew on Saturdays. Visitors to the synagogue must first get permission in writing.

Morris-Jumel Mansion

During the Revolutionary War, this was the head-quarters for General George Washington. Built in 1765 by Roger Morris, this Tuscan-columned, Georgian-Federal style house has a colorful history. Its longtime resident, Madame Elizabeth Jumel, Napoleon's friend, married Aaron Burr, and sparked a juicy scandal. The mansion, located at Edgecombe Avenue and West 160th Street, is the oldest house in Manhattan.

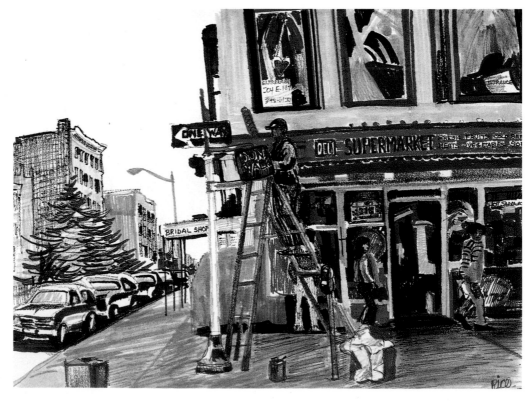

Spanish Harlem

This small neighborhood market on East 125th Street calls itself a "supermarket."

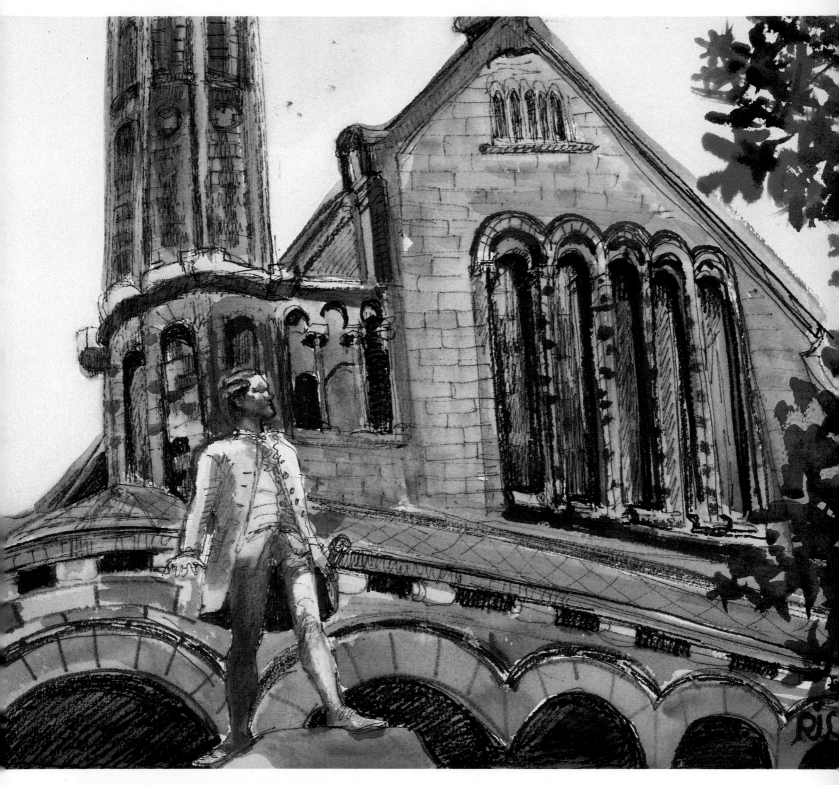

Hamilton Grange National Memorial

The statue of Alexander Hamilton, one of the signers of the Declaration of Independence and the first Secretary of the Treasury, graces the front of the house in which he lived in the area named after him, Hamilton Heights. He was also the founder and publisher of the oldest existing newspaper in the United States, the *New York Post*. Alexander Hamilton died in 1804 from gunshot wounds sustained in his historic duel with Aaron Burr.

Yorkville

Queen Anne Buildings in Yorkville

Yorkville is bounded by Lexington Avenue on the west, East 86th Street on the south, the East River on the east, and East 96th Street on the north. Once a neighborhood of German and Eastern European immigrants, the neighborhood has retained a delightful variety of excellent stores, cafes, and restaurants. From shops displaying an array of sausages hanging from the ceiling to cozy cafes boasting sinfully delicious pastries, Yorkville offers a memorable taste of the Old World.

East of Franklin D. Roosevelt Drive and nuzzling up to the East River is Carl Schurz Park. Gracie Mansion, the official residence of the city's mayor, is located here and is open to the public. The John Finley Walk along the park's waterfront esplanade offers a ringside seat to all the action on the East River. A short walk away is the Henderson Place Historic District, with its well-preserved Queen Anne–style homes.

John Finley Walk

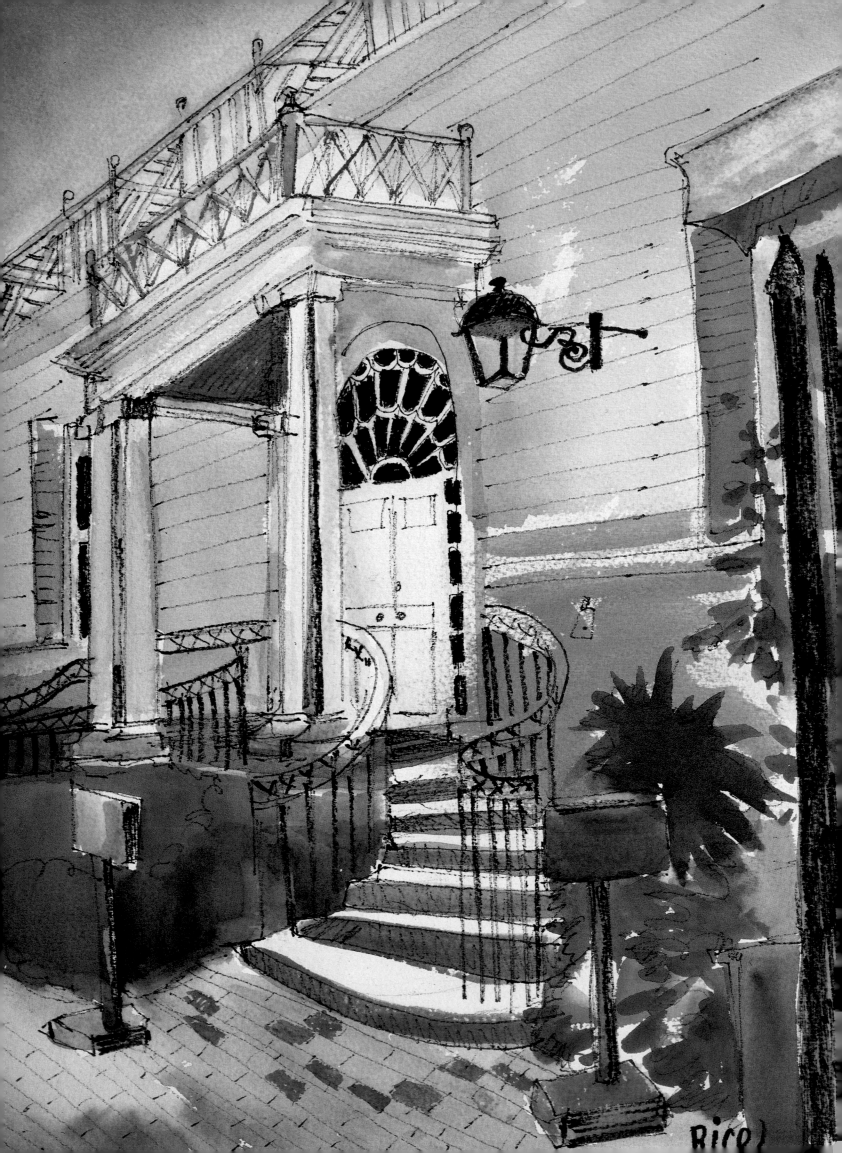

A Summer Day in
Carl Schurz Park

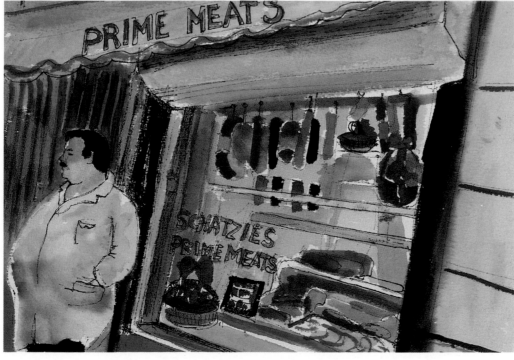

Prime Meats

< Entrance to Gracie Mansion

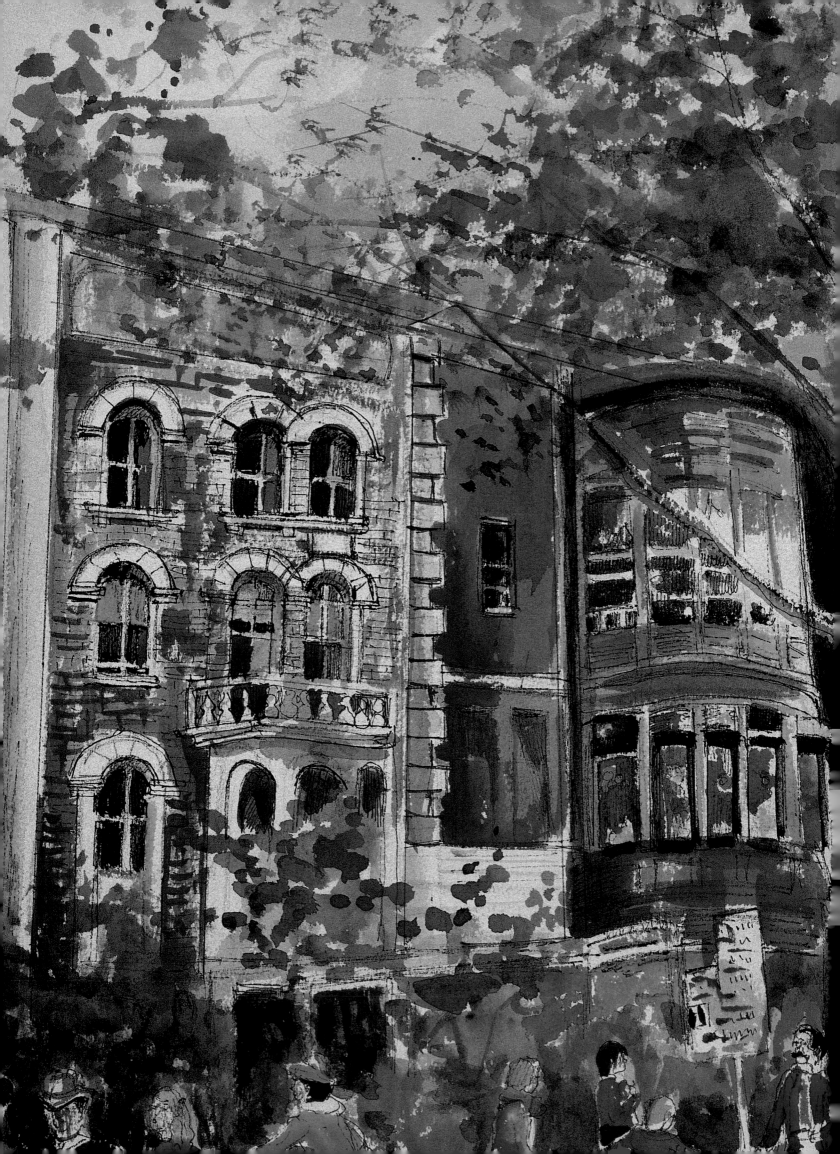

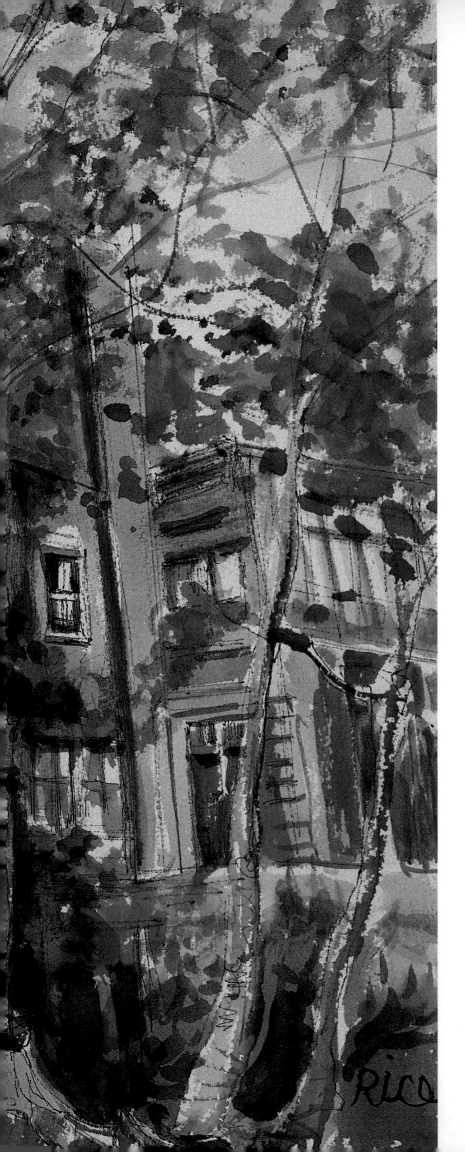

THE CHIC EAST SIDE

THE ALWAYS FASHIONABLE EAST SIDE which stretches from East 86th Street down to 59th Street between the East River and Fifth Avenue, has retained an Old World sense of style and elegance. Shaped by its high society residents with family names such as Astor, Armour, and Tiffany, the area was the first to boast indoor plumbing, intercom systems, and elevators in private houses that were superbly designed by renowned architects. Today, the East Side remains a place of sophistication and culture.

I experience a feeling of rediscovery whenever I see Park Avenue's breathtaking expanse, which is the equal of any European boulevard. The beautiful center divider with its seasonal blossoming flowers, and the mammoth buildings lining each side of the street complete the majestic picture.

Crossing Park Avenue at East 59th Street and continuing east to Lexington Avenue, you will arrive at Bloomingdale's, the famous shopping emporium, which is often a first stop for out-of-towners in Manhattan. The East Side has great shopping almost everywhere. The clothing stores, art galleries, and antique shops make window shopping along Madison Avenue a virtual must. The East Side boasts

Townhouses on the Upper East Side

81

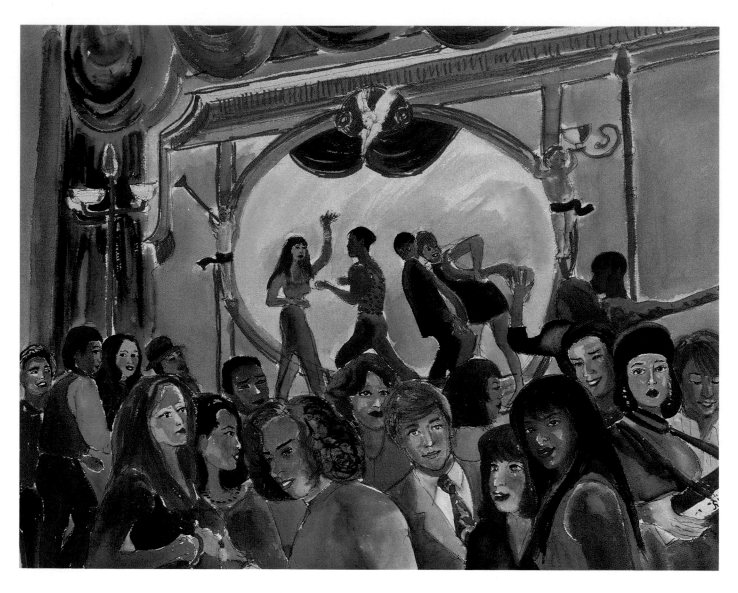

Tatou Night Club

Nightlife in Manhattan has always been something special. The El Morocco, the Stork Club, the Latin Quarter, and the Copacabana were legends in their time. One of today's hot spots is Tatou on the East Side, where I spent a late night dancing with a group of friends.

magnificent hotels—both large and small—as well as some of the best restaurants in the world. Small family-run markets, flower shops, gourmet food and specialty stores, dry cleaners, shoe repair shops, bakeries, hardware stores, and other neighborhood businesses help cater to the necessities of life.

I have never lived in one of the notable mansions on Millionaires Row, but I have friends who do. Visiting the gorgeous residences on upper Fifth Avenue facing Central Park or the penthouses and townhouses on the side streets off Fifth Avenue takes you away from the real world. The museum-quality furnishings and the portraits of the occupants and their ancestors seem to blend with the formality of these well-kept homes and lives. Family-owned townhouses or maisonettes (separate-entrance townhomes) are my personal preference. I am also particularly fond of carriage houses, which were once stables for horses and carriages. These houses are redone with lavish interior designs and luxuriously furnished and also serve as garages for the family cars.

The self-contained Manhattan lifestyle on the chic East Side has its own social activities. Residents enjoy theater, opera, charity balls, fashion luncheons, horse shows, and at-home dinners served with impeccable table settings and all the accoutrements. As other people move from place to place, the wealth and style live on here.

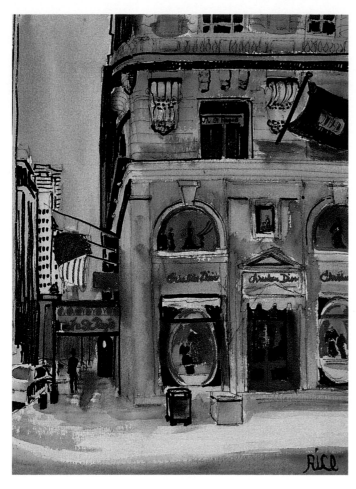

Christian Dior Boutique on Fifth Avenue at the St. Regis Hotel

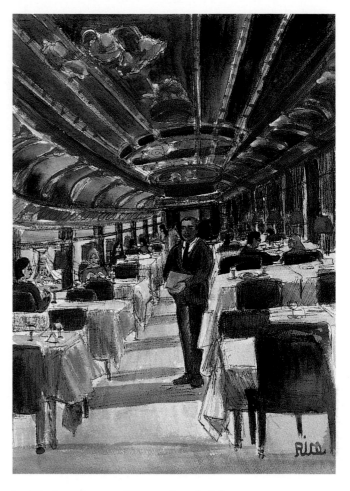

Le Train Bleu at Bloomingdale's

A respite from a day of shopping, Bloomingdale's offers an enjoyable dining experience in its restaurant, Le Train Bleu. A re-creation of the dining car of the Orient Express,

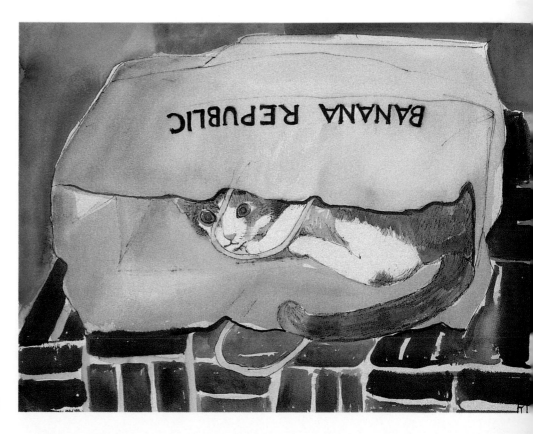

Cat That Went Shopping

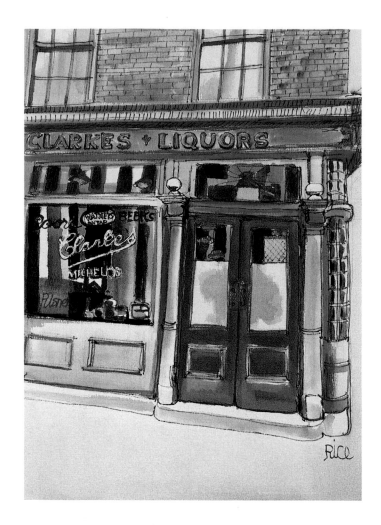

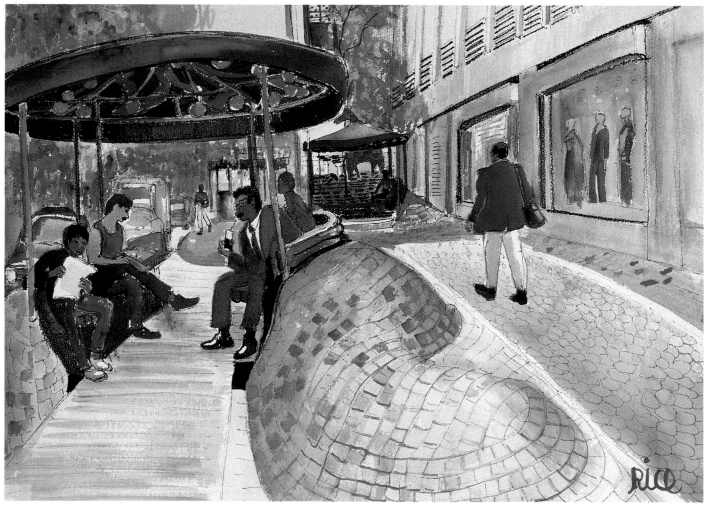

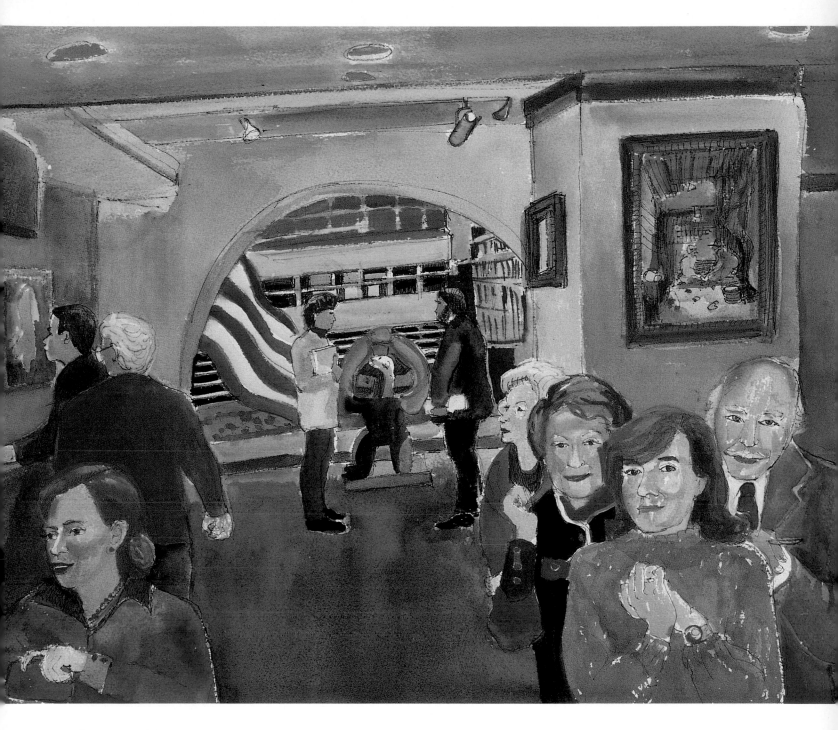

Opposite top left

< P.J. Clarke's

A neighborhood bar, P. J. Clarke's is a hangout overflowing with celebrated people in the art, advertising, and business worlds.

Opposite top right

Lipstick Building

Located on Third Avenue at 54th Street, the Lipstick building with its telescoping tiers got its colorful name because of its reddish brown and pink hues.

Opposite bottom

Third Avenue Streetscape

This respite for passersby to relax and enjoy themselves was cleverly designed by Pamela Waters.

Christie's on Park Avenue

Auction time brings out the crowds at Christie's, the American branch of the famous London auction house, specializing in European and American fine art.

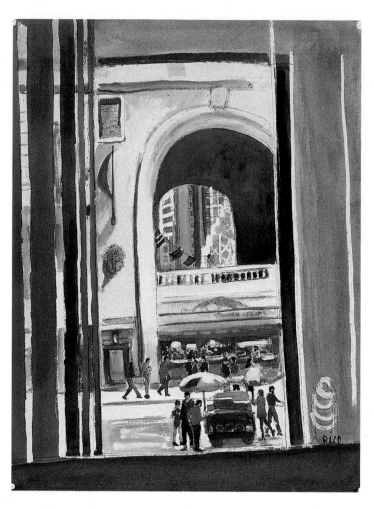

**Looking from the Met Life Building Through
Helmsley Drive to Park Avenue**

Crossing Park Avenue

This is the view you get while
strolling by St. Bartholomew's
Church, the Waldorf-Astoria Hotel,
and the Met Life building.

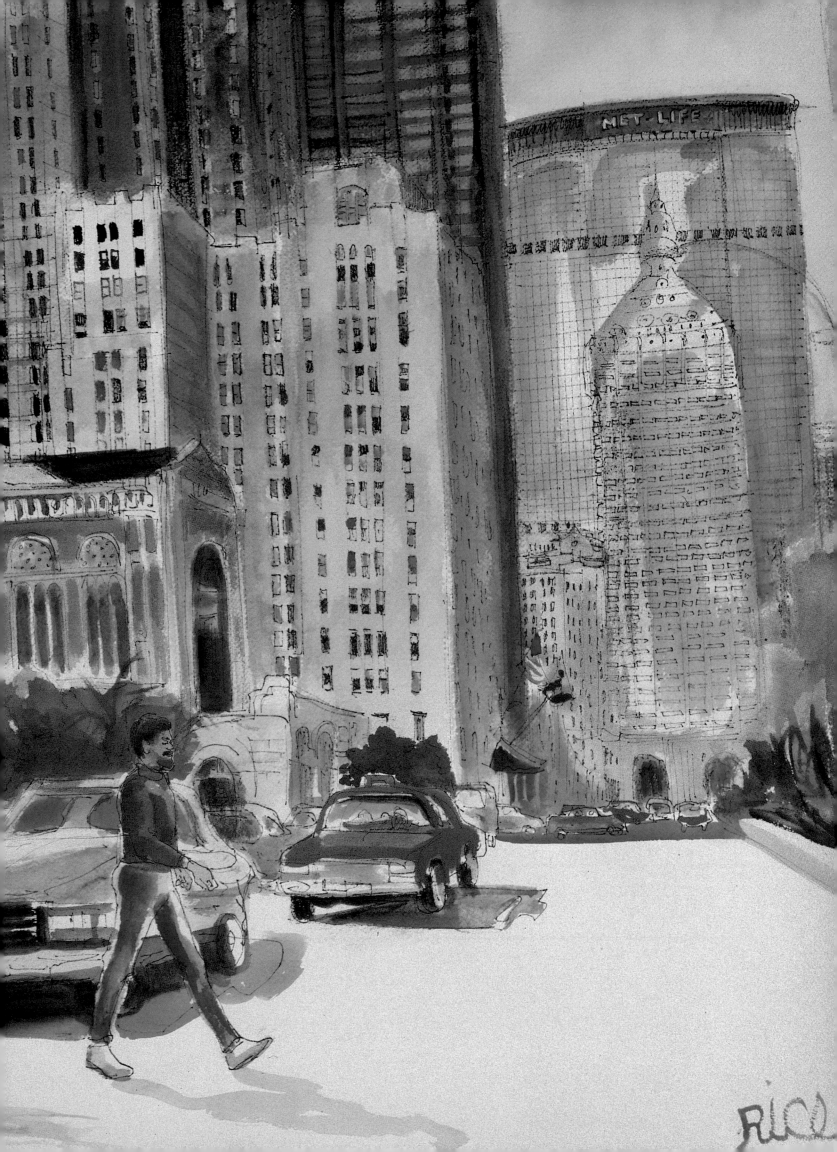

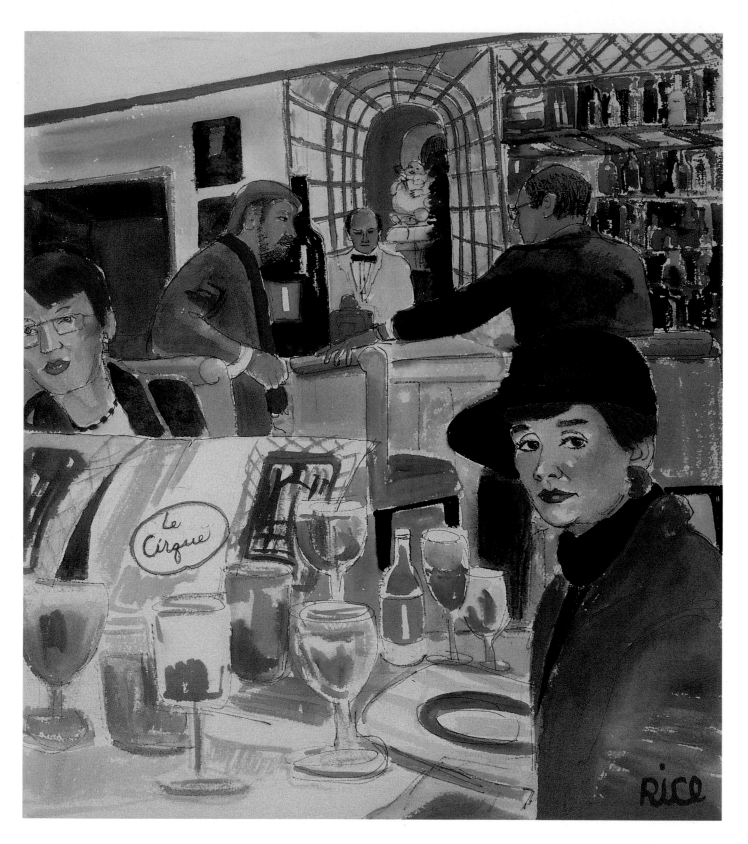

Le Cirque Restaurant

Lunching at Le Cirque, one of the finest French restaurants in Manhattan, means surrounding yourself with the patter of many languages.

Opposite above
Carriage Houses East >
69th Street

Opposite below
Madison Avenue Shops — Versace and Armani

Some of the most glamorous clothes on Madison Avenue are found at Gianni Versace and Giorgio Armani.

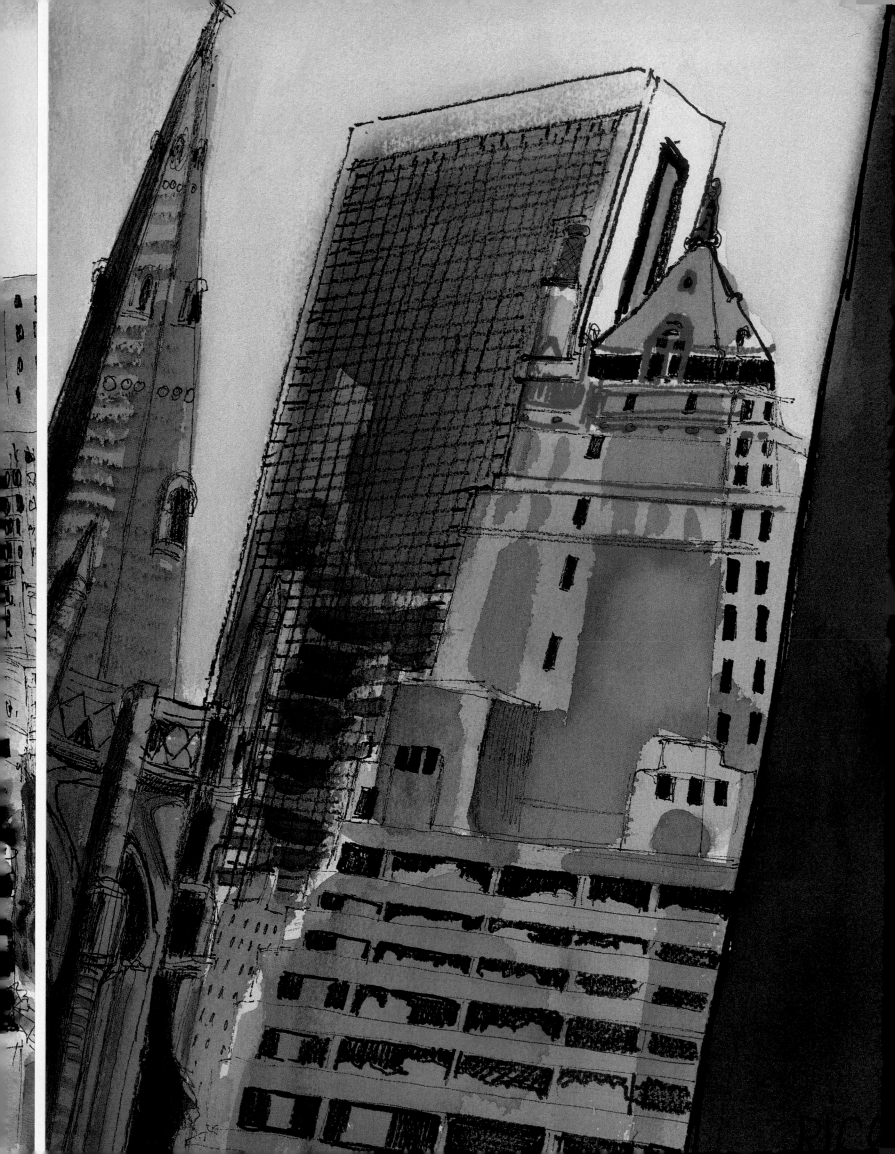

Peninsula Hotel

A beautiful view of the east side of Fifth Avenue can be seen from the sweeping staircase of this elegantly appointed hotel, which leads to the rooftop bar where people from all over the world come to sit and admire the impressive city panorama.

< *Fifth Avenue Presbyterian Church,*
Solo Building, and Trump Tower—57th Street

This was the view from my room at the St. Regis Hotel.

IDTOWN IS THE BEATING heart of Manhattan. It flows and bustles with professionals, laborers, clerks, storekeepers, shoppers, street merchants, and tourists, who are constantly in motion on sidewalks, in taxicabs, on buses, in subways, and in helicopters. Midtown is the very center of Manhattan and is home to the biggest stores, the national headquarters of the largest corporations, and the international garment industry. Cosmopolitan, smart, culturally diverse, and businesslike, Midtown combines the old-fashioned grandeur of two centuries with the modern, stylish buildings of today.

Bounded north and south by 59th and Washington Square and on the east and west by the East River and Tenth Avenue, Midtown comprises a wonderful collection of such grand old public buildings as Grand Central Terminal and the New York Public Library, alongside the more modern United Nations building and the Museum of Modern Art. They share the spotlight with such architecturally impressive private office buildings as Rockefeller Center, the Flatiron Building, and the Chrysler Building, with its majestic Art Deco pinnacle.

Nothing can compare to the nineteenth-

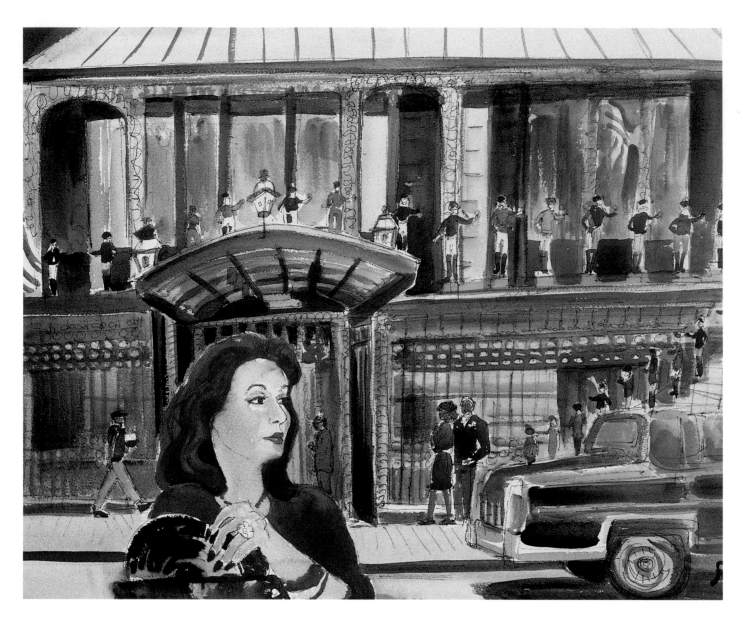

21 Club

Known for its marvelous food and atmosphere and ringed by miniature jockey statuettes, this sophisticated restaurant at 21 West 52nd Street has been tops for years. Its social and business clientele are still packing it in along with a hip, younger crowd.

century splendor of Midtown's churches and synagogues, including St. Patrick's Cathedral and St. Thomas Church on Fifth Avenue, St. Bartholomew's Church on Park, and the Central Synagogue on Lexington. But make no mistake: it is the people who energize the buildings. They go in and out of Saks Fifth Avenue, the Algonquin Hotel, Penn Station, and the 21 Club, gather at the wide array of restaurants from fast food to haute cuisine, and visit such Midtown parks as Bryant Park behind the library and Ralph Bunche Park at the United Nations building to enjoy a breath of greenery. Midtown also includes Chelsea, with its historic Chelsea Hotel, the Art Deco Joyce Theater, Herald Square, the Garment District, Union Square, Gramercy Park, and Times Square.

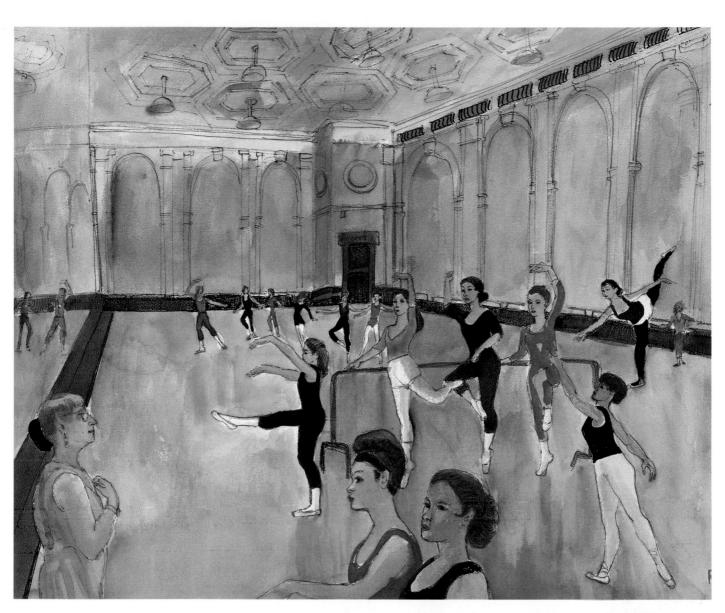

Dance Class at City Center Theater Studio

Famed Danish-born ballerina Nina Stroganova of the Ballet Russe de L'Opera Comique in Paris taught classes for New York's up-and-coming ballet artists.

Harley-Davidson Cafe

This cafe is truly an "in" place on West 56th Street and Sixth Avenue. A motorcycle revolves above its door to attract the curious and the biker enthusiasts who fill this place.

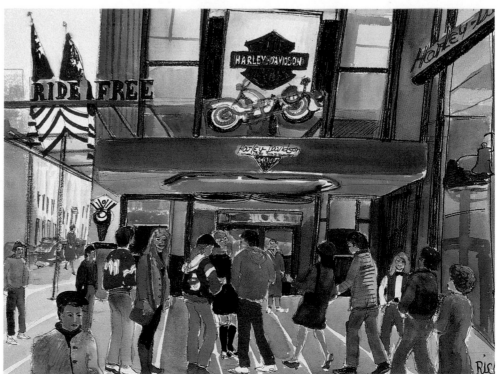

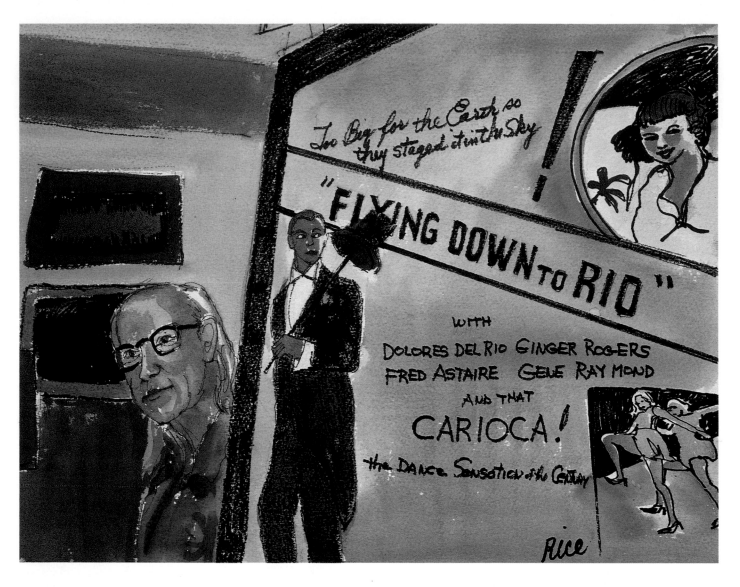

Backstage at Radio City Music Hall

I met with George LeMoine, "the Phantom of Radio City," in his office backstage among his photographs and old posters of Radio City Music Hall. The likable LeMoine worked his way up to company photographer and is now retired, although he still keeps an office here.

Radio City Music Hall Ladies' Lounge

Yasua Kuniyoshi designed the wall decorations of the second-mezzanine ladies' lounge. The elaborate Art Deco setting displays lush and fanciful floral designs.

Rockette

Radio City Music Hall >

Home of the famous Rockettes, whose precision dancing has delighted audiences for years, Radio City Music Hall, on the corner of West 50th Street and Sixth Avenue, was at one time the largest theater in the world. With 5,882 seats, this lavish Art Deco palace is an impressive venue that is worth seeing.

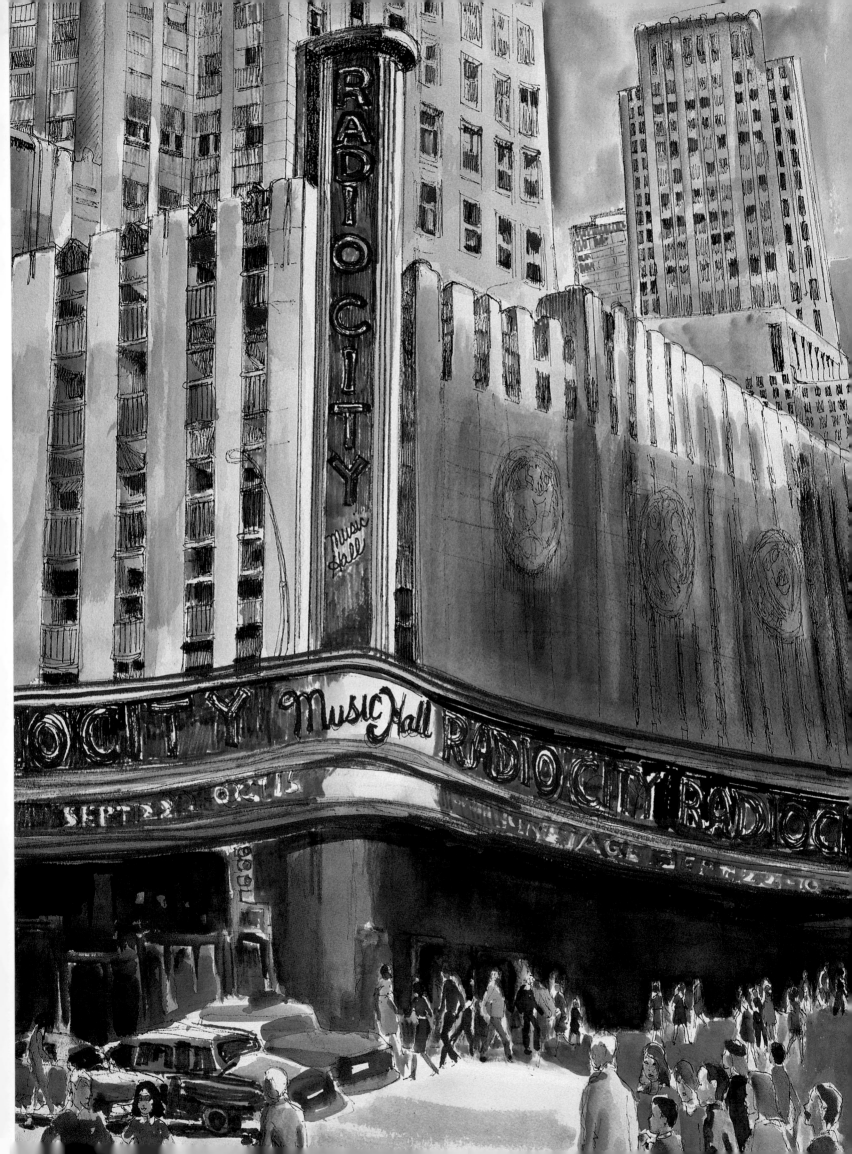

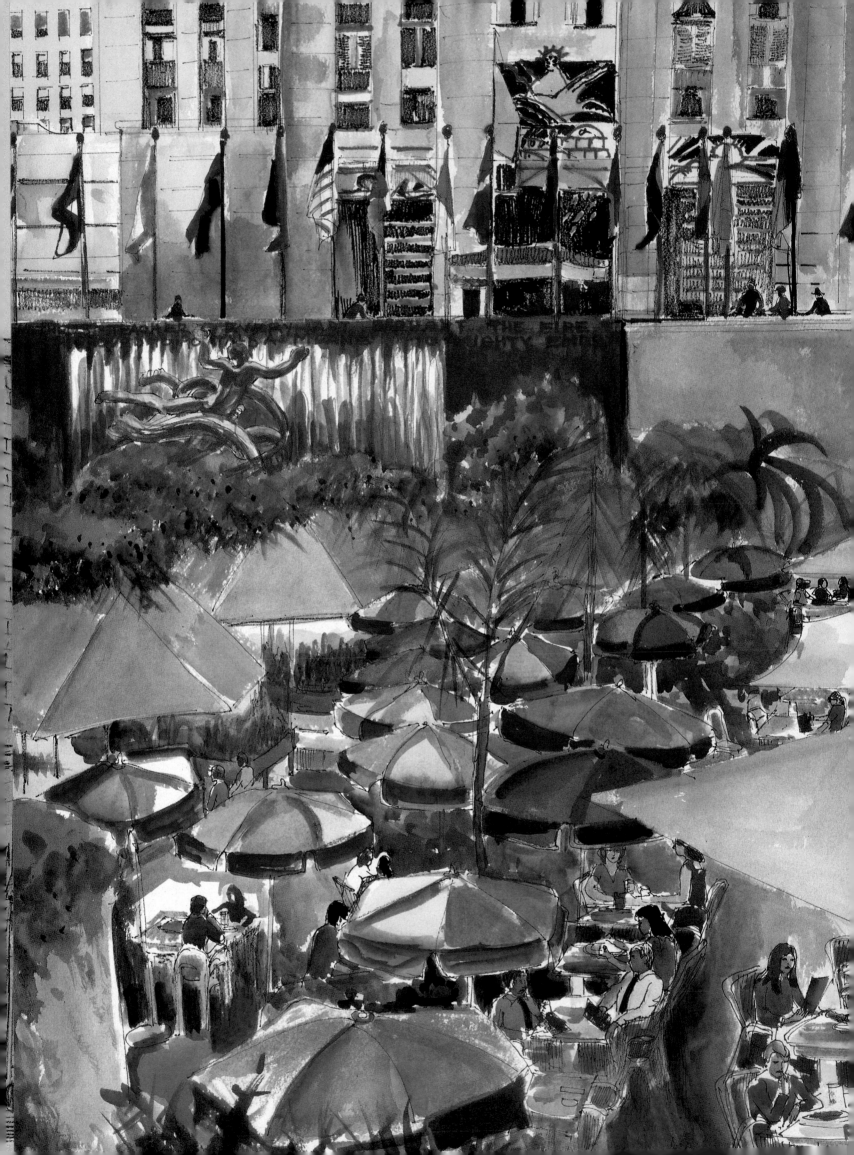

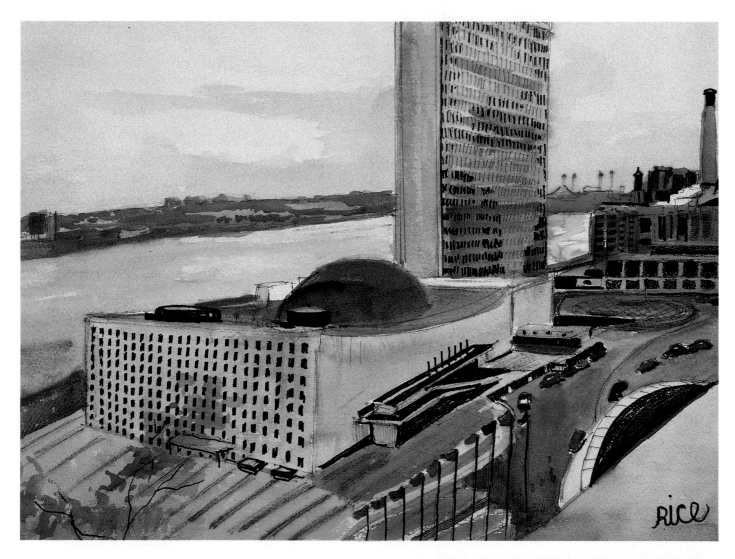

United Nations Plaza

The spectacular view of the East River was an added plus while I lunched in the U.N. Delegates' Dining Room. The buffet was an unforgettable experience. The U.N. buildings cover an eighteen-acre area. The members meet in the General Assembly building, and the flags of all member nations fly outside, arranged in alphabetical order.

Inside the United Nations Building

< Lunching at Rockefeller Plaza

Rockefeller Plaza is crowned by a gold-leaf statue of Prometheus by Paul Manship. This celebrated landmark provides a vibrant burst of colorful umbrellas on a summer's day and converts to an ice-skating rink in winter.

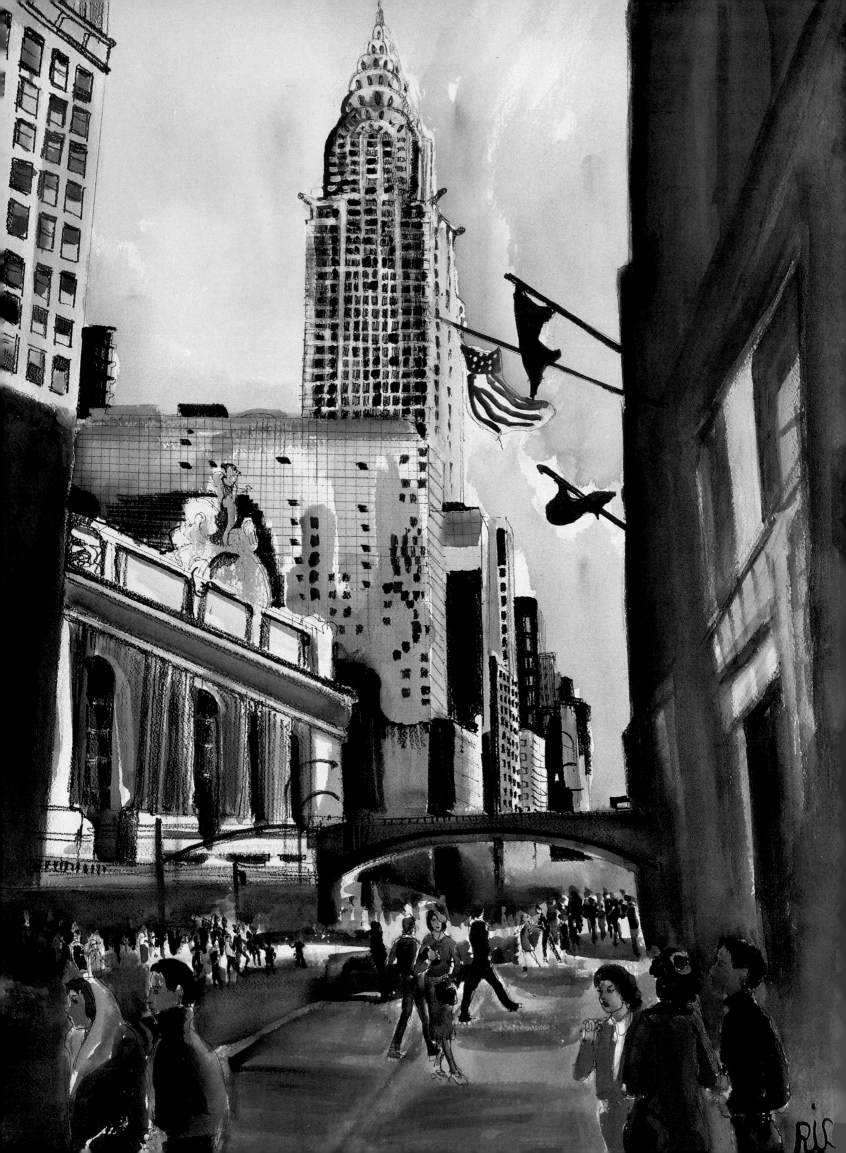

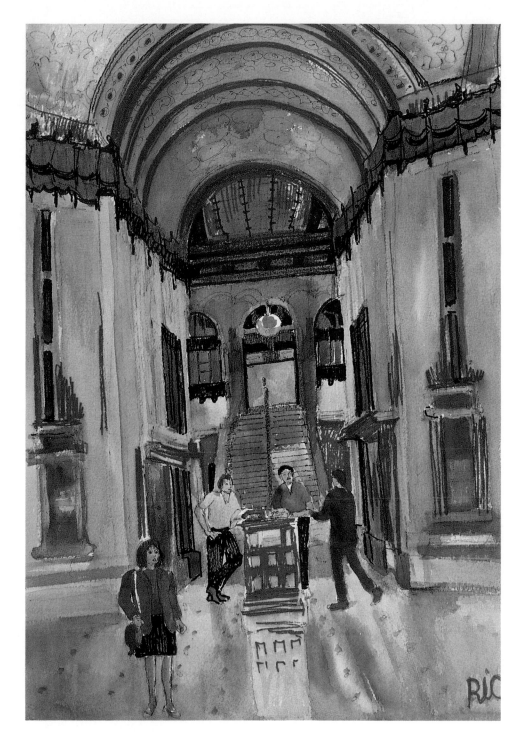

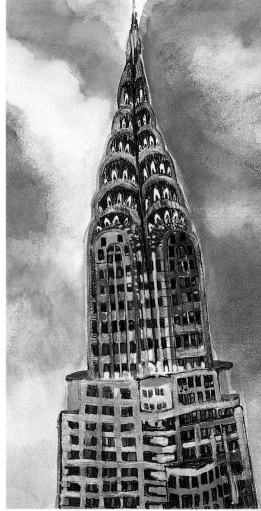

**Crown of the
Chrysler Building**

Lobby of the Chrysler Building

Once used as the major showroom for
new Chrysler automobiles, marble walls
and recessed lighting with overhead murals
and Art Deco designs make this one of the
most beautiful lobbies in the world.

< East 42nd Street Seen
from Vanderbilt Avenue

Two of Manhattan's most prominent
landmarks, Grand Central Station and the
Chrysler Building, dominate the skyline.

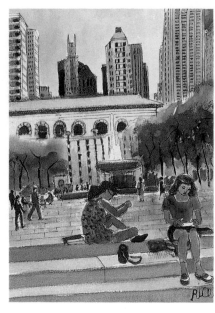

Studying in Bryant Park

Midtown's largest greenspace, ringed with trees and a formal garden, four kiosks, subway stations, two restaurants, and a pavilion, Bryant Park is a place for concerts and relaxation. It is located behind the New York Public Library between Fifth and Sixth Avenues. The park is home to statues of William Cullen Bryant, William E. Dodge, Goethe, José de Andrada, and a booth that sells half-price tickets for music and dance events playing that evening.

New York Public Library

Protected by two crouching lions christened Patience and Fortitude by New York City Mayor Fiorello La Guardia, the New York Public Library is one of the largest research libraries in the world. In addition to reading rooms, exhibition halls, and research services, you will find Charles Dickens' writing desk and Thomas Jefferson's original handwritten copy of the Declaration of Independence. The famous and instantly recognizable portrait of George Washington by Gilbert Stuart hangs in the main building. There is also a museum and art gallery presenting periodic exhibitions with special themes. Noontime finds many of New York's working people enjoying lunch or just lounging, chatting, and basking in the sun on the expansive library steps on 42nd Street and Fifth Avenue.

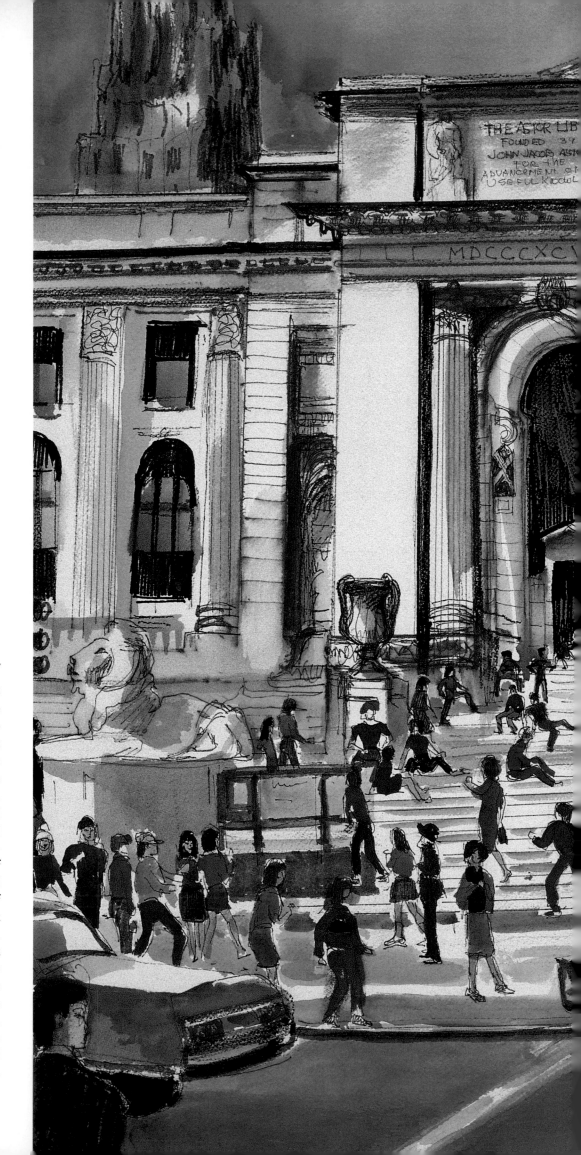

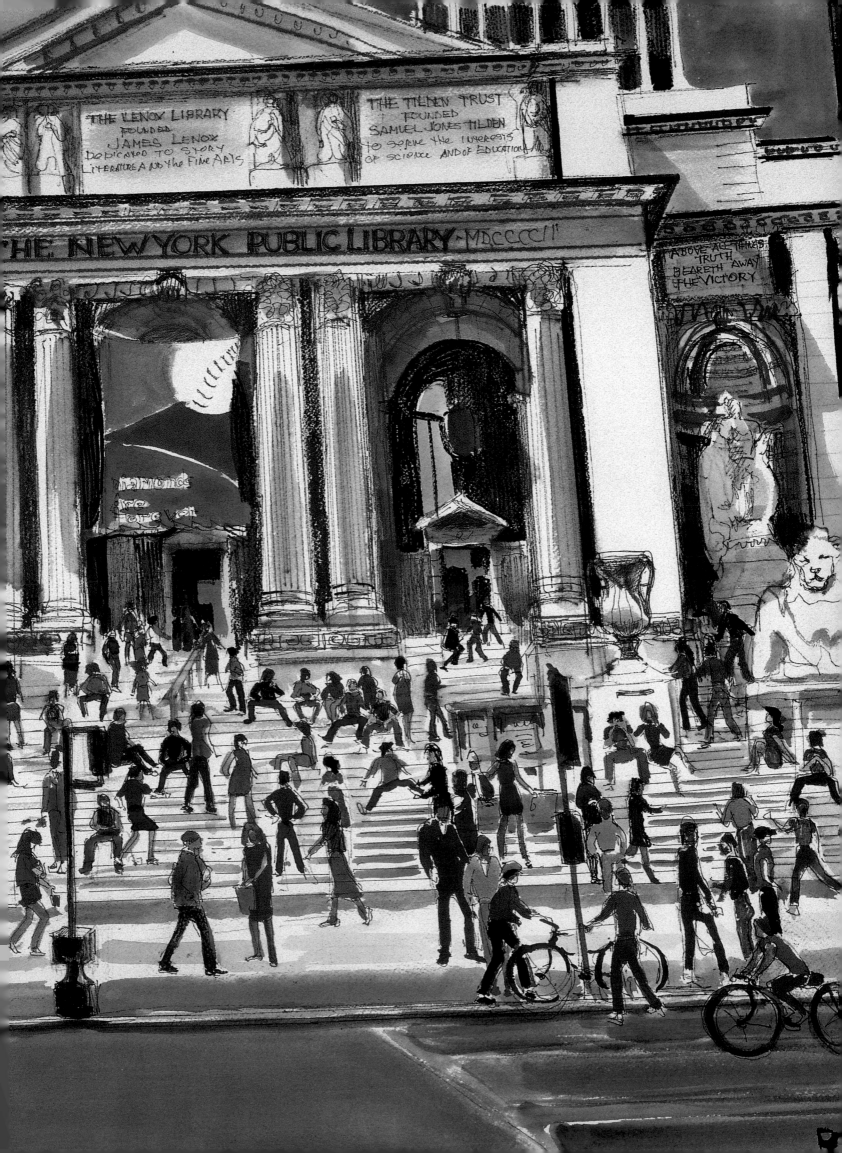

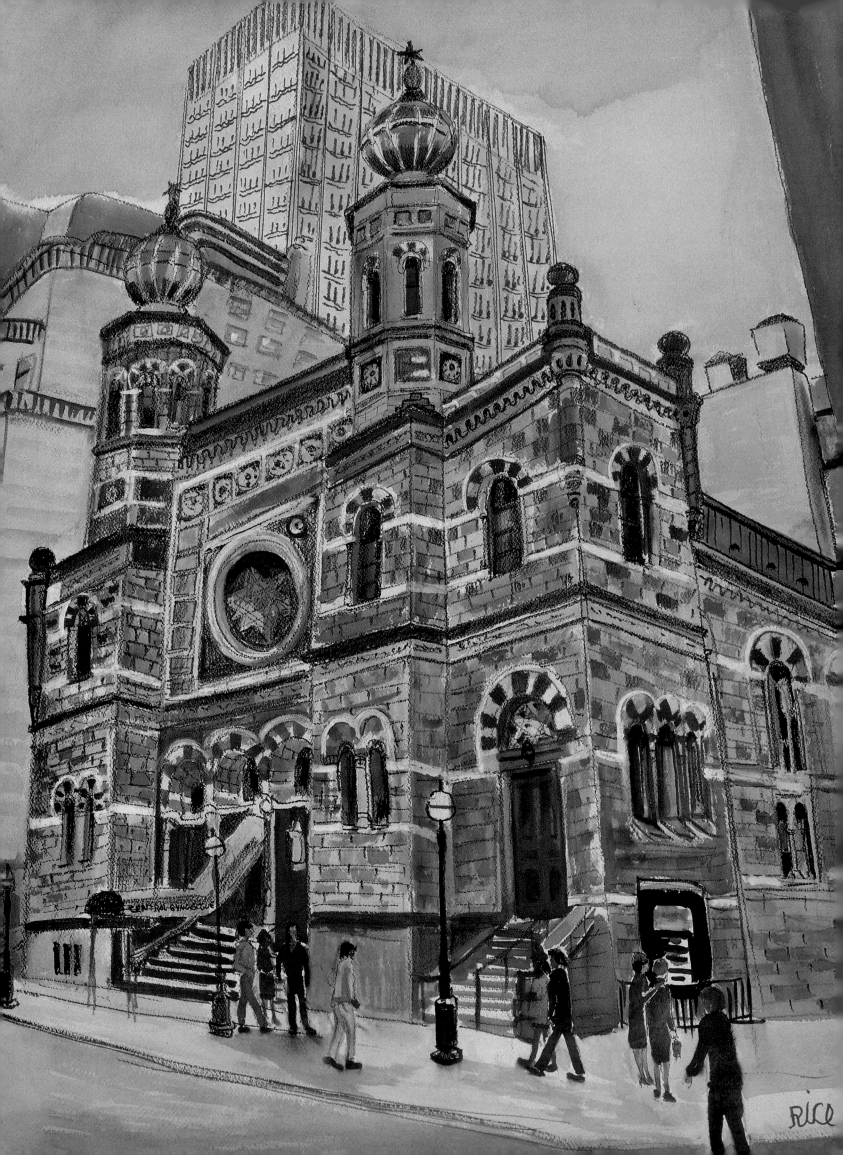

Inside the Museum of Modern Art on West 53rd Street

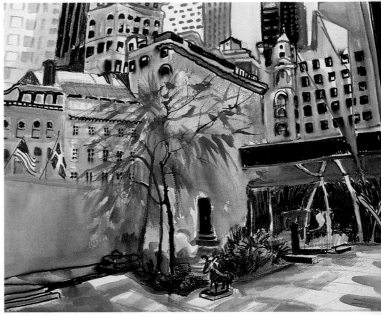

Museum of Modern Art— View of the Sculpture Garden

Opening just a few days after the great stock market crash of 1929, the Museum of Modern Art represented a revolution in the approach to art in the United States. MOMA was created as a museum dedicated to contemporary visual arts, including the so-called non-museum worlds of photography, music, architecture, film, and industrial design. It has thrived and more than fulfilled its innovative charter, and now encompasses a publishing house, movie theater, and film department.

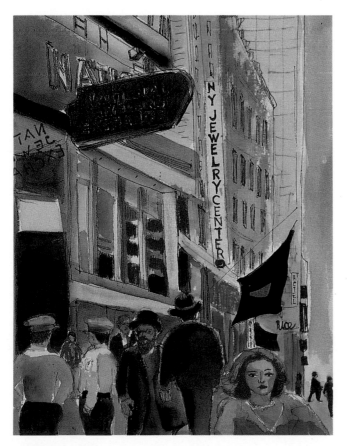

Jewelry Center on West 47th Street

One of the leading jewelry shopping areas in the world, this busy street gets lots of action. It is a great place for comparison shopping for any kind of jewelry.

< Central Synagogue

The oldest synagogue in use in the state of New York, the Central Synagogue was designed by America's first prominent Jewish architect, Henry Fernbach. After passing 55th Street and Lexington Avenue so many times, I "rediscovered" it and was absolutely startled to see this Moorish, romantic architecture in a synagogue.

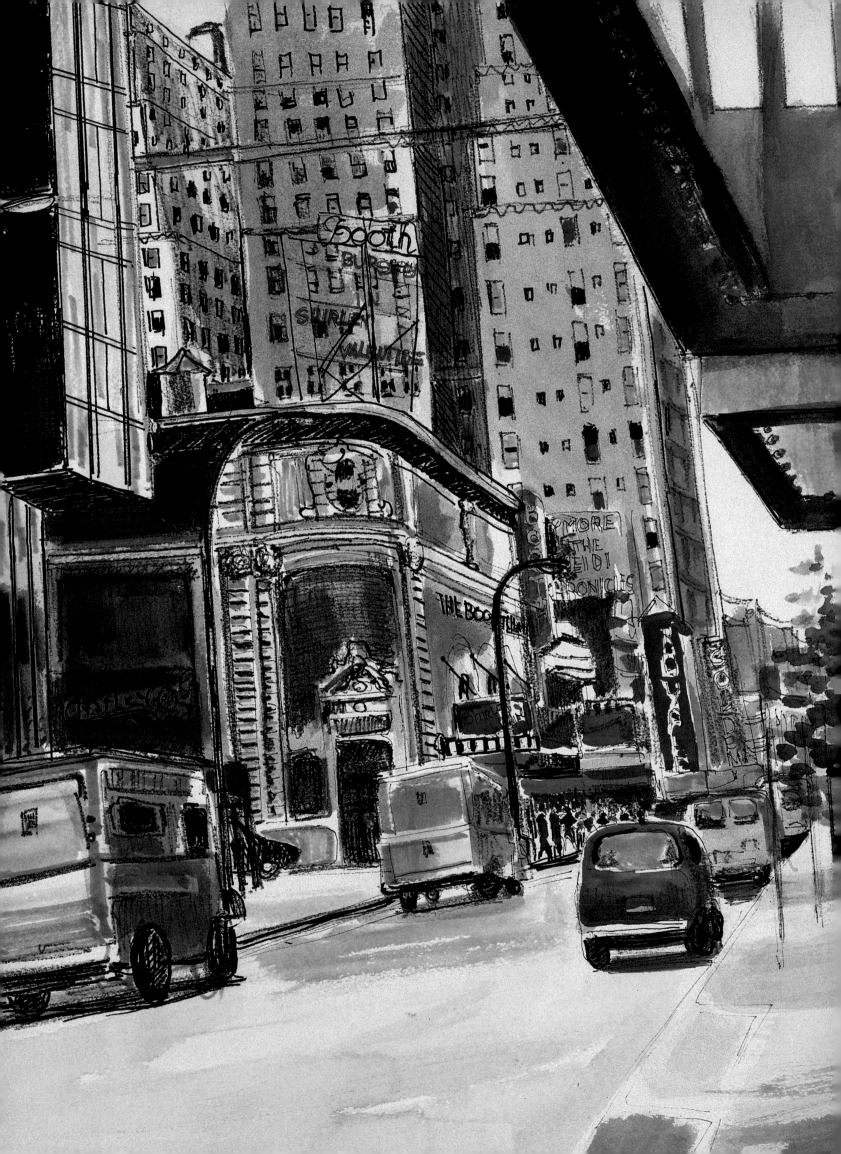

The Theater District

The name BROADWAY conjures up images of glamour and excitement. I was eight years old when I saw my first Broadway show, and I have been stagestruck ever since. When I grew older, I pursued every ingenue role possible. My ambitions toward a life in the theater eventually met with success, and I appeared in several Broadway and off-Broadway shows. I loved being in a show because it made me feel like part of a family. Even today, when I am sitting in the audience, I still get a thrill when the curtain goes up.

Along with visitors from all over the world, I am lured by the famous neon lights of the Theater District and feel drawn into its beautiful theaters to see plays and musicals. Whenever I visit Manhattan, I try to see as many productions as possible on or off Broadway. Some of the area's best known restaurants are Sardi's, Gallagher's, Broadway Joe's, and Lindy's, and the wall-to-wall restaurants of Restaurant Row on West 46th Street also offer great dining fare. Many cabarets and supper clubs with shows and fine food now enliven the Broadway district, and new thriving off-Broadway theaters sprawl invitingly along a revived West 42nd Street.

45th Street Broadway Theater District

The street is famous for its landmark theaters. Names such as the Booth, Martin Beck, Music Box, Imperial, Golden, Plymouth, and Royale are the heart of the American stage.

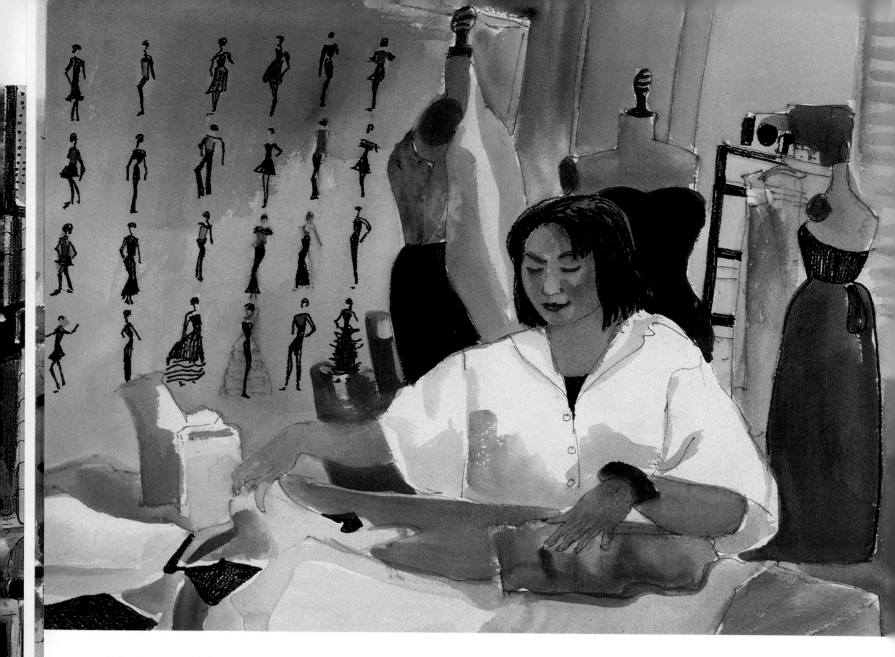

Workroom of Carolina Herrera

I was impressed by the way super-couturier Carolina Herrera designed her workroom and showroom. Everything was immaculate. The area even had relaxation places for the employees, as well as kitchens, televisions, music, and comfortable seating. Not only was Carolina Herrera glamorous and beautiful, but her dreamy clothes also were a knockout, and her interior design was the epitome of good taste. Her selection of employees was top-rate, too.

GARMENT CENTER DISTRICT

WEST 30S AND 40S between Sixth and Eighth Avenues. Racks of clothing, bustling people, trucks unloading and blocking traffic, beautiful models, serious shoppers, and workers of all types crowd the area. Fashion designers have established empires within these environs. Manhattan has been the center of clothing manufacturing in the United States for 150 years.

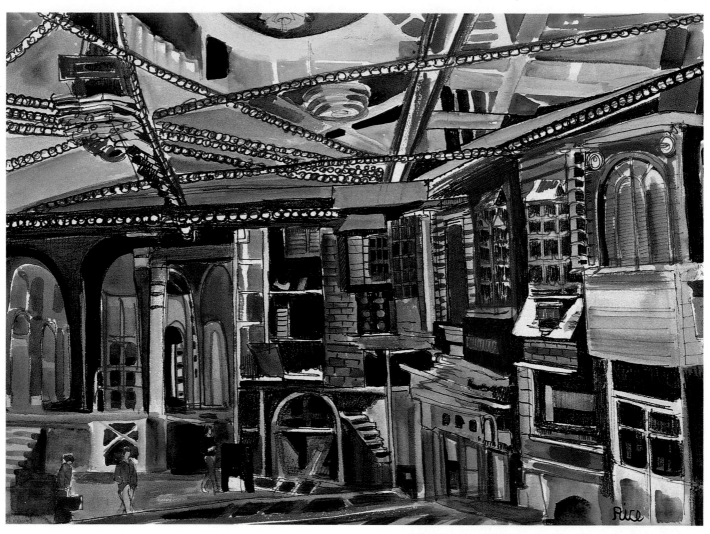

The Paramount in Madison Square Garden

Setting up for a musical production of *A Christmas Carol* in the 6,000-seat Paramount Theater was just one event taking place in the giant Madison Square Garden complex, which covers two city blocks bounded by 31st and 33rd Streets on the south and north and by Seventh and Eighth Avenues on the east and west. America's premier entertainment mecca, Madison Square Garden is also home to the New York Knicks, the New York Rangers, the Ringling Bros. Barnum and Bailey Circus, and endless trade shows; exhibitions; sporting events including boxing, ice-skating, and wrestling; rock concerts; horse, dog, and cat shows; and you name it.

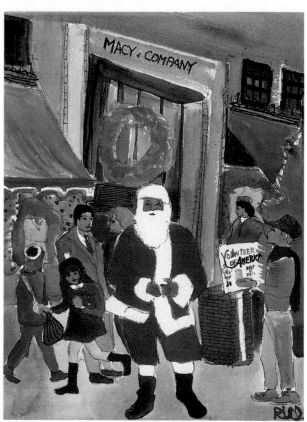

Christmas at Macy's

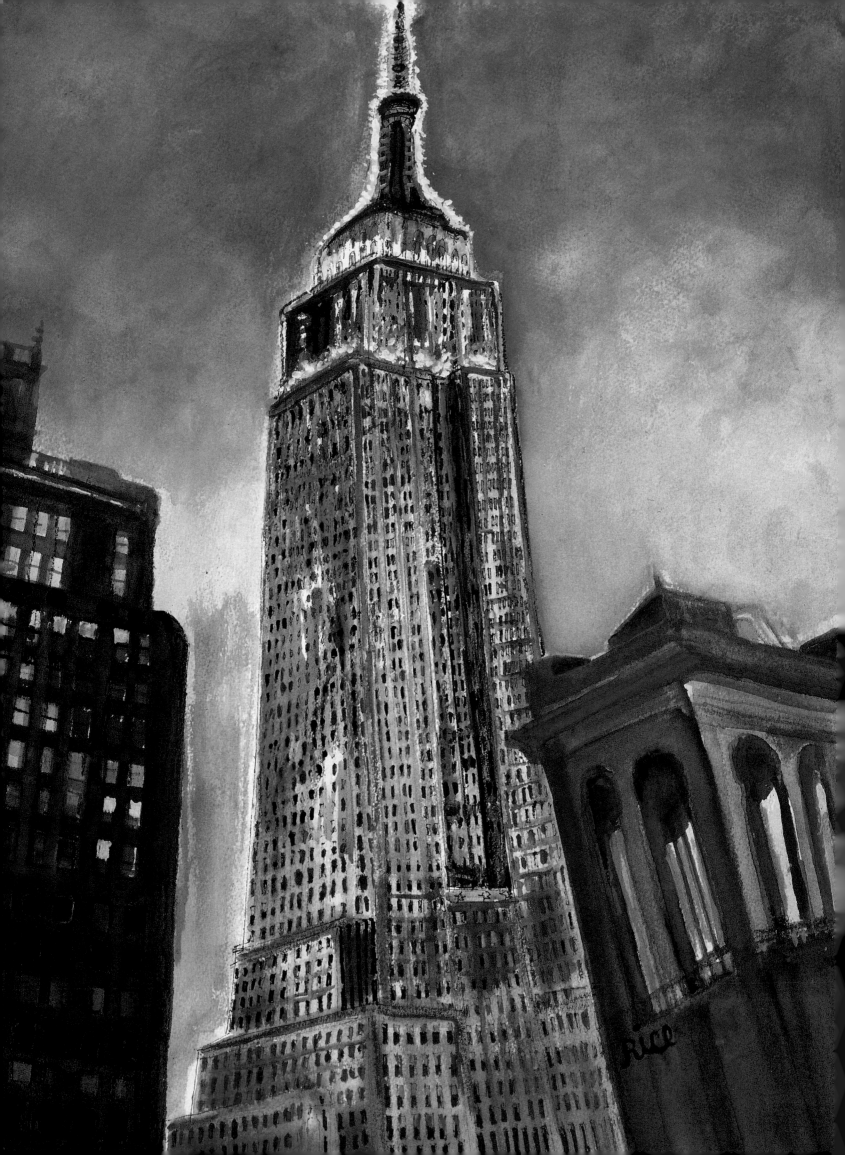

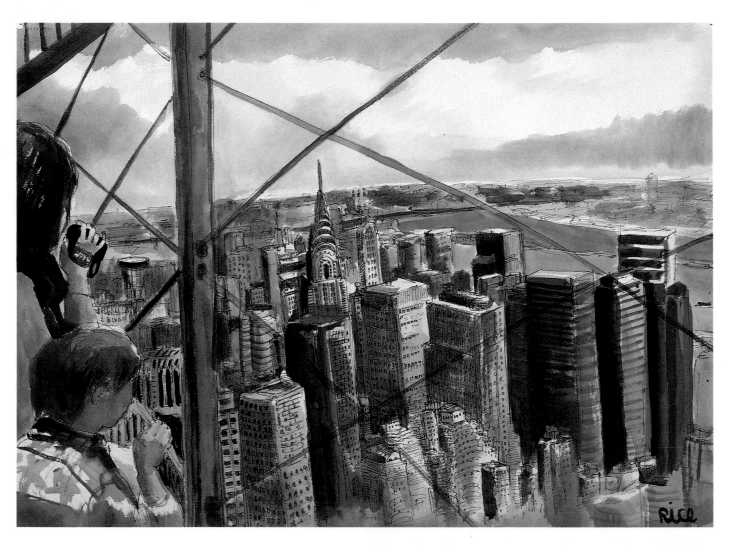

Looking East from the Observation Deck of the Empire State Building.

Garden Court of the Pierpont Morgan Library

This three-story skylit garden atrium is a tranquil place for lunch during a visit to the Pierpont Morgan Library, which showcases rare manuscripts, books, and period prints.

< Empire State Building

With its 73 elevators, 102 floors, and 1,860 steps, the Empire State building has become one of New York City's most enduring landmarks. The view from the observation decks on the 86th and 102nd floors gives you a commanding fifty-mile view in all directions.

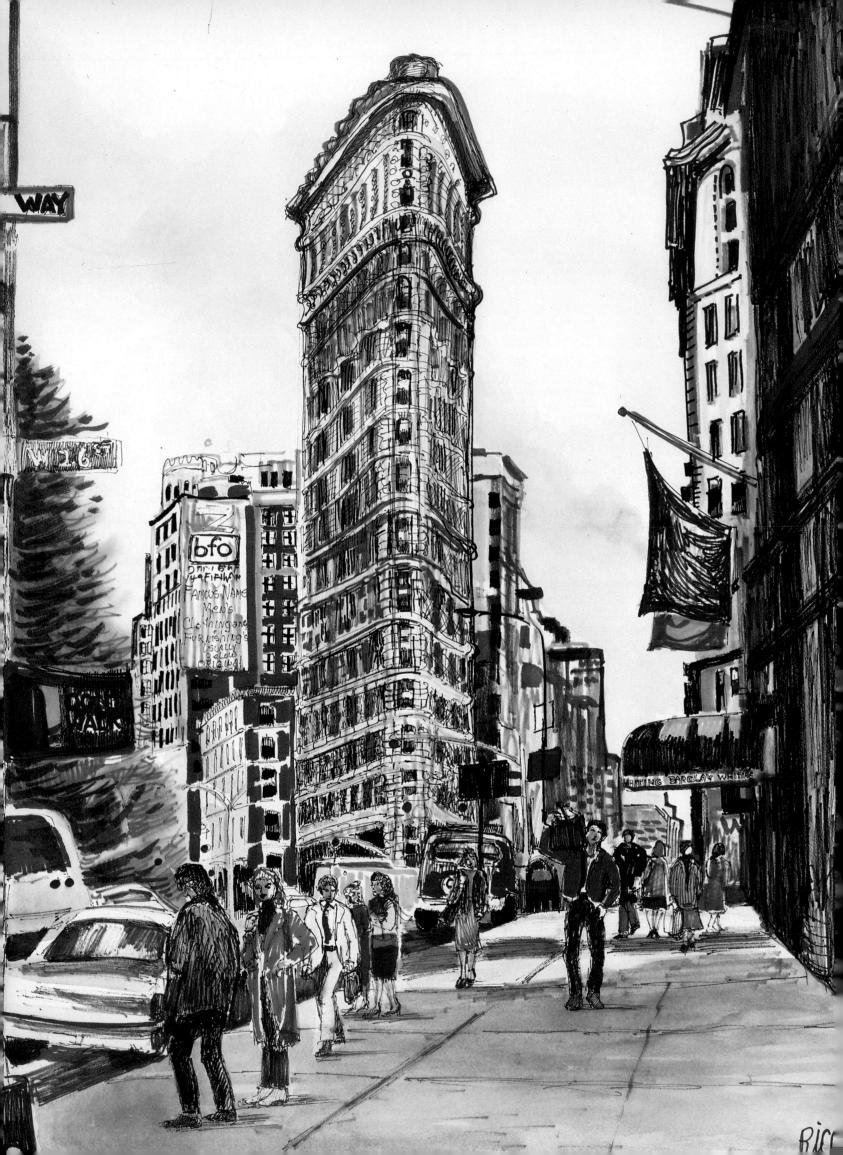

Birdhouse in Gramercy Park

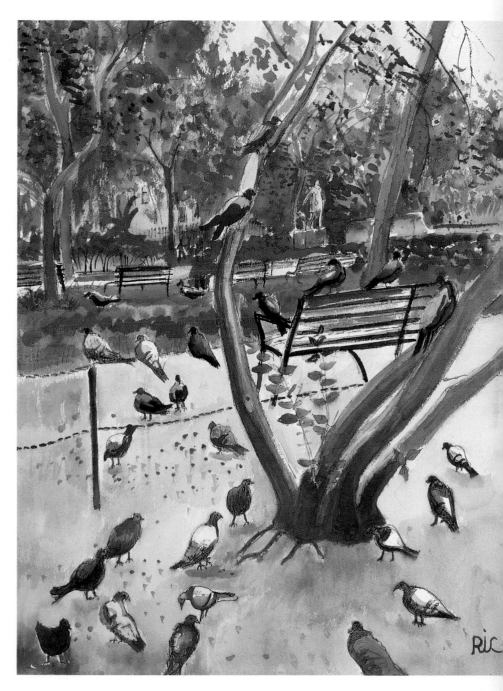

Birds of Gramercy Park

< *Flatiron Building*

Designed by architect Daniel H. Burnham, this 1902 Renaissance-style construction was the tallest building in the world when it opened. With a width of only six feet on one of its sides, the eye-catching design resembles the prow of a ship at sea.

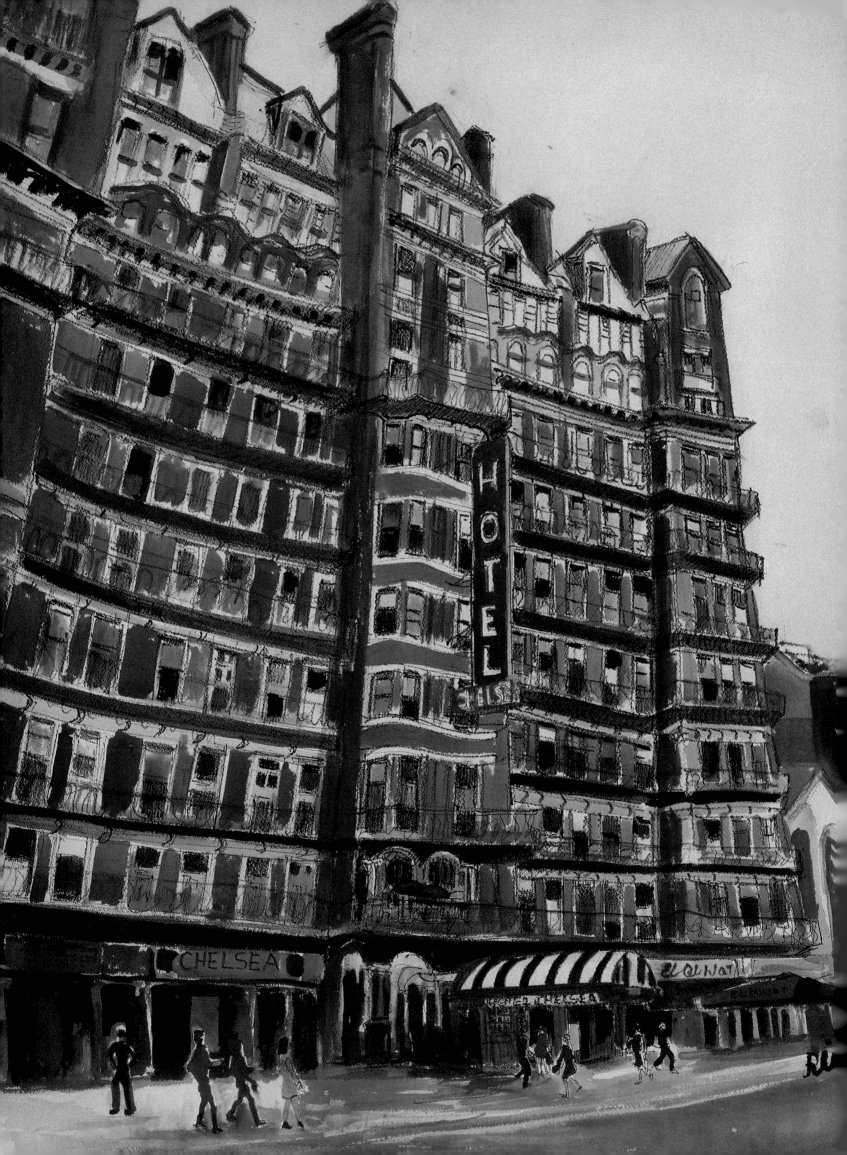

CHELSEA

Dog Walkers

Dog walkers strut ceremoniously all over Manhattan, equipped with various disposal devices and materials to help keep the city streets clean.

To the west of the Flatiron building is the neighborhood of Chelsea, roughly bound by West 14th, West 30th, Sixth Avenue, and the Hudson River. Rock musicians, artists, and writers give this area its special flavor. The Chelsea Hotel on West 23rd Street is famous for its amazing, ever-changing roster of celebrity artists who have lived there since its opening in 1884. The impressive list includes Mark Twain, Dylan Thomas, Arthur Miller, Thomas Wolfe, and Brendan Behan. Among the more infamous residents were Andy Warhol, superstars Viva and Edie Sedgwick, rock legend Janis Joplin, and punk rocker Sid Vicious.

Dance concerts are regularly held at the Joyce Theater on Eighth Avenue, a veritable dance mecca. Chelsea is a gritty mixture of nineteenth-century townhouses in Federal and Greek Revival architectural styles, housing projects, industrial buildings, churches, aging tenements, antique shops, office supply stores, furniture outlets, and clothing stores such as the comprehensive Barney's at West 17th Street and Seventh Avenue. The wholesale flower district between 27th and 30th Streets keeps city dwellers supplied with exotic plants and flowers. The all-night Art Deco Empire Diner on the corner of 22nd Street and Tenth Avenue is a fixture of daily life for anyone who gets a sudden craving for a midnight snack or an early breakfast.

< Chelsea Hotel

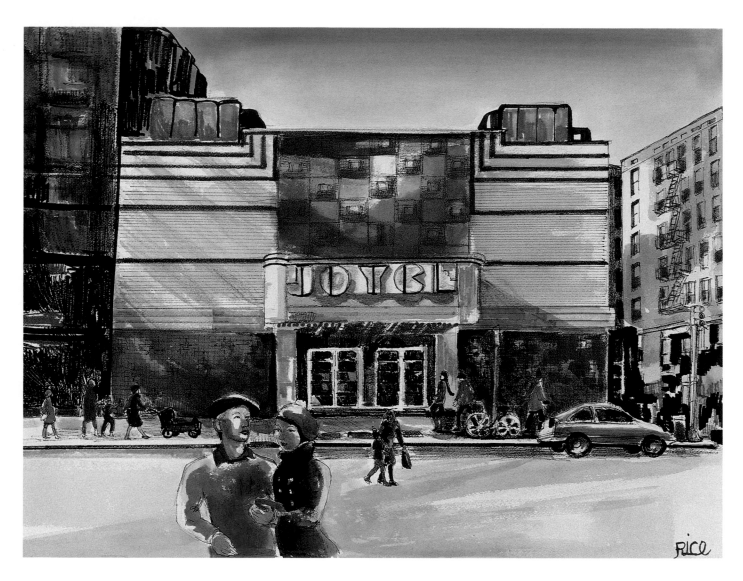

Joyce Theater

Dedicated to the art of dance, this is one of
the most treasured theaters in Manhattan. Eric
Hawkins, with whom I once studied dance,
Merce Cunningham, Eliot Feld, Katherine
Dunham, and virtually every renowned dance
artist and troupe have performed here.

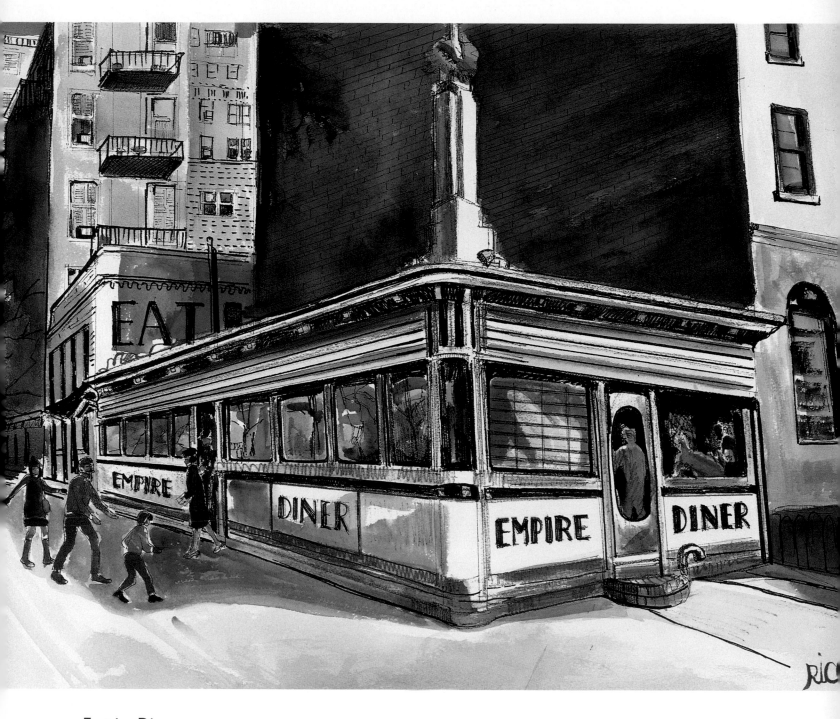

Empire Diner

Built in 1930 on Tenth Avenue and West 22nd
Street, this Art Deco eatery is open twenty-four
hours a day. A great meeting place for breakfast
or an ice cream sundae, the diner bustles with
an assorted mixture of people from bikers to
Upper Eastsiders. Outside, motorcycles and
limousines park side by side.

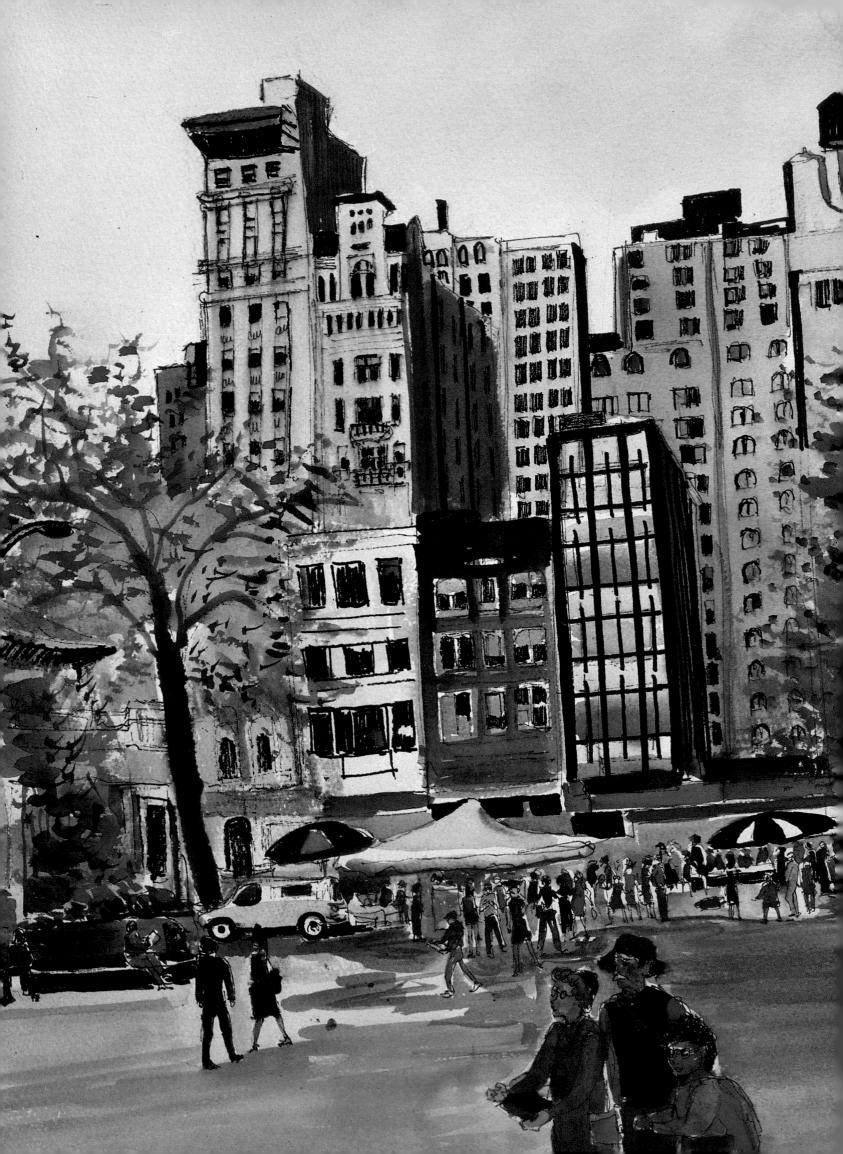

UNION SQUARE

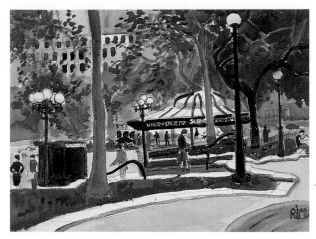

Subway Kiosk in Union Square

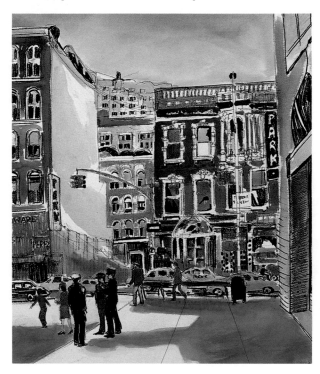

Irving Place/14th Street

Luchow's and its fine cuisine once attracted people from all the boroughs. Irving Place was named in honor of the writer Washington Irving, a prominent and active New Yorker in the nineteenth century.

Union Square

Union Square, originally called Union Place, was given its name because it was the junction of many streets. Over the years the square has been used to hold political and union-organized demonstrations as well as by street venders to hawk their goods. It also served as Andy Warhol's home base during the late 1970s. Situated at the junction of Broadway and 14th Street, Union Square offers a lovely rose garden and statues of George Washington, Abraham Lincoln, Lafayette, and Mahatma Gandhi.

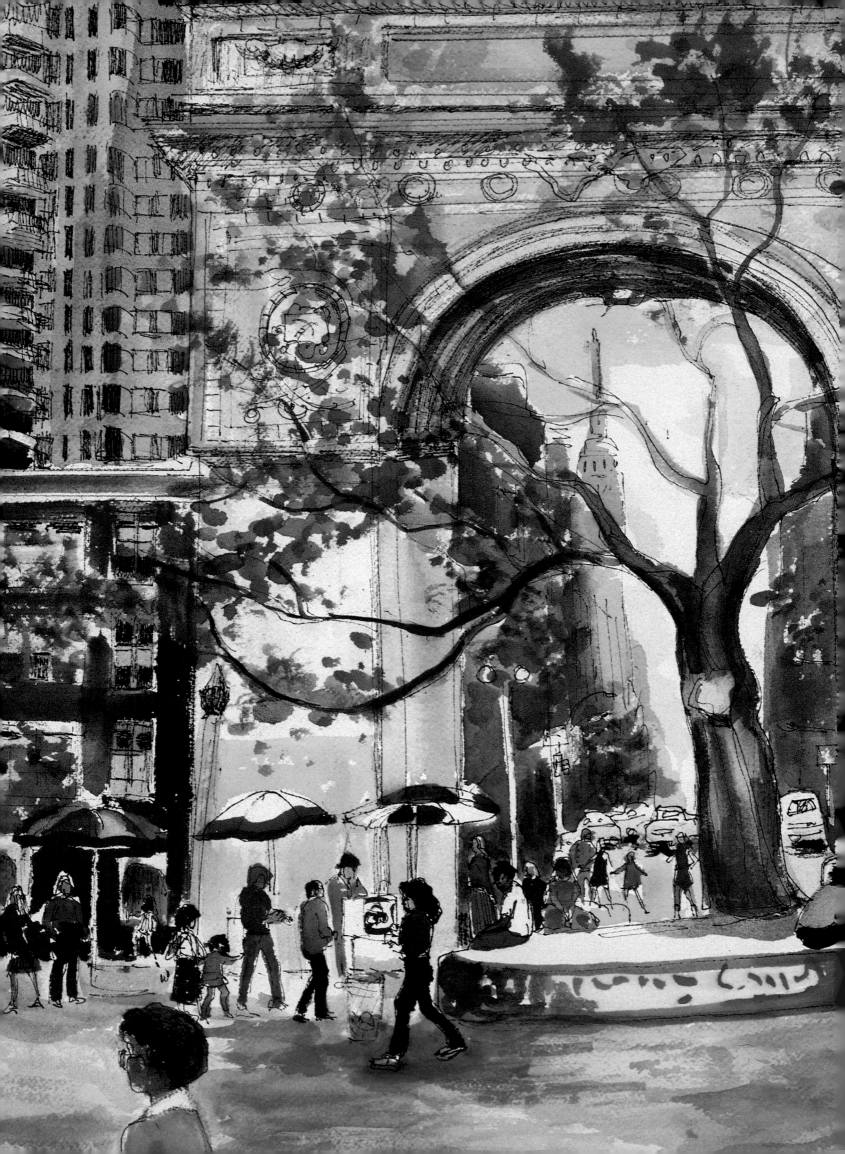

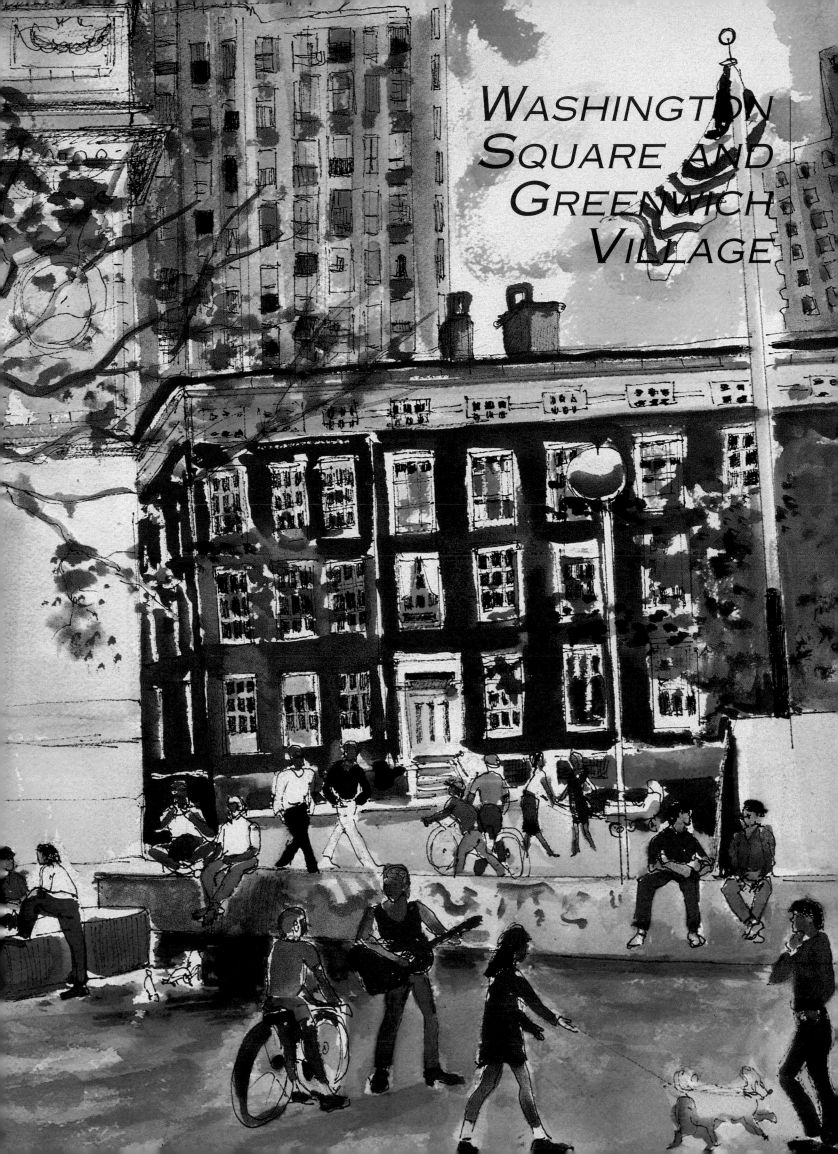

WASHINGTON
SQUARE AND
GREENWICH
VILLAGE

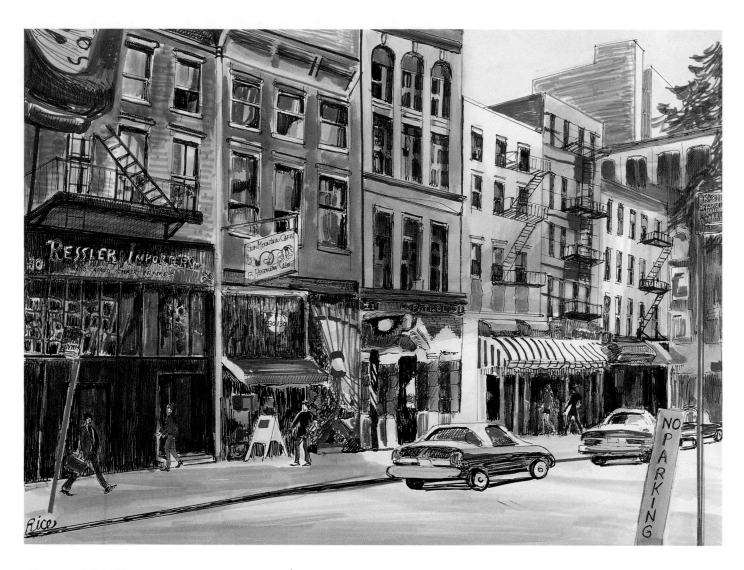

Greenwich Village Street and Its Colorful Storefronts

FIFTH AVENUE BEGINS IN THE HEART OF GREENWICH VILLAGE at Washington Square. A stately 1899 arch commemorating the spot where George Washington took the presidential oath of office is flanked by blocks of row houses in mint condition.

With a pace all its own, Greenwich Village has everything from off-Broadway theaters to cozy jazz clubs. Its boundaries are 14th Street on the north, the Hudson River on the west, Broadway on the east, and Houston Street on the south. Edgar Allan Poe, Walt Whitman, Edna St. Vincent Millay, and Dylan Thomas have been among Greenwich Village's more notable residents. They joined their fellow artists, writers, musicians, actors, designers, and students in a unique, richly diverse cultural potpourri in what remains one of the most fun-filled neighborhoods in Manhattan.

For several years I lived on Washington Place off Washington Square. I had a place above an Italian restaurant, and the waiters often served us food from their kitchen. My apartment had French windows that opened out to the street, and I would often sit watching the Village life go by. Once in a while a mouse or two came inside for a visit!

Shopping in the West Village is a marvelous experience. The fresh

Previous page
Washington Square

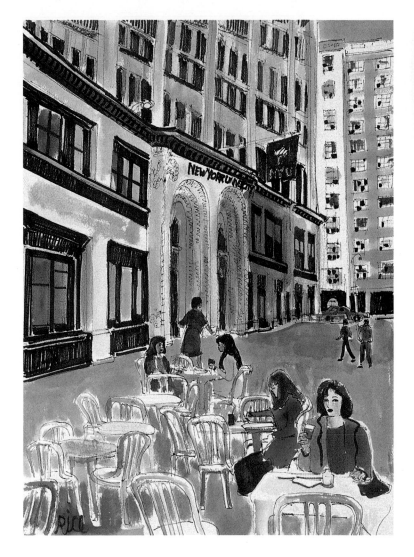

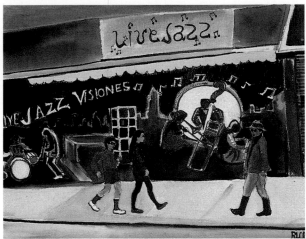

Live Jazz

New York University

This 175-year-old university is located on historic Washington Square, which still boasts some of the most beautiful Federal and Greek Revival row houses in the country. Much of the real estate in Greenwich Village is owned by NYU, which is the largest private university in the United States, serving over 46,000 students.

bread, fish, coffee, meat, and flowers have always been first-rate and affordable. The surrounding area has some charming townhomes complete with front stoops and cobblestone alleyways. The commercial streets, such as Christopher Street, abound with specialty shops such as Oscar Wilde's Bookstore, card shops, crystal gazers, and leather clothing stores. I had my fortune told, ate lunch at Sázerac House on Hudson Street, stopped in at the White Horse Tavern and admired the photographic tribute to poet-playwright Dylan Thomas, and wandered the streets from Gay Street to Beth El Apartments, which housed artists and actors near the Hudson River.

Music enthusiasts inevitably find their way to the jazz clubs on MacDougal and Thompson Streets, as well as to the Italian coffeehouses and the off-Broadway theaters nestled here. When I set up my easel, Washington Square Park was alive with acrobats, chess players, lovers, bikers, college students, children on the playground, and bystanders munching on hot dogs, pretzels, and bagels. The feeling here is definitely free and easy—it's the trademark of the Village—and encourages you to just "be yourself!"

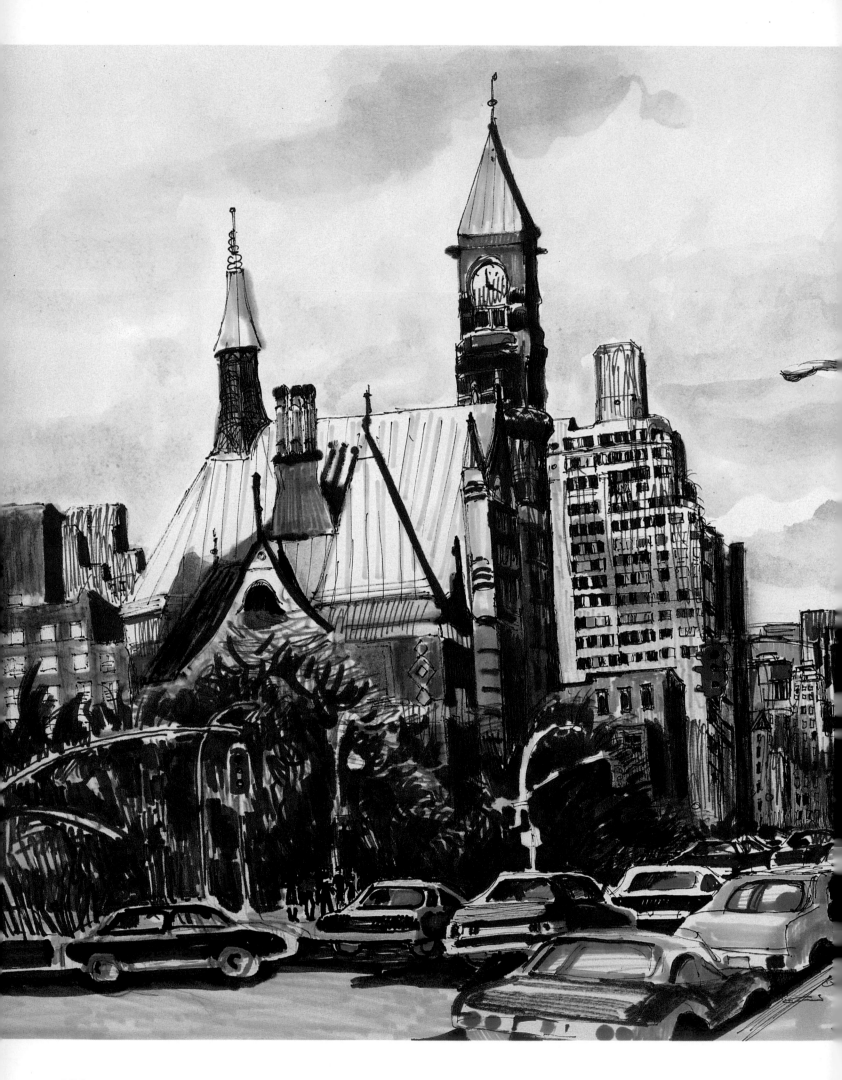

134

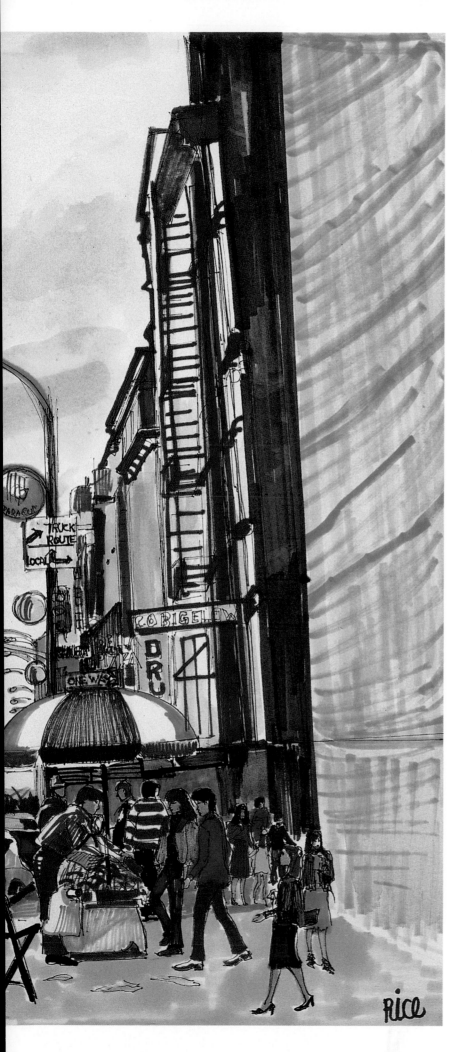

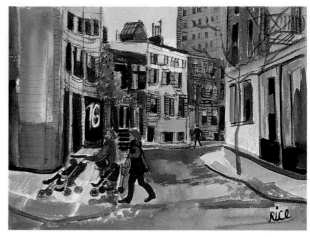

Gay Street

A small charming enclave of little Federal-style houses off Christopher Street and Waverly Place curves through a small single street in the West Village.

Sixth Avenue at Eighth Street Looking Uptown

The dominant Victorian Gothic building is the Jefferson Market Branch of the New York Public Library, which was designed by Frederick Clark Withers and Calvert Vaux and built in 1877 to serve as the Third Judicial District Courthouse. Its clock tower was once used to spot fires.

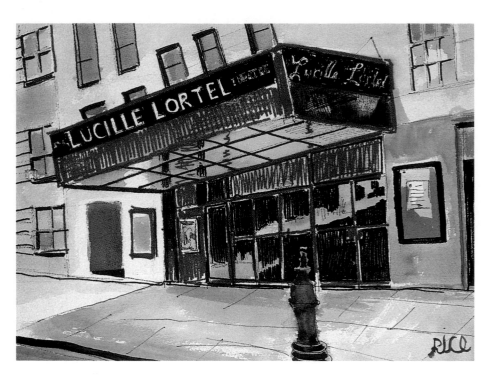

Lucille Lortel Theater

Situated on Christopher and Hudson Streets in West Greenwich Village, the Lucille Lortel Theater, formerly the Theater de Lys, is where the record-breaking production of *The Threepenny Opera* produced by Stanley Chase put off-Broadway theater on the map. This smash-hit production of the Kurt Weill–Bertolt Brecht musical starred the legendary Lotte Lenya and helped launch the careers of such well-known actors as Bea Arthur, Carroll O'Connor, Leonard Nimoy, Ed Asner, Tige Andrews, Jerry Orbach, Jimmy Mitchell, Charlotte Rae, and John Astin.

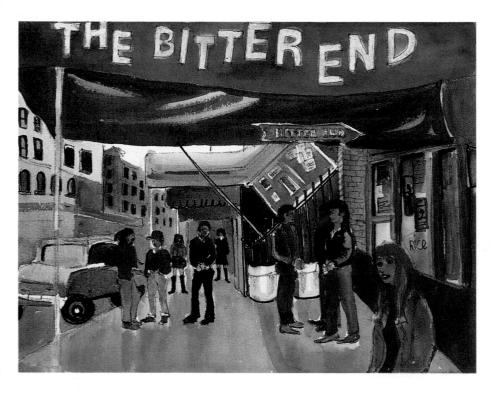

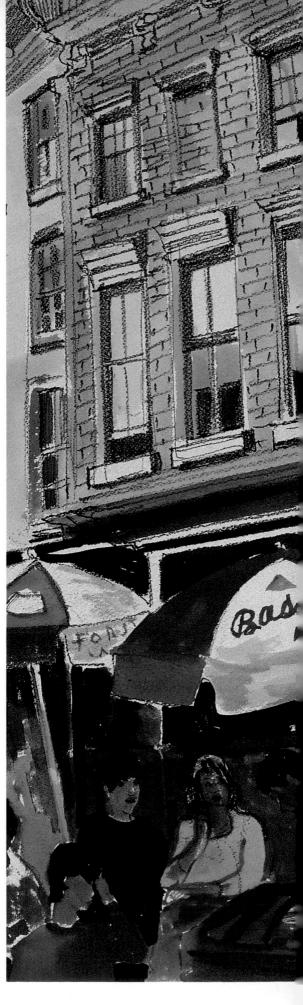

The Bitter End

Young hopefuls hang around this small Bleeker Street club in hopes of establishing a career in rock, folk, or country music. It has been the starting point for many careers.

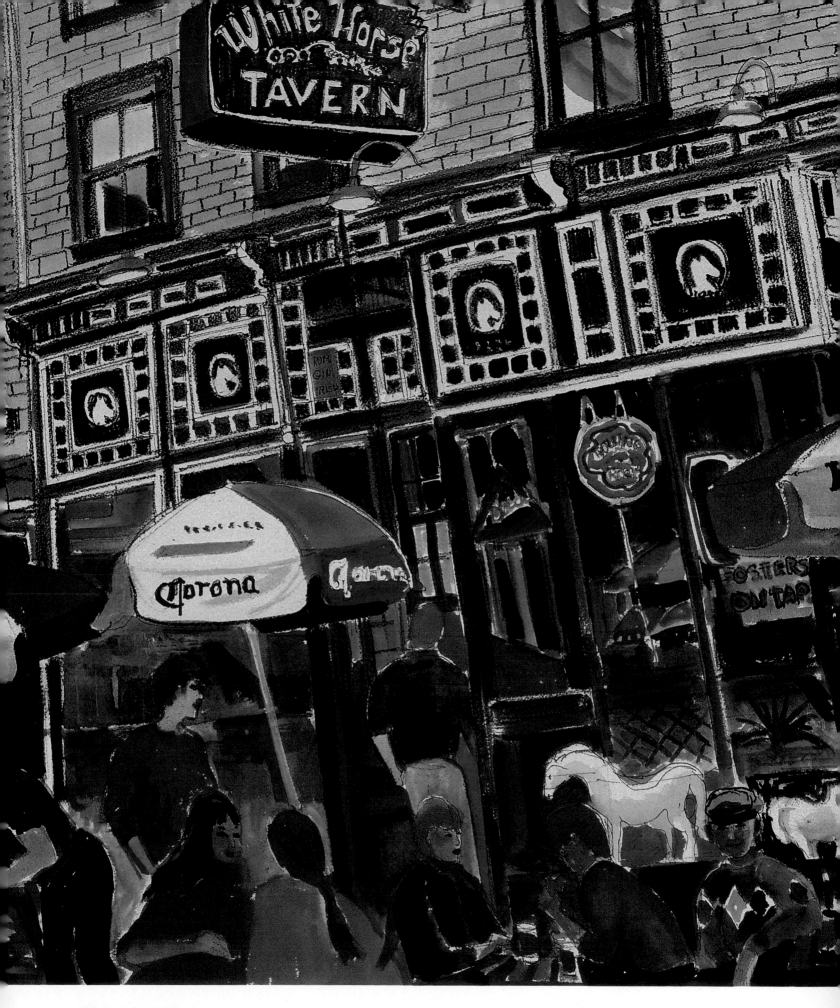

White Horse Tavern

A favorite hangout of Dylan Thomas, this charming spot on Hudson Street has preserved his memory with memorabilia and photographs. Its upbeat atmosphere makes it a popular place in the West Village.

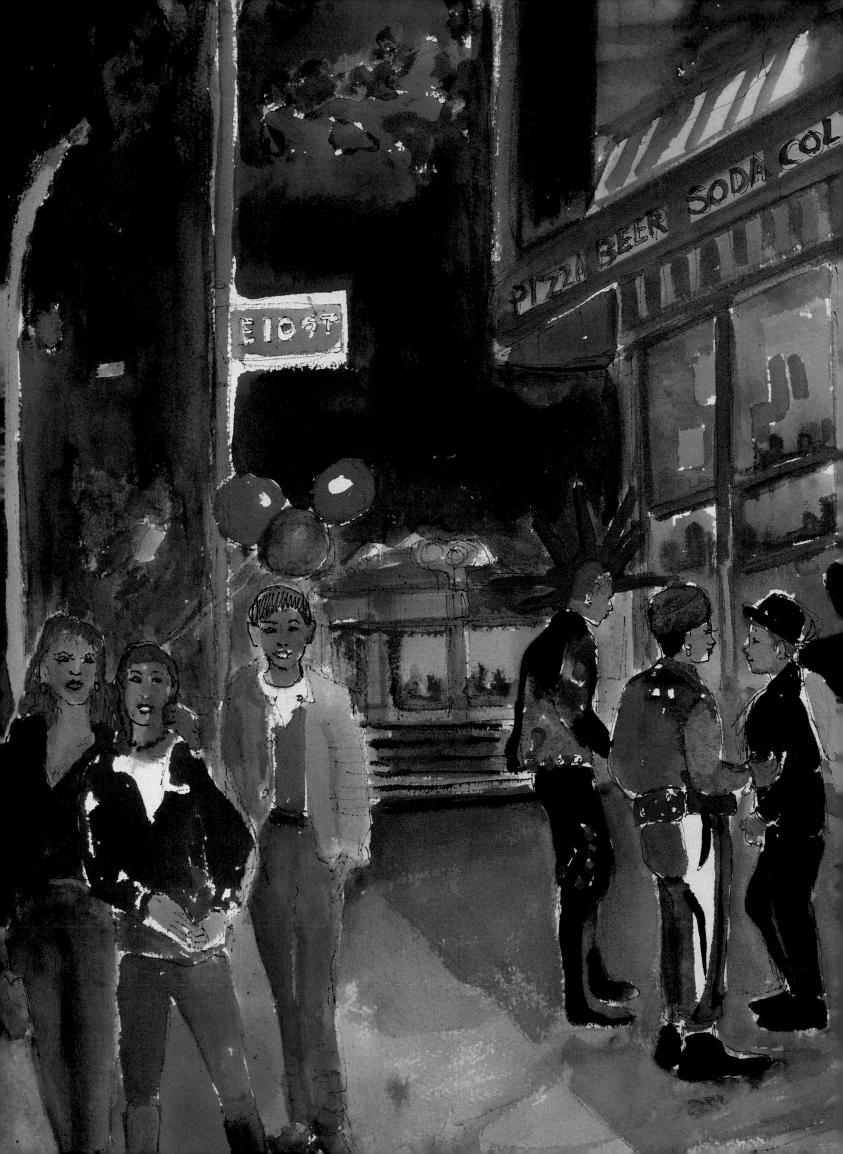

THE EAST VILLAGE

THIS AREA OF MANHATTAN, bounded by 18th Street, Broadway, Houston Street, and the East River, was once considered a northern extension of the multicultural Lower East Side. In the 1960s, it took on the title of "East Village" when the flower-child generation moved in, seeking less expensive quarters. The East Village is a patchwork of ethnic peoples and businesses commingling with young artists, boisterous punk musicians, and the galleries and clubs that offer a venue for their art. Notable places of interest are the Cooper Union Building, a school of art and science; McSorley's Old Ale House; Joseph Papp's Public Theater on Lafayette Street, which houses seven auditoriums; St. Mark's-in-the-Bowery Church; and St. Mark's Place, which is alive with street merchants, street artists, and general hubbub both day and night.

David Bach

David Bach invited me to see St. Mark's Place at night.

Night Scene

The night was brimming with leather-clad people meeting each other. Except for being hassled by a miniskirted, spike-haired girl, everyone else treated me with humor and interest or ignored me as I worked on the spot.

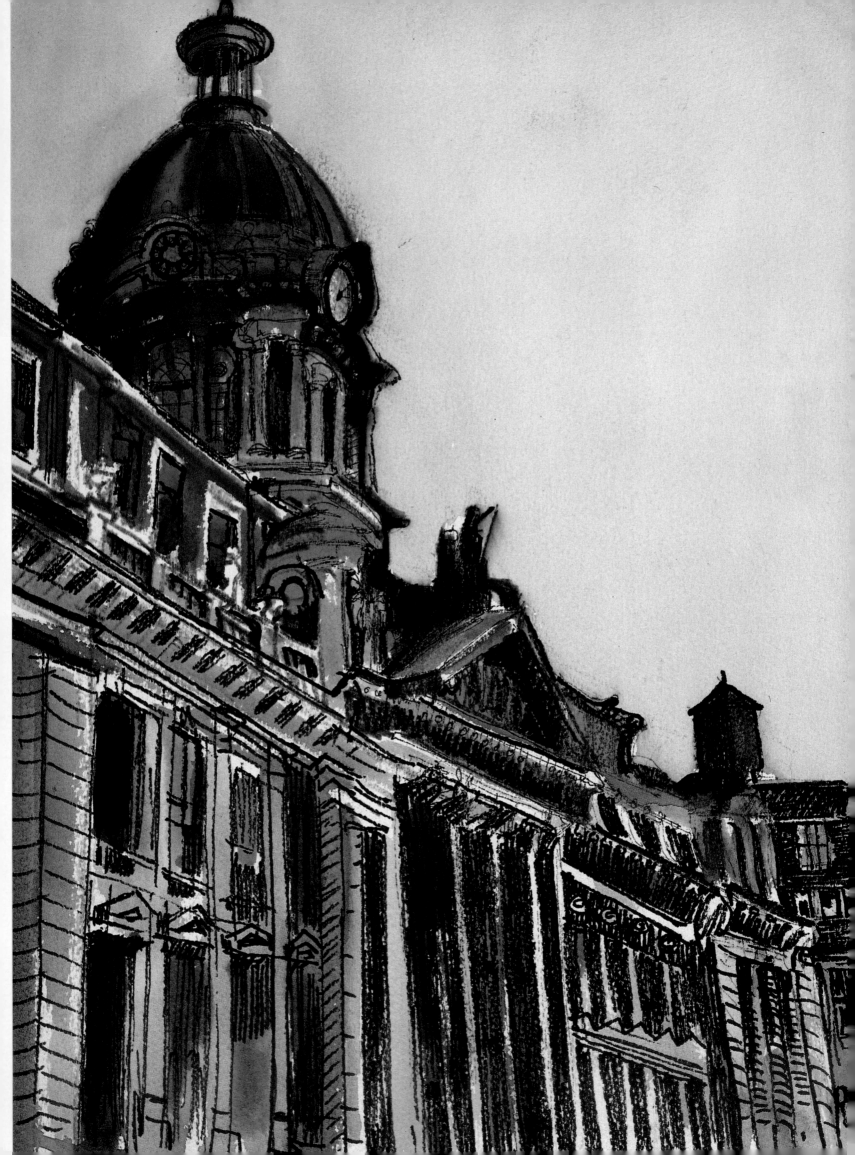

NoHo, Soho, Tribeca

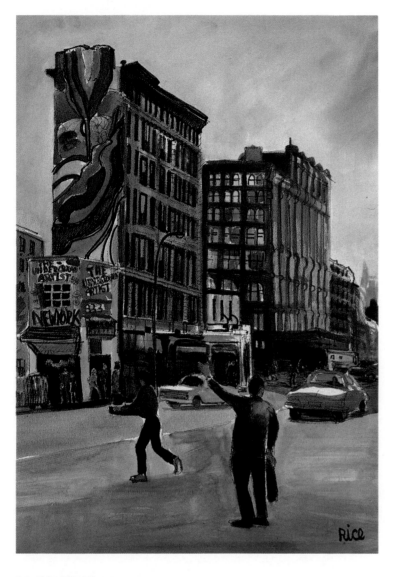

NoHo/SoHo

The Underground Artists Building in the foreground is in NoHo, while the building directly behind it is in SoHo. Houston Street, which is the dividing line between these neighborhoods, separates the two buildings.

F OR WANT OF MORE FLAMBOYANT or historic titles, these three areas take their names from abbreviations of their geographic boundaries: North of Houston (NoHo), South of Houston (SoHo), and Triangle Below Canal (TriBeCa). All three areas were centers of industry and manufacturing at one time and were home to large ethnic and immigrant populations.

NoHo is a tiny, newly christened area of cultural arts offices, restaurants, and boutiques whose boundaries of 3rd Street on the north, La Guardia Place on the west, 3rd Avenue on the east, and Houston Street on the south actually overlap the southeast corner of Greenwich Village by a couple of blocks.

SoHo is a busy district defined by Houston on the north, Sixth Avenue on the west, Lafayette Street on the east, and Canal Street on the south. SoHo was built up between the 1840s and 1860s, a time when architecture was revolutionized by the incorporation of lightweight cast-iron frames and skeletons. This style enabled architects to design the huge loft spaces and floor-to-ceiling windows that attract artists from all over the world and have become the landmark

< The Old Police Building

Built in 1908, the Old Police Building occupies an entire city block and has been converted into one of the most chic, luxurious co-op apartment buildings in the city.

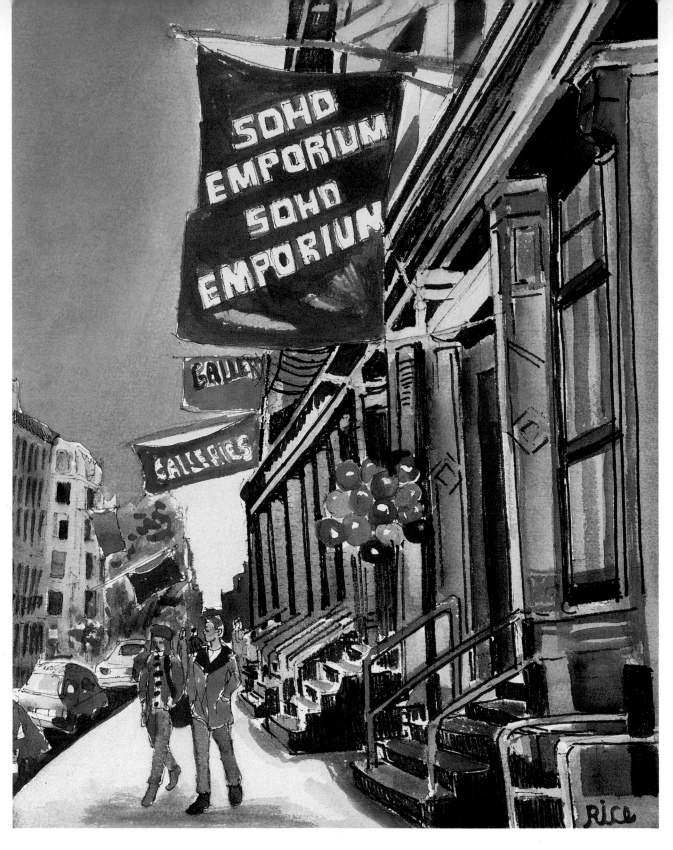

SoHo Galleries of this area. SoHo retains the world's greatest concentration of cast-iron buildings and is home to many individual galleries, cafes, home-furnishing shops, and one-of-a-kind boutiques. An art lovers' paradise, SoHo now boasts the Guggenheim Museum SoHo, the Museum of African Art, the New Museum of Contemporary Art, and the New York City Fire Museum.

TriBeCa is bounded by Canal Street on the north, West Street on the west, West Broadway on the east, and Chambers Street on the south. TriBeCa once danced to the tune of the warehousing, heavy shipping, and manufacturing industries. Art and commerce have since moved into this area, but TriBeCa still holds on to much of its ethnicity and its rugged charm. TriBeCa has a plethora of trendy restaurants located in some of the oldest buildings in Manhattan.

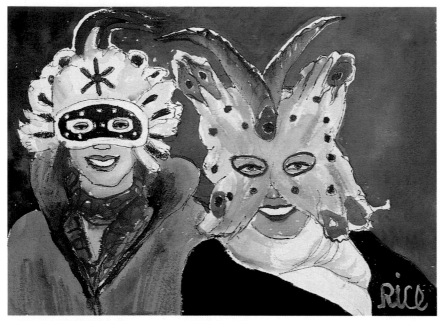

Masked Partygoers

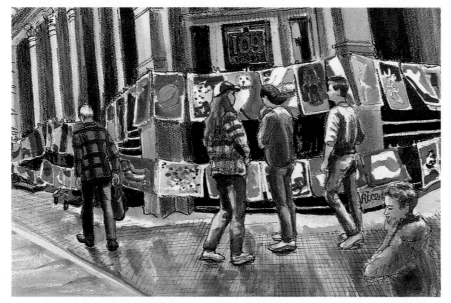

Art Show on Prince Street

Halloween Night on Prince Street

**Two German Artists Leaving
the Leo Castelli Gallery**

145

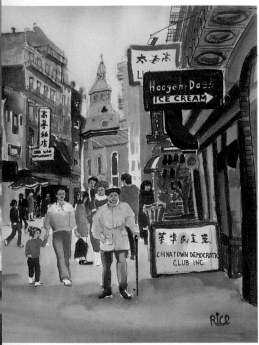

Street in Chinatown

Seen in the background is Mott Street's Church of the Transfiguration. Its Roman Catholic Mass is conducted in both Mandarin and Cantonese dialects.

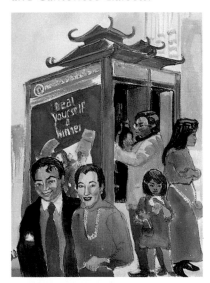

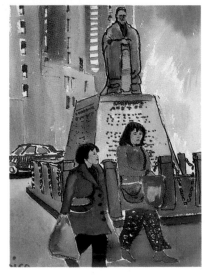

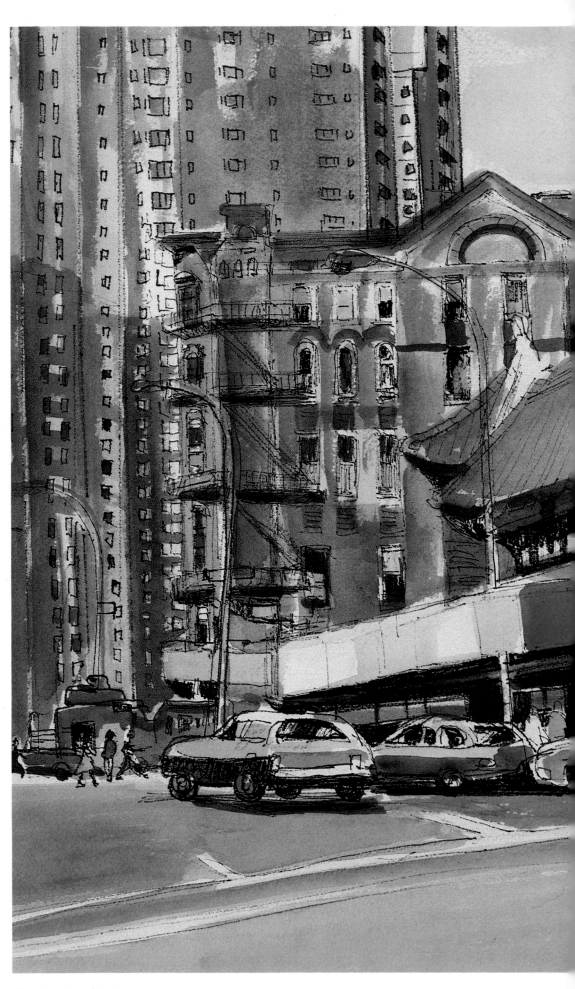

Confucius Statue

Chinatown honors Confucius with this statue.

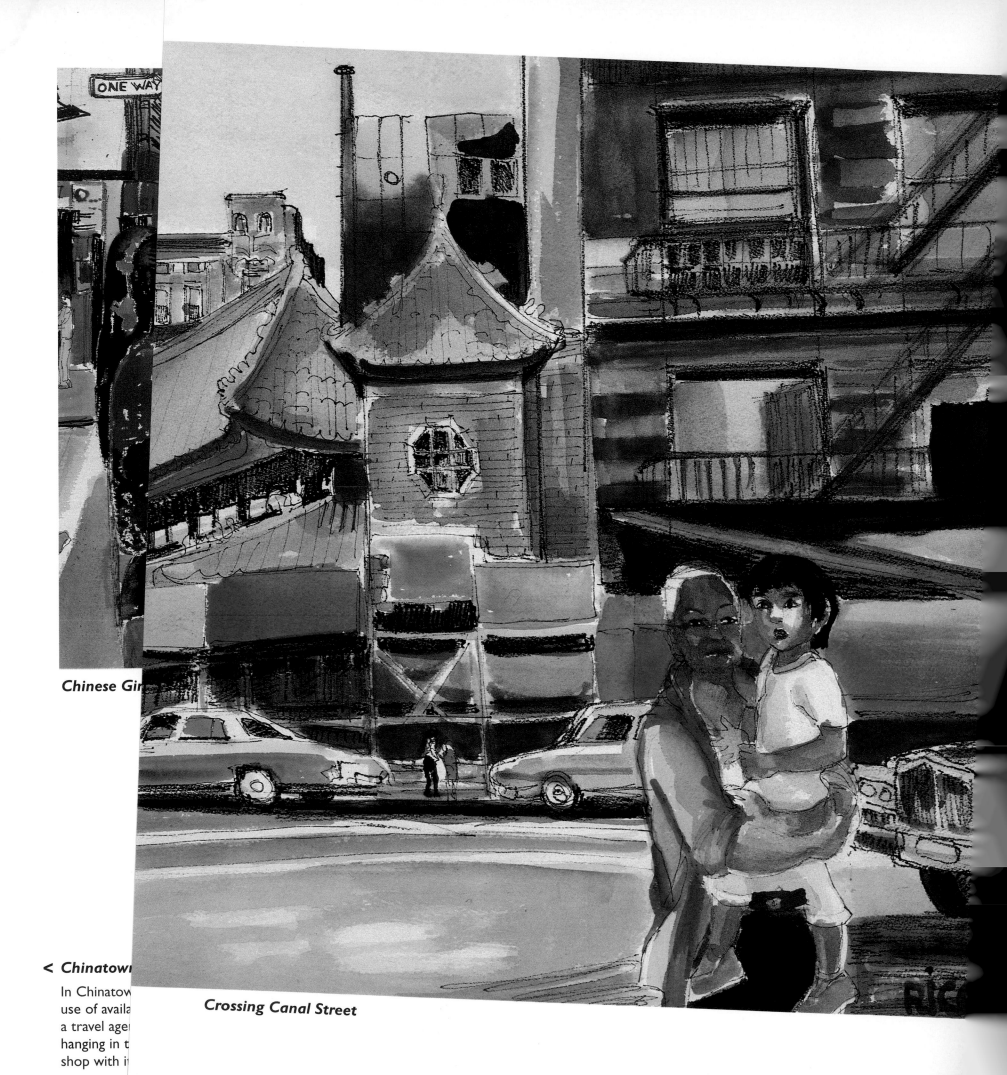

Chinese Gir

< Chinatown

In Chinatow
use of availa
a travel age
hanging in t
shop with i

Crossing Canal Street

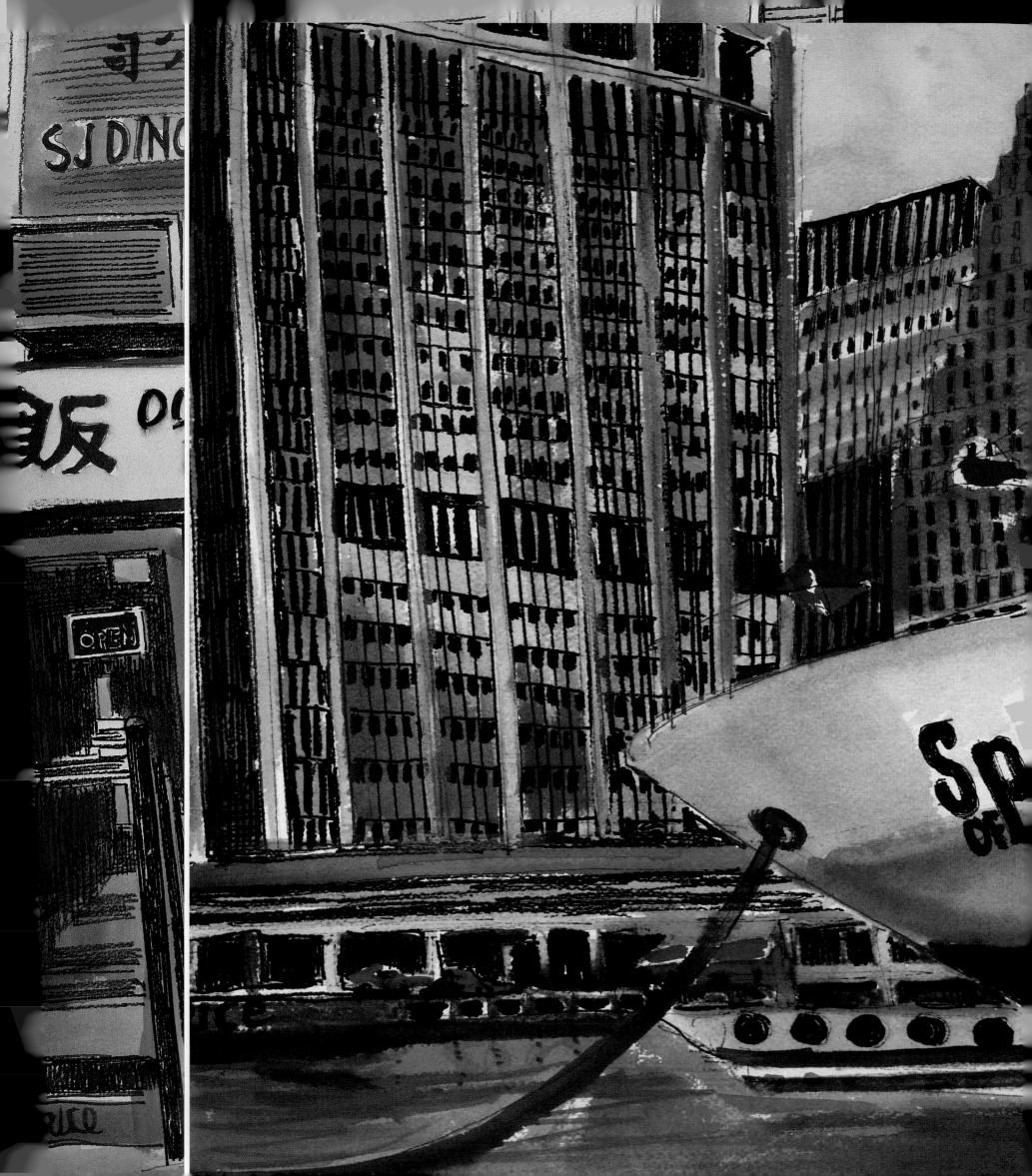

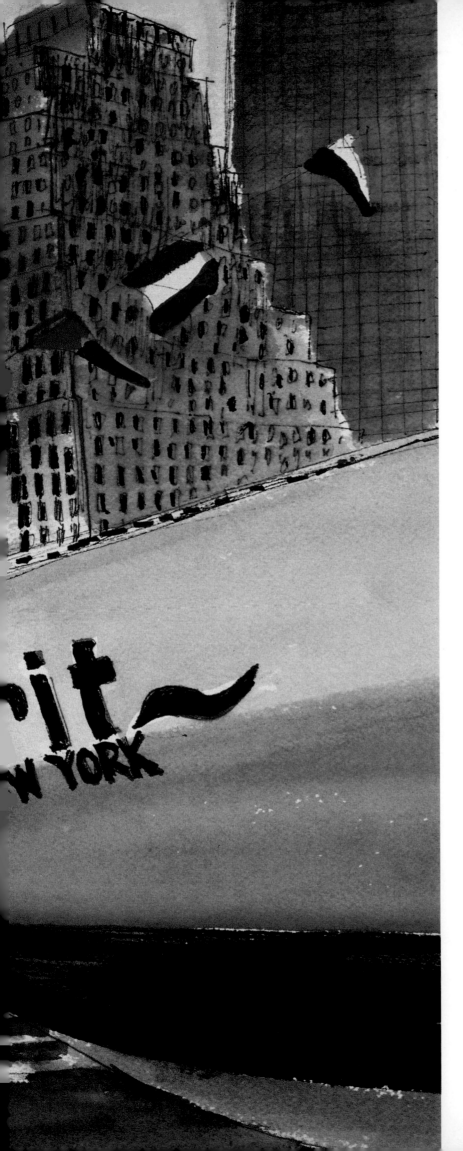

SOUTH STREET SEAPORT

Spirit of New York

My boat trip on the *Spirit of New York* at night as it circled the island of Manhattan is one I will always remember. There was dancing, good food, and lively entertainment on board as we cruised New York Harbor and the Hudson and East rivers. The impressive sight of Manhattan from the deck was constantly changing as we floated past the skyline filled with buildings of all shapes and sizes. All of the passengers came topside as the *Spirit of New York* cruised by the Statue of Liberty, brilliantly lit up in the night.

Girl with Balloon

Overleaf
The Peking >

Anchored at Pier 15, the last of the great sailing ships takes visitors back to when majestic vessels ruled the high seas.

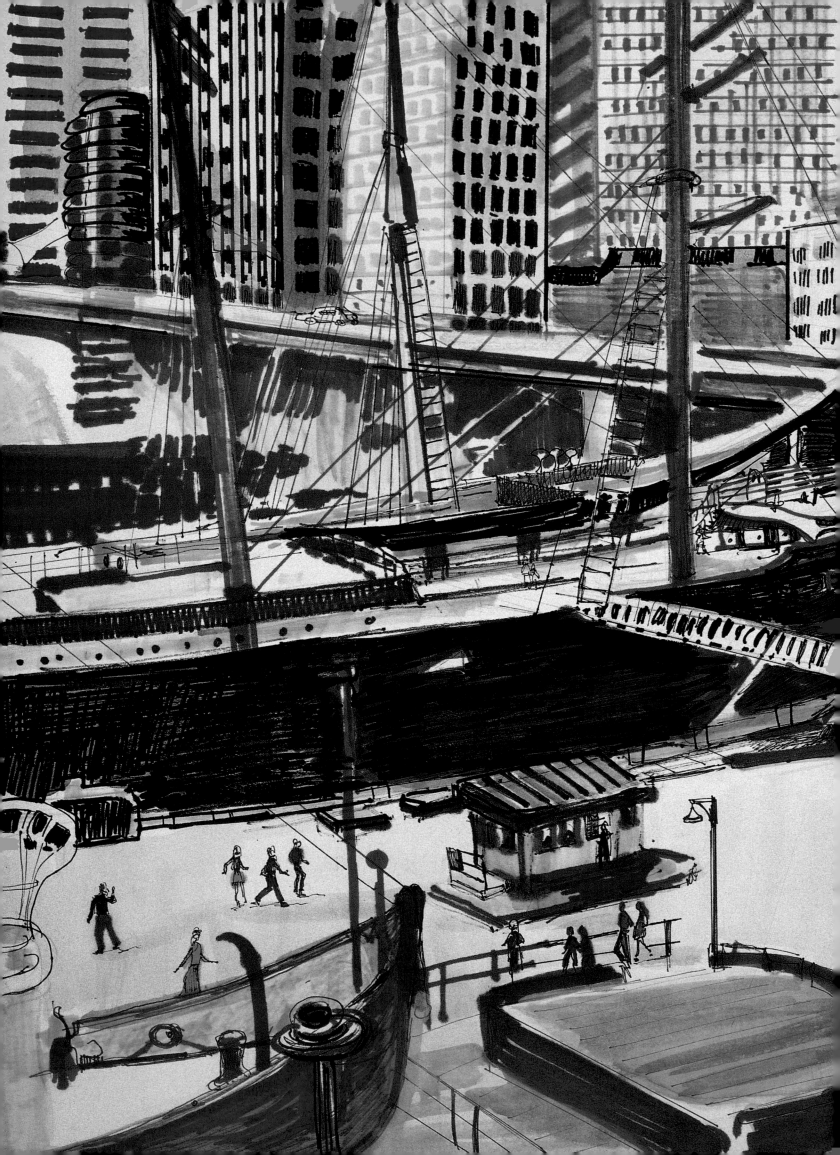

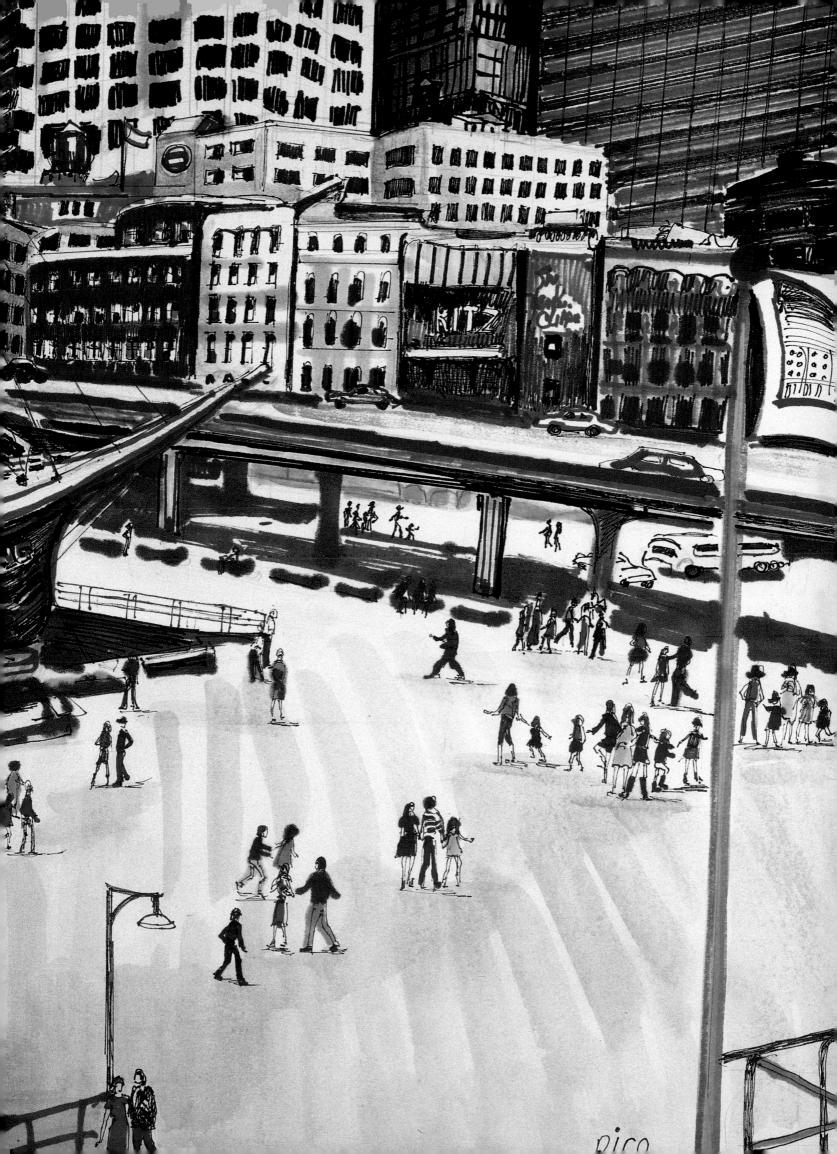

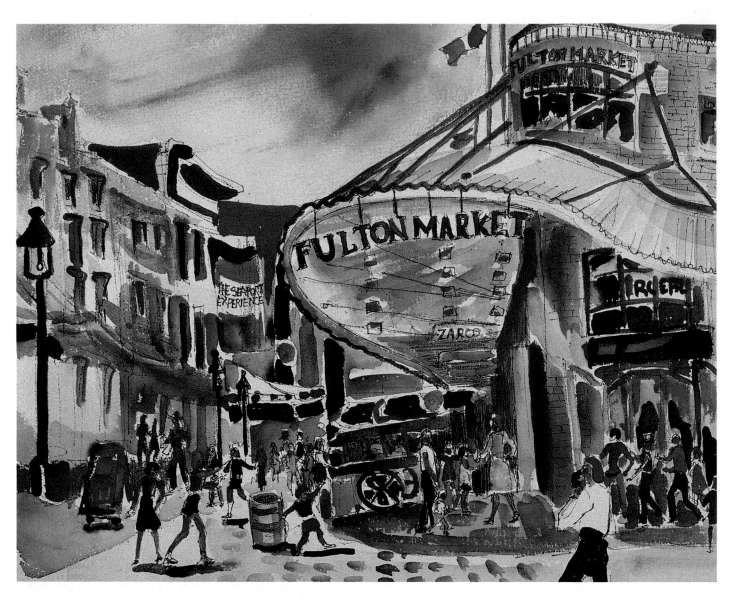

Fulton Market

Love at South Street Seaport

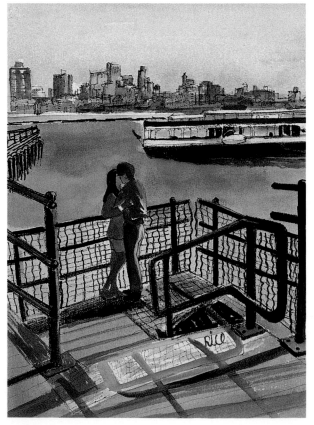

William Street Leading to City Hall >
This area preserves the feeling of old Manhattan.

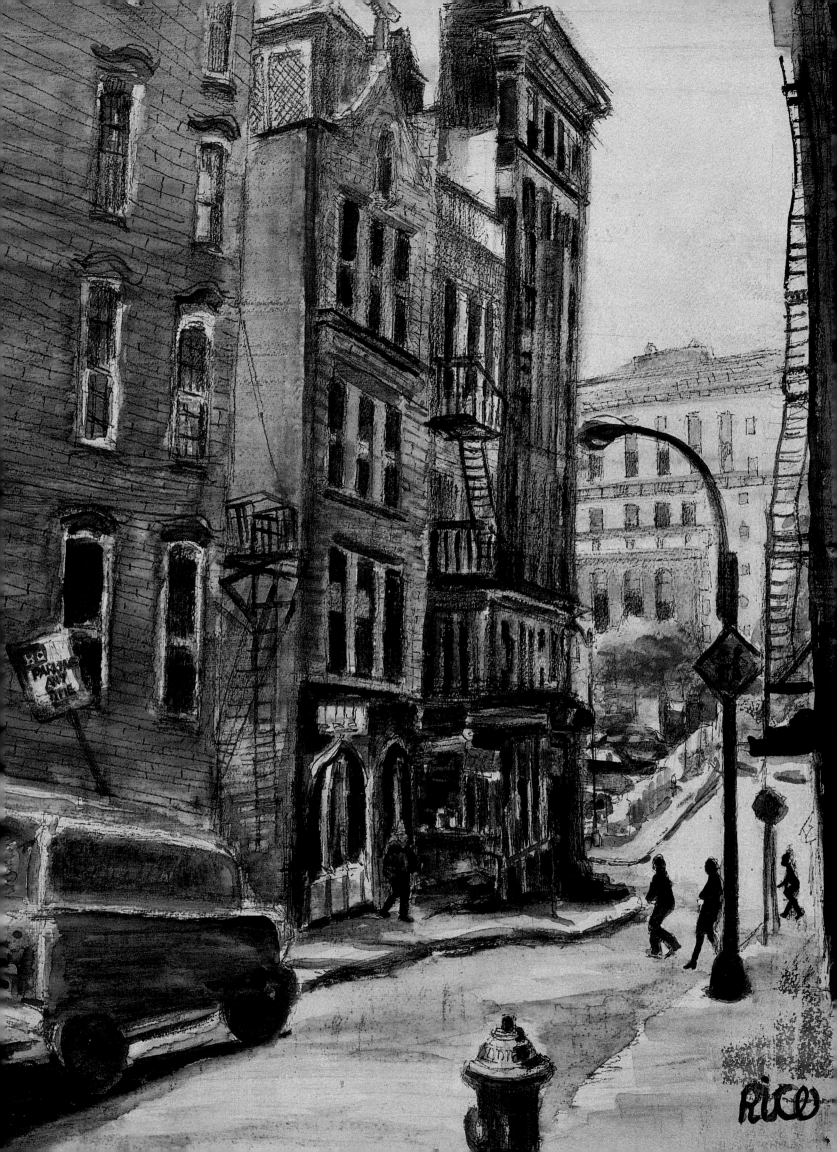

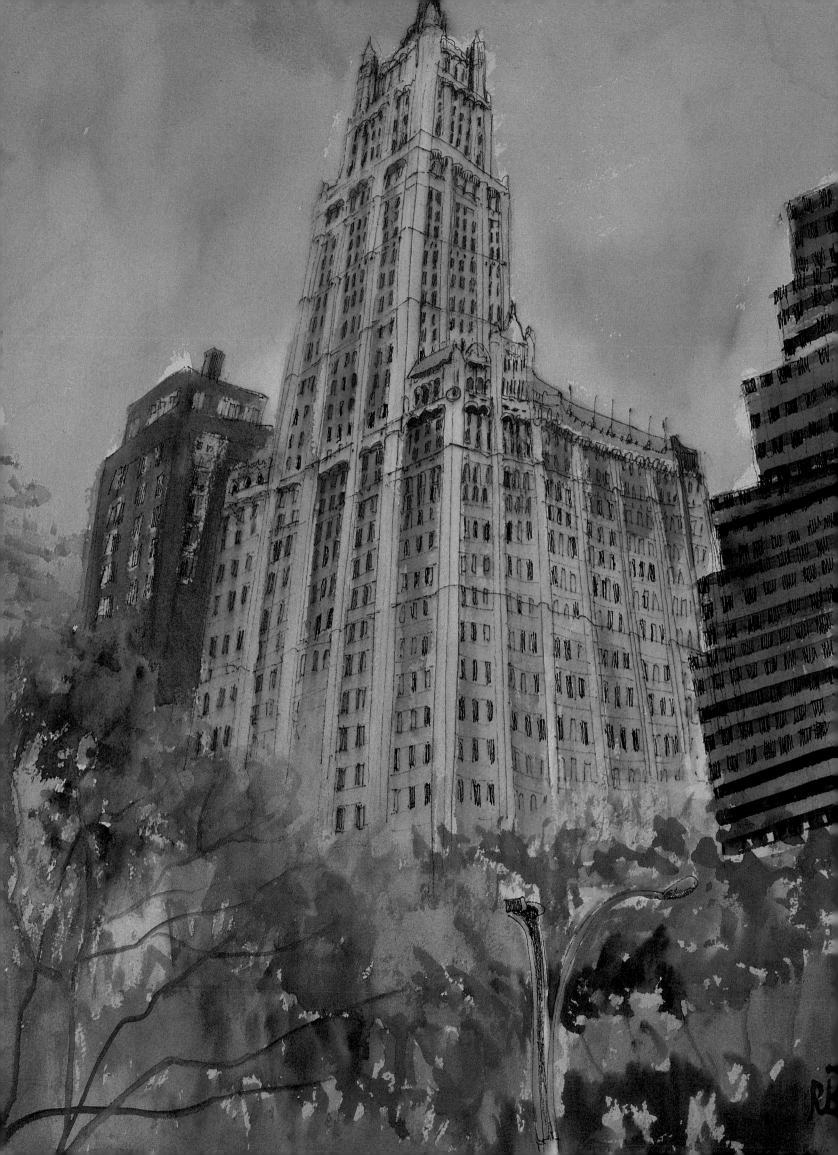

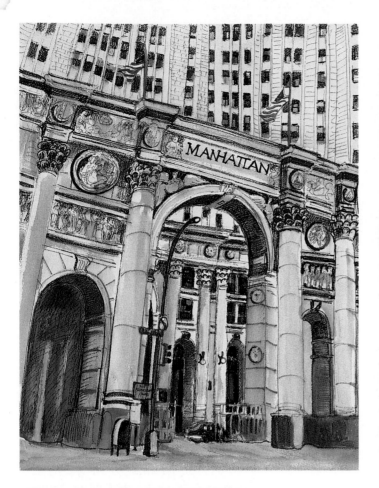

Front of the Municipal Building

City Hall weddings actually are performed in the marriage chapel inside this building. Flower vendors solicit prospective couples on the building steps.

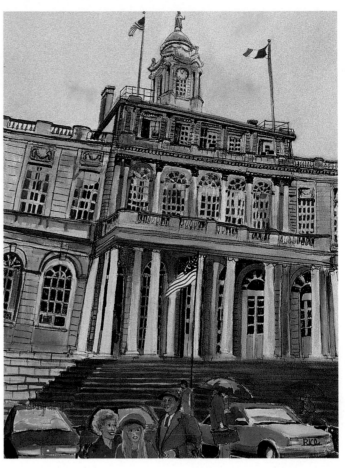

City Hall

Located between Broadway and Park Row, this elegant Georgian domed building, which has been the seat of government since 1811, is a blend of Federal neo-classical style and French Renaissance influences. The Declaration of Independence was first read to George Washington and his troops on July 9, 1776 on the present site of City Hall's west lawn.

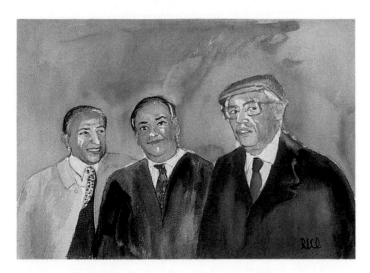

Three Judges

Deep in the heart of the court area of Manhattan is the Civil Court of New York on Centre Street near City Hall, where three judges, Judge Augie Moresca, Judge Arthur de Phillips, and Judge George Postel, posed for me and then invited me to lunch.

< Municipal Building

This Beaux Arts building is so large it straddles Chamber Street.

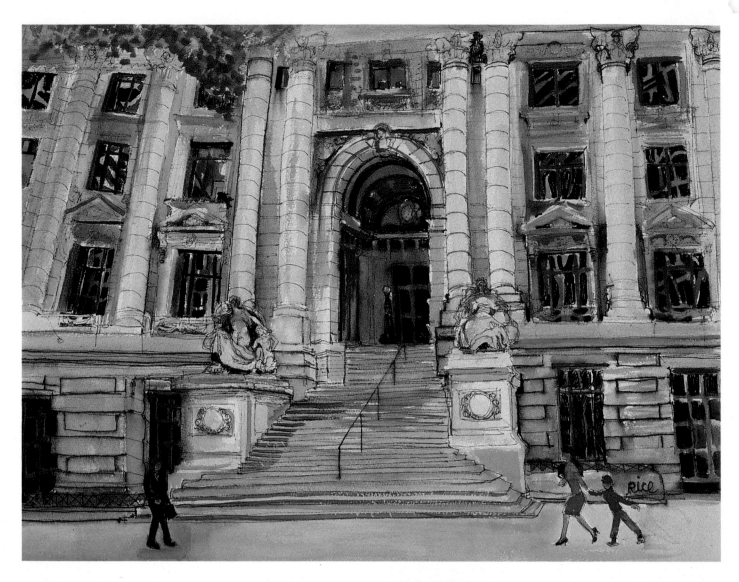

National Museum of the American Indian, Smithsonian Institution

Formerly the historic Alexander Hamilton U. S. Custom House at One Bowling Green at Broadway, it was designed by Cass Gilbert in 1907 and is an exemplary Beaux Art landmark. Converted to a museum, it boasts the world's most comprehensive collection of Native American artifacts, comprising more than one million items, a vast photographic archive of historic and contemporary prints and negatives, a video-and-film center, and a library of over 40,000 books. The museum and its resources are dedicated to the cultural achievement of the natives of the western hemisphere. Serving double duty, the U.S. Bankruptcy Court is situated at the base of the building.

Civic Center

This is the seat of justice for Manhattan. You'll find every court imaginable in Foley Square—from Tax to Family and Small Claims Court. Even the FBI has its offices here.

Municipal Building >

This Beaux Arts building is so large it straddles Chamber Street.

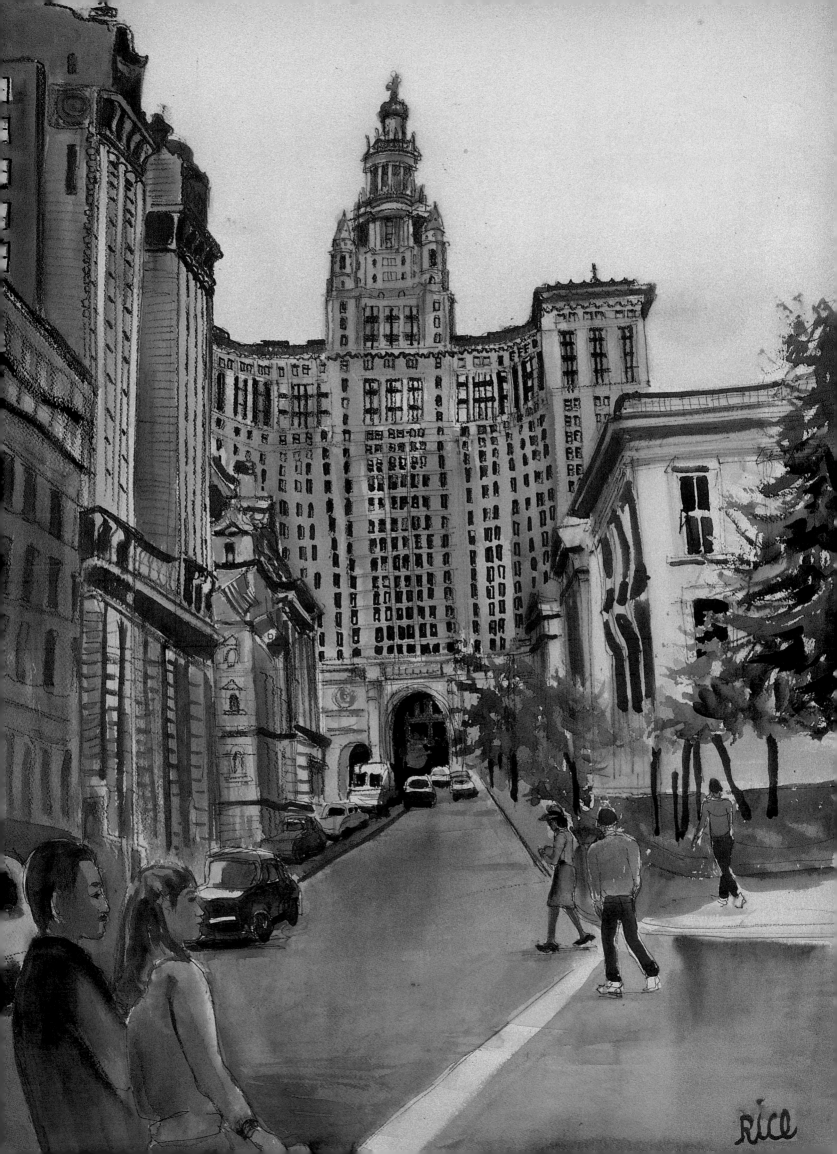

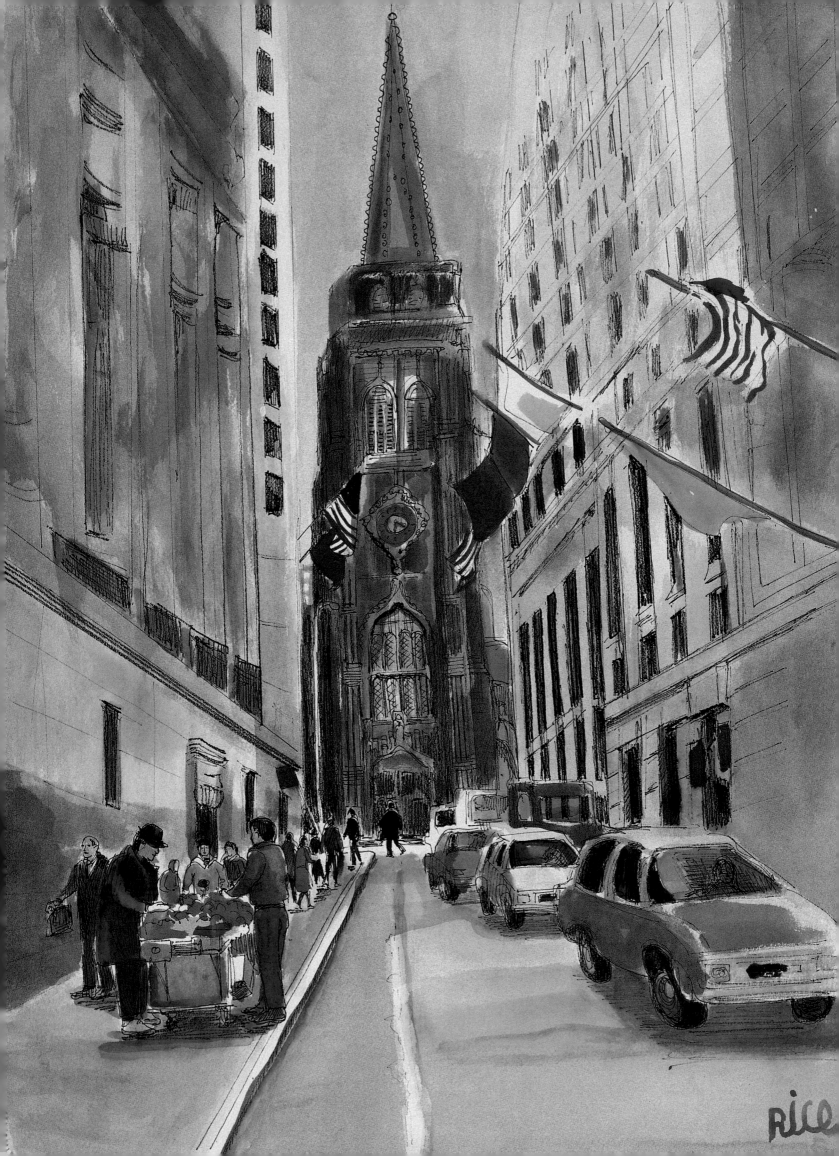

WALL STREET

New York Stock Exchange Building

The first time I visited the Stock Exchange was the day that I did the sketches for this painting. The place was crowded, noisy, dirty, and thoroughly enjoyable! It gave me a fascinating glimpse into the daily work routine of the people who are on their feet all day long, rushing from one place to another. The Stock Exchange consists of three rooms filled with sophisticated equipment. Papers litter the floor, visual proof that there is a great deal going on here. Telephones are everywhere, and people in various colored jackets are busy carrying on the business of the day in constant motion. The New York Stock Exchange can be found at 11 Wall Street. There is a visitors gallery overlooking the action, but the real fun is being on the floor amidst all the hubbub of this amazing financial arena.

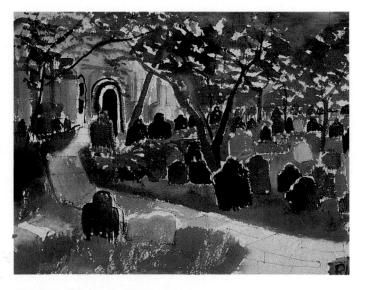

Trinity Church Graveyard

The Trinity Church graveyard is a popular place for a quiet walk insulated from the frantic pace of the city. Among the points of interest is the memorial to the unknown martyrs imprisoned by the British during the Revolutionary War. The graves of William Bradford, New York's first printer, Robert Fulton, and Alexander Hamilton also attract a steady stream of visitors.

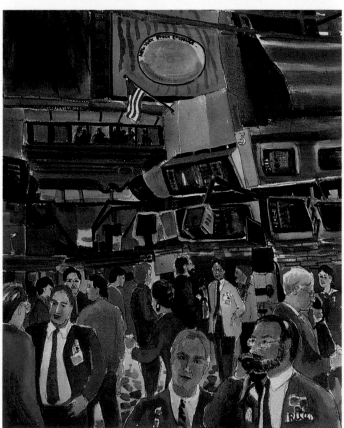

Traders on the floor of the New York Stock Exchange

< **Wall Street**

With Trinity Church as the focal point, this is the site of the American Stock Exchange at Trinity Place.

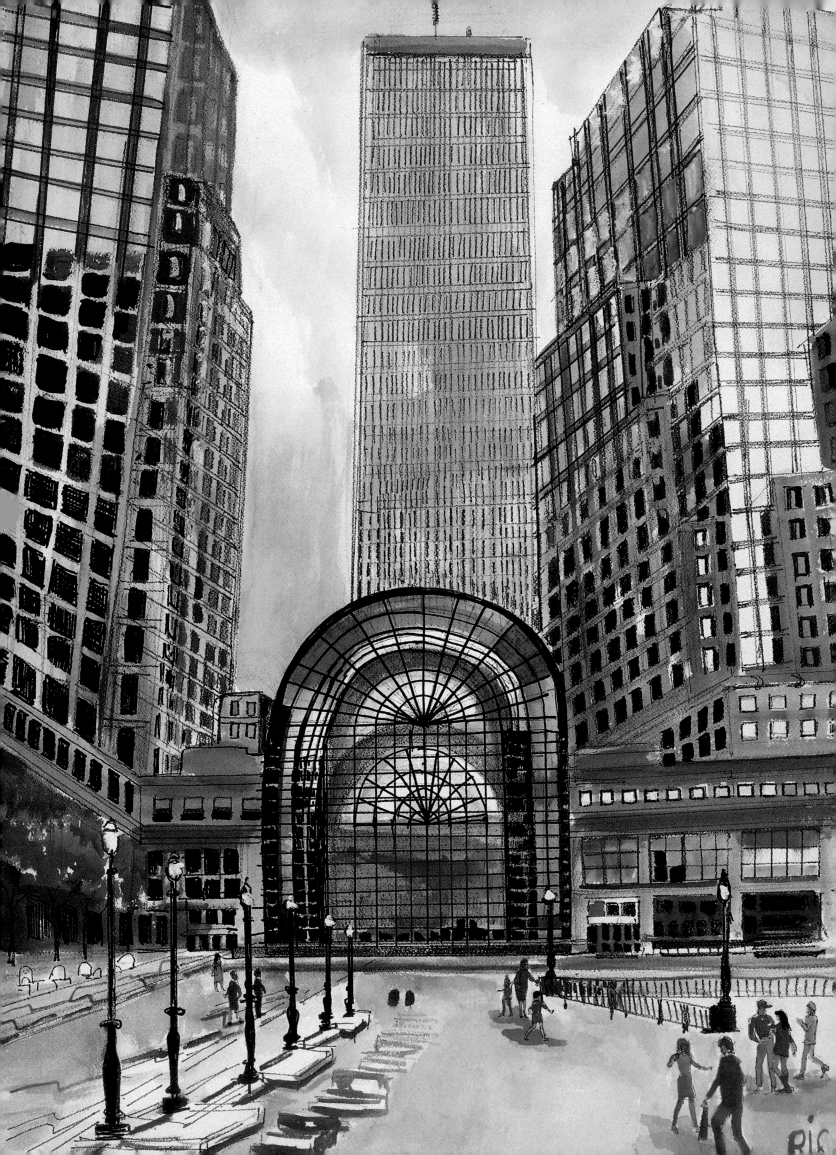

< World Financial Center

The World Financial Center is a seven-million-square-foot
commercial complex with towers varying in height from
thirty-three to fifty-one stories, each with a different geometric
termination. This geometric glass building, bounded by
the marina in front, is a perfect sight to paint. Concerts and
entertainment are presented in the tree-lined, glass-enclosed
Winter Garden Courtyard. The effect is spectacular.

**Winter Garden Courtyard in
the World Financial Center**

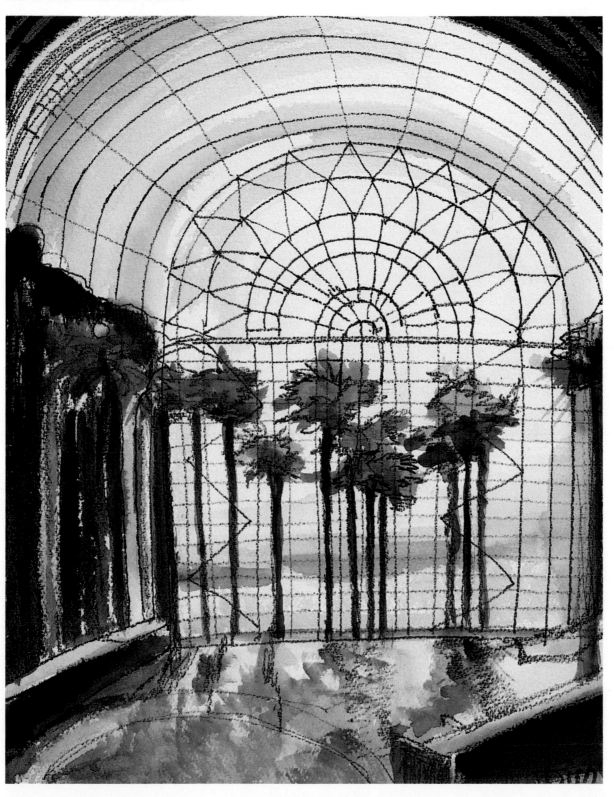

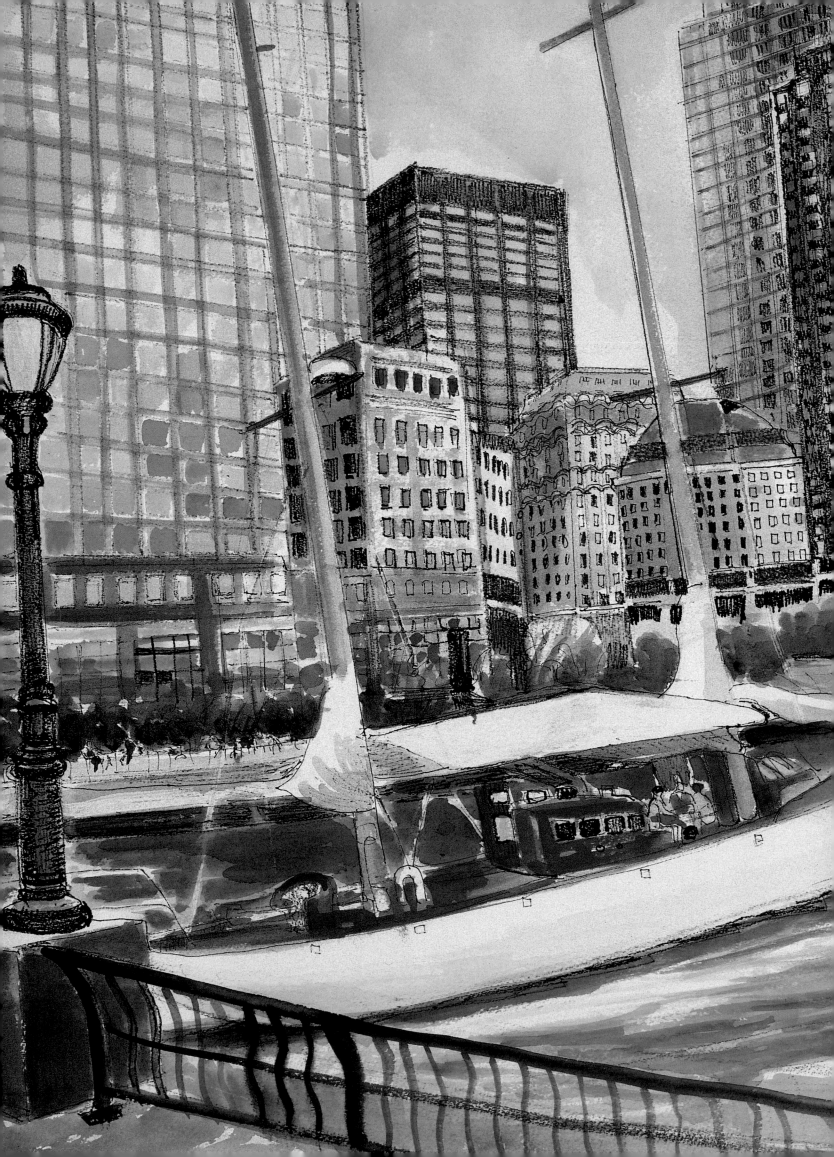

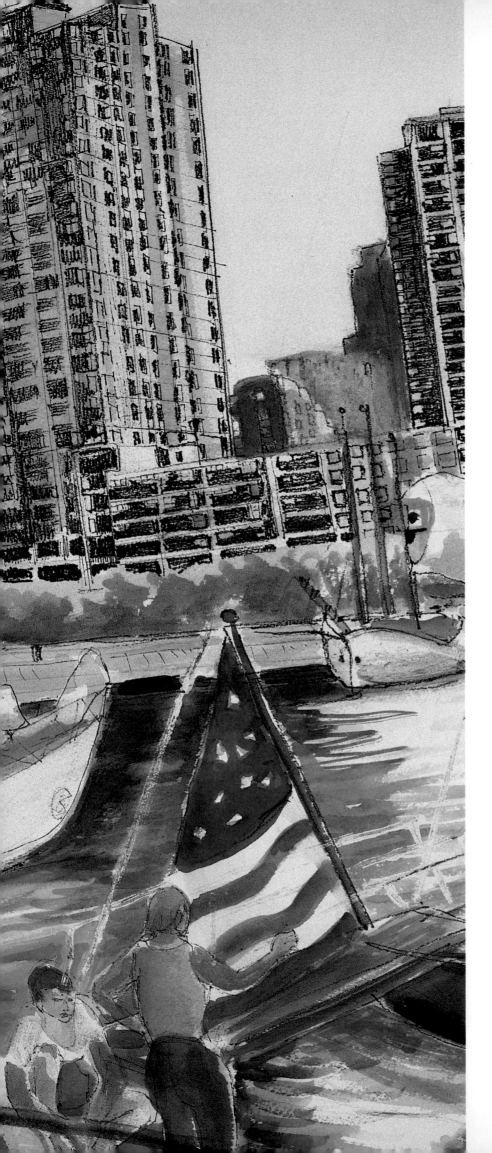

Radio Mexico Restaurant Under the Brooklyn Bridge

Peter Minuit Flagpole

Located in Battery Park, this memorial was presented by Holland to the City of New York in friendship in 1926. It is a tribute to the first Dutch settlers of New Amsterdam, later renamed Manhattan, and commemorates Peter Minuit, director-general of the settlement. Manhattan Island, which the Indians called Man-a-hat-tu, meaning "heavenly land," was purchased by Minuit from the Indians for about $24. As it turned out, the Indians with whom he was negotiating were not from Man-a-hat-tu, at all!

Battery Park City, North Cove

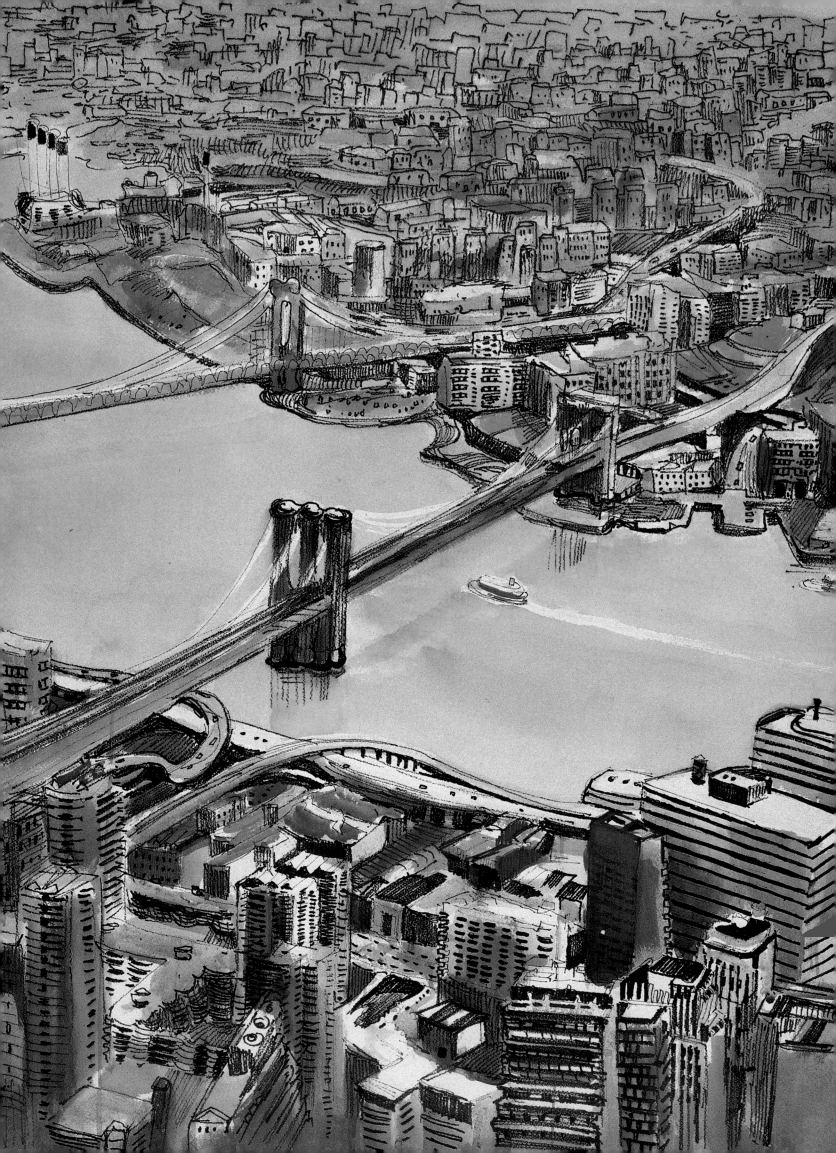

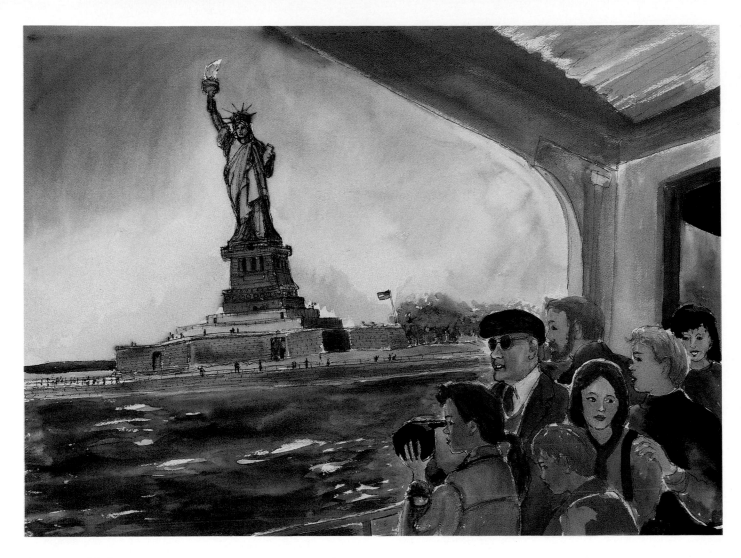

Statue of Liberty

This statue is so magnificent that all the passengers
on the Circle Line boat huddled as tightly as they
could at the edge of the boat to be near her. Many
people think of Lady Liberty as the first image of
New York; I like to think of her as the lasting image
of everything good that Manhattan, and America as
well, has to offer.

< New York Harbor with Brooklyn Bridge and Manhattan Bridge Beyond

The view from the 107th floor of the World
Trade Center offers a breathtaking panorama
of New York Harbor looking toward Brooklyn.

Joseph Devernay

ABOUT
DOROTHY RICE

Cliff Lipson

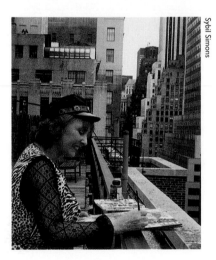

Sybil Simons

WHEN DOROTHY RICE BEGAN PAINTING AND WRITING ABOUT the places and people of Manhattan for her book *Manhattan With Love,* she embarked on what was to become a journey of the heart—back to the city of her childhood and of her early career as a top fashion model; then, actress; later, respected photojournalist; and ultimately, renowned artist.

Manhattan probably changes more often than any other city in the world, and yet somehow it always feels like home to those who love her. Fortified with a sense of adventure and the innate knowledge that any transformations she might find couldn't alter the essence of a city she's always loved, Dorothy Rice immersed herself in the vibrant life of Manhattan today. She took to the streets, mingling with the people to capture in exuberant watercolors the feelings and pulse of this extraordinary city. Whenever an image intrigued her, she painted it on the spot, recording the spirit of Manhattan in that moment in time. *Manhattan With Love* balances a diversity of people, architecture, and environments with a joyous unity of visual splendor.

Ms. Rice studied at the Art Students League in Manhattan, the Otis/Parsons Art Institute, the Art Center College of Design in Los Angeles, and the University of Guadalajara, Mexico. She works in a variety of media including oil, palate knife, and watercolor, and her interests range from creating small, intimate portraits to large-scale murals. Ms. Rice is one of the few American artists ever honored by invitation to paint a mural in Mexico, a country renowned for its own great muralists. Her one-woman show of lush oils of Mexico, *Serenata Mexicana,* was such a runaway success at the prestigious Southwest Museum in Los Angeles that it was held over for two months. Her paintings are owned by well-known collectors and have been exhibited in galleries throughout the United States.

Ms. Rice's previous books include *Los Angeles With Love,* a unique artist's eye view of living in Los Angeles, which has become a collectors' item, and *Israel With Love,* a magnificent book depicting her artistic sojourn in Israel, which has met with international acclaim. Following a gala reception honoring the artist-author, hosted by the Ambassador at the Israeli Embassy in Washington, D.C., these paintings were sent on a two-year, sponsored tour across the United States, promoting the land of Israel through Ms. Rice's inspired and radiant visions.

Various publications have written about Dorothy Rice and her unique artistry including *Architectural Digest,* which devoted a major article to her and illustrated it with a series of her paintings.

As Ray Bradbury wrote, "Dorothy Rice has fresh eyes and her own palette. Which means a talent for making the familiar unfamiliar, younger than when you last saw it."

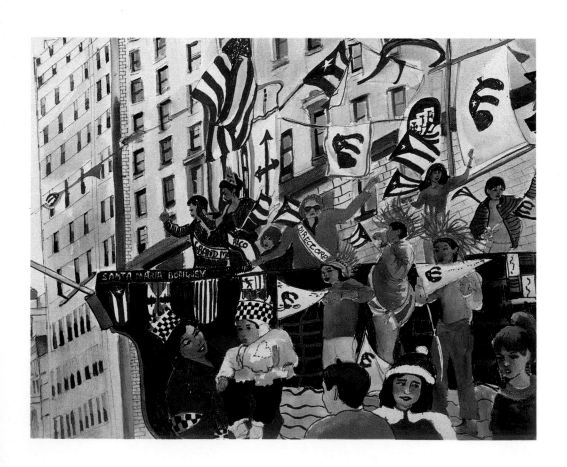